Nicolas Lampert, *Where's the Chickens?* 1995.

Opposite page: **Jane Alexander**, *The Municipal Crucifix*, 1986. Photo: Bob Cnoops

Becoming Animal

Contemporary Art in
the Animal Kingdom

MASS MoCA

Nato Thompson

Foreword by Joseph Thompson

MASS MoCA Publications
North Adams, Massachusetts

Distributed by The MIT Press
Massachusetts Institute of Technology

Becoming Animal: Contemporary Art in the Animal Kingdom

Nato Thompson, editor
With Joseph Thompson, Christoph Cox
Graphic design by Arjen Noordeman

MASS MoCA Publications
North Adams, Massachusetts

Distributed by The MIT Press
Massachusetts Institute of Technology
Cambridge, Massachusetts 02142
http://mitpress.mit.edu

This publication accompanies the exhibition *Becoming Animal*,
organized by MASS MoCA, and presented in North Adams from
May 2005 through March 2006.

Printed and bound in China by Palace Press International

MASS MoCA (Massachusetts Museum of Contemporary Art)
1040 MASS MoCA Way
North Adams, Massachusetts 01247
PH 413-664-4481
FAX 413-663-8548
www.massmoca.org

©2005 Massachusetts Institute of Technology and
Massachusetts Museum of Contemporary Art.

Library of Congress Control Number: 2005920811
ISBN 0-262-20161-5

10 9 8 7 6 5 4 3 2 1

Front Cover: Ann-Sofi Sidén
From *QM, I think I call her QM* (1997)
Photograph by Tom Legoff

Back Cover: Patricia Piccinini, *The Young Family* (2003)

Table of Contents

Acknowledgements

The artists in *Becoming Animal* participated at multiple levels – producing new and amazing installations, providing interviews and source material for the catalogue, and lending considerable time and energy – and we would like to thank them for that. The MASS MoCA staff continues to produce amazing exhibits at break neck speed, and with unparalleled dedication, commitment, and quality. A special thank you goes out to Roger Conover and MIT Press. We would like to thank our underpaid but fully appreciated interns – Guinevere Johnson, Molly O'Rourke, Briana Toth, and Rebecca Uchill – for their tremendous assistance on the catalogue and exhibition. This exhibition would not be possible without the generous support of our funders: Citigroup, Massachusetts Cultural Council, The National Endowment for the Arts, and The Nimoy Foundation, which fuels our residencies.

MASS MoCA, which has no permanent collection, is deeply grateful to the lenders – galleries, museums, and individuals – who allowed us to create this exhibition: American Fine Arts Co, New York; The Barbro Osher Pro Suecia Foundation; The Consulate General of Sweden; Joel and Sherry Mallin; Robert Miller Gallery, New York; Moderna Museet, Stockholm; The Nimoy Foundation; Pierogi Gallery, New York; Anthony and Heather Podesta; Brent Sikkema Gallery, New York; Toshiko Ferrier Collection, Tokyo; Yamamoto Gendai Gallery, Tokyo.

FUNDING PROVIDED IN PART BY

MASSACHUSETTS CULTURAL COUNCIL

Foreword

Overlapping with *Becoming Animal*, MASS MoCA is presenting a major suite of works by Cai Guo-Qiang, all grouped under the title *Inopportune*. Several elements of the installation are evocative of car bombs — a loaded subject for our times if there ever was one. Our staff therefore spent considerable energy readying ourselves for the public's response to Cai's use of car explosive imagery. Adjacent to the cars, Cai also arrayed nine beautifully crafted tigers, each pierced with dozens of bronze-tipped arrows. Though synthetic, the tigers have a powerfully realistic presence, their lithe bodies leaping and turning through space. In the first few months of *Inopportune*, we've received not one comment or expression of concern by the public about the exploding car imagery — its implicit violence, wrapped, though it is, in a dazzlingly beautiful show of light -- but many patrons, including my son, have found the tigers to be disturbing to view, even knowing they are theatrical props. On the scoreboard of sheer emotional reaction, it's shot tigers 1, exploding cars 0.

In La Jolla, California, just outside the San Diego Museum of Contemporary Art, there is a lovely jetty built in the 1930's by a private donor, at considerable expense, to create a small, sandy cove for children, since protected swimming spots are hard to come by on the rocky Pacific coast. When a few seals first hauled out onto the sandy beach cove, residents were delighted. But then another seal took roost, then another, until the cove had become an inadvertent refuge for some 200 pinnipeds. In fact, the jetty was recently closed to human use: seals and humans cannot cohabitate, for health, safety, and animal protection reasons. This act of animal colonization, in which a man-made environment constructed for human use has become redefined, by humans, as a protected wildlife refuge, has divided the La Jolla community as few other issues have. On the scoreboard of La Jolla beach rights, its seals 1, children 0.

Animals, in other words, have a tremendous call on human emotion, and, increasingly, legal rights and ethical standing. As curator Nato Thompson and essayist Christoph Cox both write, humans are reaching deep into the very essence of animal existence in all sorts of ways: through advances in our comprehension of animal communication, through genetic research and through stranger pathways, including the paranormal (and, of course, through art). But animals are also reaching deep into us: there is a high likelihood that the next major pandemic, for example, will be an avian flu or another form of exotic zoonosis, perhaps hatched in some remote Indonesian village, where humans, chickens and pigs live in close domestic quarters amid perfect conditions for cross-species viral vectors. The artists of *Becoming Animal* are acutely aware of the diminishing space between human and animal existence, and the extraordinary opportunity — and mutual threat — this shrinking space provokes.

Joseph Thompson
Director
MASS MoCA

NATO THOMPSON
MONSTROUS EMPATHY

We are becoming animal in more ways than one. The clues are in the air, the sea, our genes, the TV, and even our breakfast cereal. Somehow, while we were cleaning the house and heading out to work, the separation between human and animal diminished from an absolute biological distinction to an increasingly delicate web of ecological, social, and personal relationships.

In a world where the lives of humans and animals are increasingly interwoven — where the distinction between what we know to be humankind, and what we believe to be animal, is shrinking — the artists of *Becoming Animal* are linked by an intense focus on the philosophical, medical, biological, and ethical connections that bind us to them. Artist Kathy High unveils the biological and surprisingly personal connections between laboratory rats and herself; Rachel Berwick brings to life the effects of humans on animals extinct and nearly so; Natalie Jeremijenko's *For The Birds* (2005) lends voice and sight to the fanciful needs of pigeons; philosopher Peter Singer writes compellingly of animals' legal rights. The once sacred and obvious distinction between humans and their feral counterparts shrinks and, as it does, we are forced to imagine what it might be like to live without this division altogether.

Jeff Goldblum in David Cronenberg's remake of *The Fly*, 1986. Photo: Photofest

Such hybridity cannot help but cause trepidation since it breeches one of the longest standing human boundaries. If we actually are becoming animal, whether our ethical, moral, sacred, and legal systems, let alone our dinner? These questions not only shake the foundations of our relationships with the animal world, but in changing our opinions about the toothed and clawed, they also reformulate what it means to be human.

How do we incorporate the new knowledge that the human genome is only a few strands away from that of a flea? When a human ear is grafted to the back of a mouse, or a human is supposedly cloned by an alien-worshiping cult in Montreal, how should we react? What do we see when we can see — quite literally — through the eyes of our pets? Do we have an ethical framework nuanced enough to respond to the diminishing degrees of separation from animals? At the beginning of the 21st century these questions offer a perplexing future which contemporary artists are eagerly exploring.

The exhibition *Becoming Animal* takes a cue from the work of Gilles Deleuze and Felix Guattari in their seminal book *A Thousand Plateuas: Capitalism and Schizophrenia* (1980). When Deleuze and Guattari write of "becoming animal," they destabilize the strict (and possibly arbitrary) boundaries modernity established between humanity and the animal kingdom. Their sweeping notion of *becoming* takes on diverse fields such as "becoming geology," "becoming woman," and "becoming imperceptible," but it is at its most acute with animals. Rather than fixed and discreet, for Deleuze and Guattari the individual is an ever-shifting being, a "desiring machine", that can take on new forms of animal-ness (or an animal capable of taking on forms of human-ness). Similarly, the term "becoming" allows for exchange between otherwise static conceptions of the world: man/nature, man/woman, I/we, human/animal.[1]

Be Afraid, Be Very Afraid

"And perhaps even the most luminous sphere of our relations with the divine depends, in some way, on the darker one which separates us from animal." — Giorgio Agamben, *The Open: Man and Animal*, 2004

"My, what big teeth you have, grandmother," said Little Red Riding Hood.

While liberating, Deleuze and Guattari's challenge to the Cartesion notion of individuality — I think therefore I am — can produce a tremendous amount of anxiety. The monstrous, the hybrid, the cyborg (to use Donna Haraway's

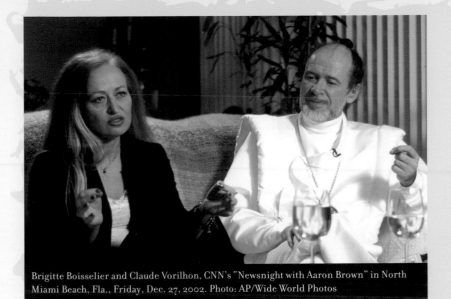

Brigitte Boisselier and Claude Vorilhon, CNN's "Newsnight with Aaron Brown" in North Miami Beach, Fla., Friday, Dec. 27, 2002. Photo: AP/Wide World Photos

term) have a long paranoiac history stretching from the Greek's Chimera to PT Barnum's freak shows. We imagine trans-animals as predators stalking the night. In David Cronenburg's 1986 remake of the 1958 Vincent Price classic *The Fly*, for example, the genius scientist Seth Brundle (Jeff Goldblum) invents a teleporting machine only to accidentally find himself fused with a fly that enters the teleport pod.[2] Dr. Brundle takes on some particularly grotesque traits such as vomiting on his food and acquiring an indomitable sexual appetite. The film culminates in Brundle's inexorable transformation into a six-foot fly renamed Brundle-fly, and the heroine (Geena Davis) tellingly dreams of giving birth to the most abject embodiment of becoming animal, the larva, referencing Franz Kafka's *The Metamorphosis*. Horror films are a common vehicle by which the monstrous can draw upon latent fears of cross-species hybridity. But what is it that we are afraid of exactly?

We can turn to the macabre and richly detailed paintings of the great Flemish painter Heironymus Bosch (c. 1450-1516) whose stunning triptych, *Garden of Earthly Delights* (circa 1500), details not only the dreadfulness of the conjoined animal/human world, but in particular Bosch's Protestant conception of hybridity. Riddled with parading unicorns, goats, canaries and insectal lizard-men, both the Garden of Eden and hell resemble a playground for the monstrous. And at the same time that Bosch's painting seems to condemn the evils of the flesh, it also reveals Bosch's own imaginative obsessions. One can't help believe that Bosch's freakish hell was more enjoyable to paint than the sterile work of his contemporaries, which is to say that ever since Eve engaged in small talk with the serpent at the tree of wisdom, animal/human relations have been ensconced in the repulsive longing of taboo.

It should not surprise us that fear plays such a strong role in our conceptions of becoming animal. For at the center of the discussion is the question of where humanity ends and, more dramatically, how we construct human subjectivity altogether. In his 2004 book *The Open: Man and Animal*, philosopher Giorgio Agamben tracks the lengthy historic discussion of what is animal versus what is human. As he weaves this story from prophecies of animals and humans becoming one in the Hebrew Bible, to definitions of human versus animals in Aristotle, to the origins of taxonomy in Carl Linnaeus (1707-1778), and to the lectures of Alexandre Kojève (1902-1968), he outlines how central the definition of "non-human animals" is to our own existence. In short, what makes us human is simply that we are not animals, but what that means has changed dramatically over the course of history.

Kind-ness — the acceptance that we are all of one kind…

However, *Becoming Animal* charts a path more kind than alarming. As its conscious point of departure, *Becoming Animal* focuses on empathetic and sympathetic approaches to hybridity rather than those conveniently fear-laden. The artists in *Becoming Animal* do not see the animal as a canvas on which to subject their anxieties, but rather refractive beings through which we can consider new forms of existence. Often in the work of this exhibit, we see ourselves looking out from the great expanse of animality. Such gestures feel counterintuitive as they butt up against the long-standing definition of what

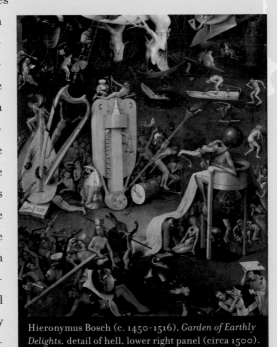

Hieronymus Bosch (c. 1450-1516), *Garden of Earthly Delights*, detail of hell, lower right panel (circa 1500). Photo: Erich Lessing/Art Resource, New York

constitutes human. However, radically sympathizing with the animal has had some of its strongest historical advocates in both art and zoology.

As Giorgio Agamben traces animal theories of the great philosophers, he often focuses on the perspective of famed zoologist Jakob von Uexküll. Von

Uexküll proposed that in order to understand animals, we must recognize their *umwelt*; that is, their environment world. As Agamben surmises, "The first task of the researcher observing an animal is to recognize the carriers of significance which constitute its environment."[3] Uexküll clarifies by providing a grueling example of *umwelt* — whose richness is worth quoting at length — through the small yet poetic needs of a tick.

The eyeless animal finds the way to her watch post with the help of only her skin's general sensitivity to light. The approach of her prey becomes apparent to this blind and deaf bandit only through her sense of smell. The odor of butyric acid, which emanates from the sebaceous follicles of all mammals, works on the tick as a signal that causes her to abandon her post and fall blindly downward toward her prey. If she is fortunate enough to fall on some-thing warm (which she perceives by means of an organ sensible to a precise temperature) then she has attained her prey, the warm-blooded animal, and thereafter needs only the help of her sense of touch to find the least hairy space possible and embed herself up to her head in the cutaneous tissue of her prey. She can now slowly suck up a stream of warm blood.[4]

This gross explanation provides a tangible example of umwelt, and the underlying empathy feels more in cahoots with the art in this exhibition than with science. The corporeal sensibility of von Uexküll recalls artists' attempts to throw off the artifice of civilization to reveal something more fundamental, more true to animal nature. These include the ketchup-strewn performances of Paul McCarthy in animal masks, the orgiastic rituals of Herman Nitsch and the animal-sacrifice performances of Ana Mendieta.

They also bring to mind the shamanistic rituals of Joseph Beuys. In addition to being the founder of the first political party for animals (he claimed over one billion members), Beuys's two most notable performance pieces — *I Like America and America likes Me* (1974) and *How to Explain Pictures to a Dead Hare* (1965) — were specifically intended as exercises in connecting with the animal world. In his *How to Explain Pictures to a Dead Hare*, Beuys cradled a dead rabbit in his arms and talked to it, Beuys' own head covered in honey

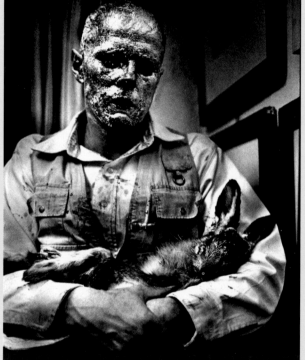

Joseph Beuys, *How to Explain Pictures to a Dead Hare*. 1965.
Photo: © Walter Vogel

and gold leaf. While the rabbit may not have understood his human-centric words, dead or alive, one feels that the dead rabbit-spirit might respond to the gold leaf and honey. In posing the riddle, "How does one explain pictures to a dead hare?" Beuys may be offering a form of being ensconced in the richness of materials, smell, texture, and symbolism. The fact that the hare was dead is all the more important because for Beuys the hare was a symbol of productivity and border-crossing. The distinctions between death/life, human/animal were, to Beuys, barriers to pass through. This meant adopting and creating new forms of language and being not dissimilar from von Uexküll's. Von Uexküll and Beuys provide a simple lesson that is familiar to many artists: in order to understand animals we must learn to think like them.

Leaving behind traditional categories for understanding the "other," we enter a radical space of empathy. Artist Kathy High evokes this territory well with her autobiographic project aptly titled *Embracing Animal* (2004). Over the telephone, Kathy High ordered a pair of laboratory test rats whom she named Echo and Flowers. The rats had been previously micro-injected with human DNA that caused their autoimmune systems to be weakened. Their incapacitated immune systems are biologically re-engineered to make them susceptible to diseases such as reactive arthritis, psoriasis, and inflammatory bowel disease. In the normal course of science, the rats would be used as test subjects for drugs to treat humans.

High, suffering from a chronic illness herself, understood that these rats were being used to find cures for people. Echo and Flowers were not simply becoming human, they had become integrally locked in a genetic relationship with humanity. As part of the project High cares for the pair of rats, treating them with homeopathic medicines.[5] Her installation consists of a lovely home for Echo and Flowers as well as elongated test tubes outfitted with LCD monitors displaying images of fear and anxiety that pervade physical crossovers between human and animal: footage of werewolves, vampires, and bestiality flickers at the bottom of the tubes. In High's impassioned and much less frightful take on animal/human relations, becoming animal is not an abstraction but an evolving condition which

requires a measured approach, and even a sympathetic response. Perhaps it was this condition that Friedrich Nietzsche grappled with in his last purported moment of sanity as he lurched at a horse being beaten, held onto its neck, and wept uncontrollably.

Destroying Nature

"Indeed nature is the chief obstacle that has always hampered the development of public discourse." – Bruno Latour, *Politics of Nature: How to Bring the Sciences into Democracy*, 2004

Of course, we are most commonly engaged with animals as food. From the horrors of mad cow disease to the recent explosion of genetic modification, the animal kingdom takes shape on the dinner plate. In his 1975 book *Animal Liberation*, Peter Singer, distinguished professor of philosophy at Princeton, laid out the theoretical foundations for the modern animal rights movement. Singer postulates that to differentiate between human and animal for arbitrary reasons is akin to racism, or to use his term, speciesism (the bias based on species). Singer takes to task the artificial boundaries between humans and animals, and uses instead the category of suffering from which to evaluate ethical basis. In particular, he asks, "Do animals feel pain?" In using pain as the focal point for discussing access to rights, Singer develops a compelling theoretical basis from which to evaluate the becoming animal.

While not everyone's favorite dinner table debate, the questions posed by vegetarians, vegans, macro-dietitians, and raw foodists gained political momentum during the mad cow scare. Whether or not people agreed with the rights of animals, they definitely felt something was awry at the stockyard. In a globalized world, meat production is simply not what it used to be. Meat production in the United States alone grew from 18 million metric tons in 1963 to 43 million metric tons in 2003.[6] No longer the bucolic home of a few country animals, the modern cattle ranch is a rigorous assembly line of beef, chicken, pork, and turkey. As the production of meat increases, its visibility conversely decreases, making only brief plastic-wrapped appearances at the market.

Current mapping of the elaborate webs of biodiversity has drawn humans and animals into compelling symbiosis. Sheep in the Andes suffering from cataracts provide clues about the shrinking ozone layer, for example. Increases in mercury levels show themselves in trout before eventually affecting those drinking the water. The fate of animals and humans is not so separate from each other.

Artist Rachel Berwick makes this point poignantly evident in her installation *Lonesome George* (2005). Why is George lonely? George, an 80 year old tortoise, is lonely because he is the last remaining member of his species from the small island of Pinta, located just north of the Galapagos archipelago. Now under the care of the Charles Darwin Research Station, George was discovered in 1971 by National Park wardens. His species had been considered extinct due to the intense hunting in the 19th century and the introduction of goats to the island in the 1950s. The goats, brought to the island to develop an alternate food source, ate all the available vegetation, destroying the turtle's habitat. In her installation, Berwick dramatizes the sense of loss that accompanies the extinction of this magnificent species. Fourteen-foot sails rhythmically fill with air while a video of George plays. Each time the tortoise retracts into his shell, the sails billow. The viewer becomes aware of the limited life of Lonesome George against the backdrop of sails that have entered its waters. Berwick's thorough research of the story of George presents us with a more complicated view of nature. It is no accident that Lonesome George's home is the Galapagos Islands, site of Charles Darwin's first visits. The Galapagos tortoises became a major influence on Darwin's development of evolutionary theory. Noting from the local fishermen that one could designate the origin of each tortoise by the shape of its shell, Darwin began to surmise the evolutionary development necessary to connect these creatures with the particulars of their environment. Strange, then, that the creature that connected the dots of evolution for Darwin has now been reduced to a single individual standing at the end of its species' evolutionary journey.

Transgenics

"Artists forming life itself to make a statement about life – what a concept! And what a great sleight of hand – mundane cookbook recipes of science that have a profound effect on knowledge, methodology, and material culture are transformed into transcendental voodoo. Such activity is mystification on an intolerable scale that directs viewers away from an understanding of their world in general and away from an understanding of the flesh machine in particular; rather, it redirects discourse into the disempowering realm of the abstract."
 - Critical Art Ensemble, *The Molecular Invasion*, 2002

On June 26, 2000, President Clinton announced that a rough draft of the human genome had been mapped. The conclusion of this long-sought human Rosetta Stone elicited responses both paranoiac and utopian. Claims of tracking down the "death" gene appeared alongside horror stories of genetic warfare and governmental eugenics. Hyperbole notwithstanding, these claims were fed by the radical implications of possessing the map to human development. Over the last decade the sci-fi-like spin-offs of biotechnology have begun to emerge. In the fall of 1999, porn industry mogul Ron Harris developed Ron's Angels, a website where consumers could purchase the eggs of models for prices ranging from $15,000 to $150,000. Harris calls the process "evolving upward." On December 27, 2002, the Montreal-based Raelians announced they had cloned the first human being. Adorned in white robes, advocating "free love" and worshiping their alien leader Rael, the Raelians were many Americans' worst nightmare of a transgenic future. The Raelians' claim proved to be an elaborate hoax and Ron Harris has had few customers, but the strange possibility became suddenly immediate.

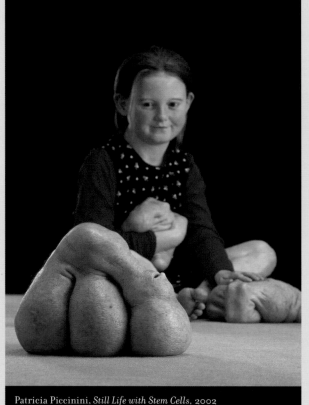

Patricia Piccinini, *Still Life with Stem Cells*, 2002

The near absurd and even sculptural implications of this research naturally attracted the attention of contemporary artists. Hungry for novelty and ready to shock audiences, many artists have eagerly seized the tools of biotechnology. Yet, as Critical Art Ensemble argues, it's one thing to redeploy the tools of technology, and quite another to provide thoughtful responses. What contemporary artists can offer instead is a measured and complex perspective in this arena beyond the animal.

For over ten years, Australian artist Patricia Piccinini has interrogated transgenics — the transfer of genes using recombinant DNA technology — in sculpture, video, and photography. Using a silicone-based sculptural technique, Piccinini and her crew of fabricators are able to bring a devastating three-dimensional verisimilitude to a hybridity that is typically only theorized. In her *Still Life with Stem Cells* (2002), a child sits calmly on a rug grasping nub-like blobs of flesh. Somewhere between a series of toes and an amorphous potato bug, these stem cell creations shock us. Is this alive? What

is absolutely so uncanny about Piccinini's sculptures (and uncanny must be the right word) is the manner in which a world barely envisioned is suddenly placed in front of us. If the mythic proportions of a transgenic future are hard to imagine, just take a look at Piccinini's sculptures. Rigorously sculpted to the level of each and every hair follicle, Piccinini's sculptures act as gestalts of flesh. Still reeling from the transgressive shock that accompanies this vision, we encounter the glowing eyes of a child. Instead of horror, the child giddily embraces one lump and stares fondly at another. These lumps too can be loved.

Them

"I believe the result of a liberating science of animal groups would better express who the animals are as well: we might free nature in freeing ourselves." Donna Haraway, Simians, Cyborgs, and Women, 1991

"...both feminism and the causes of animals must share a concern with the ways that the Other become subordinate." – Lynda Birke and Luciana Parisi, "Animals, Becoming," 1999

Transgenics offers a biologic terrain to observe the becoming animal; feminism and post-colonialism, however, provide a semiotic perspective: that "animal" and "other" have a long-standing history. Theorists like Donna Haraway have used this analysis to interrogate both these scientific, as well as language-based, distinctions. In her groundbreaking *Cyborg Manifesto*, Harraway sews together critical theory and science with a deft warning: "The degree to which the principle of domination is deeply embedded in our natural sciences, especially in these disciplines that seek to explain social groups and behavior, must not be underestimated."[7] Arguing that one cannot trust the claim of pure empiricism in science, she outlines a complex method for allowing hybridity between animal, machine, human and social politics in general - the cyborg. The cyborg stands mutably between distinct boundaries and in many respects embodies the "becoming" animal.

Perhaps this malleability is, in part, what motivates artist Ann-Sofi Sidén to produce her complex work, the *QM Museum.* A museum within a museum,

the *QM Museum* spotlights – and presents in museological form – one of Sidén's longest running projects, *the Queen of Mud*. Originally conceived as a performance character, *the Queen of Mud* was basically Sidén covered in mud. This ur-creature operated in various spheres, including a talk show and an appearance at a Chanel perfume counter in Stockholm. Sidén took on the guise of an ultimate "other" (possibly beyond animal). By physically becoming "other" in such a dramatic form, Sidén brought these tensions into the real world. Particularly by testing the relation between smell and class, Sidén zeroed in on a topic where consumers attempted to become something very far away from animal. What is most compelling about the complicated work of Sidén is that she approaches this question in multiple forms with varying degrees of the mythic, the fictitious, the factual, and historic.

In an entirely different line of work, she takes on clinical psychology. In *Would a Course of Deprol Have Saved Van Gogh's Ear* (1996), Sidén created a grid of pharmaceutical advertisements. Presented side by side, the methods for creating (as opposed to curing) anxiety, as well as the targeting of gender, becomes evident. How long before you become *the Queen of Mud*?

Connecting the "animal" to that of the feminist and post-colonialist "other" can easily lead to ridiculous conclusions. However, cultural moments of debasement and exploitation have often found resonance in the phrase, "We were treated like animals." This refrain positions the becoming animal as the lowest form of human existence. But what does it mean to treat someone like an animal? In political terms it would mean to revoke a person's basic human rights.

Giorgio Agamben refers to this political position as a "state of exception" in his book of the same name. Investigating the creation of camps for those deemed not part of society (such as concentration camps or the camps developed in 1896 by the Spanish in Cuba), Agamben locates and analyzes separated territories that delineate a population outside the usual rules of governance. A current corollary might be Abu Ghraib or Guantanamo Bay where political prisoners are no longer offered common access to the law.

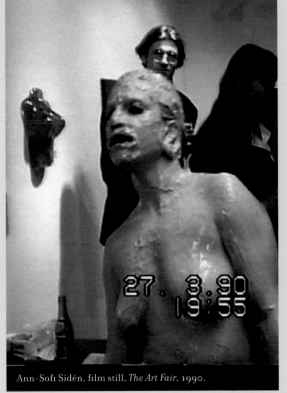
Ann-Sofi Sidén, film still, *The Art Fair*, 1990.

Imagine the photograph from Abu Ghraib of Private Lynndie England with an Iraqi prisoner on a leash or the caged enclosures of war prisoners reminiscent of a zoo.

In her photographic and sculptural works, artist Jane Alexander depicts the status of a country recovering from its infamy as a state of exception. Apartheid South Africa (apartheid is an Afrikaan term meaning separation or literally "aparthood") was institutionalized in 1948 and continued until 1990. Designed to systematically discriminate against blacks and non-white citizens, apartheid became a global example of this radical, institutionalized form of exception.

Alexander takes apartheid as the abandonment of reason, making it the subject of her haunting black and white photomontages. What pervades her works so dramatically is the absolutely terrifying sense of silence. If anything stands out as the most durable explanation of the difference between human and animal, it is the ability to speak. In Alexander's works, the children and adults appear muted with their heads covered in masks, their mouths melded over, or their eyes vacant. These children stare out, suffocated by masks of animality. Unlike the kind post-human eyes of Piccinini's sculptures, the blank eyes of Alexander's children give us nothing. They become traces of incommunicability.

In her photomontage series *African Adventure* (2000), Alexander's masked children haunt the landscape of Cape Town. Whether a drive through the industrial sector, or the littered streets of Long Street, her childlike characters look abandoned, interchangeable with the emaciated scavenging dogs. Most tellingly, Alexander has a series of three photomontages titled *Adventure Centre* that depict her characters in front of tourist bureaus in Cape Town. Acting as witnesses to the tourist's gaze, these children (whether adorned in an ill-fitted bunny hood or blindfolded) meld with vagrants who squat along these thoroughfares. They appear as strangers in a strange land, a visual analogue to the alienation felt by Franz Kafka's Gregor who suddenly finds himself transformed into an insect in his bed.

The Zoo/The Ooz

"In going back to the seventeenth century, I'm trying to imagine how things could have been different, to follow branches on the tree of knowledge that died of dry rot." – Mark Dion, 1996

"Public zoos came into existence at the beginning of the period which was to see the disappearance of animals from daily life. The zoo to which people go to meet animals, to observe them, to see them, is, in fact, a monument to the impossibility of such encounters. Modern zoos are an epitaph to a relationship which was as old as man. They are not seen as such because the wrong questions have been addressed to zoos."
– John Berger, *Why Look at Animals*, 1980

In a globalized world where well-healed tourists can travel to foreign lands to glimpse at exotic people, how far are we from an elaborate human safari? Being "on view" is not relegated to animals alone; indeed, the idea is as old as the Babylonian menageries of Nebuchadrezzar II and the Turkish harems. Although the history is far too lengthy to explore in this essay, it does provide an interesting framework through which to explore the *Becoming Animal* exhibition. As we track the evolving institution of the zoo, we must also bear in mind the parallel tale of the art and natural history museum. Neil Harris, in his book *Cultural Excursions*, writes of the foundation of American museums, "The function of our urban culture, in the eighteenth century, was to transcend the limitations of time and place which the uncultivated wilderness of the New World had established."[8] The style and content of what was deemed culturally sophisticated found its way into most civic institutions, including libraries and department stores. In response, some of the artists in the exhibition such as Mark Dion and Natalie Jeremijenko implicitly ask: How do we reorganize the problematic civic institutions derived from the legacy of the enlightenment?

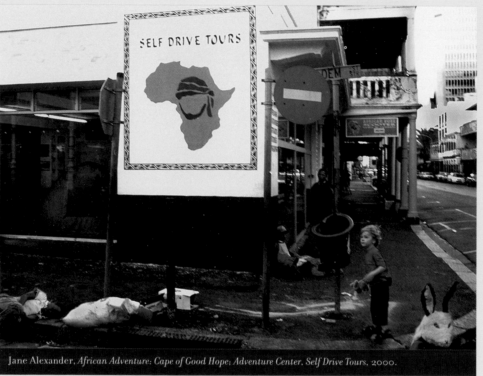

Jane Alexander, *African Adventure: Cape of Good Hope; Adventure Center, Self Drive Tours*, 2000.

Consider the birth of the modern zoo under the entrepreneurship of Carl Hagenbeck (1844-1913). Hagenbeck began his zoos in the early 1860s in Hamburg, Germany. During the 1870s, his visitorship began to decline due in large part to the lagging German economy. In order to spice up the attractions, Hagenbeck took the advice of an old friend, Heinrich Leutemann, and included a family of Laplanders.[9] "On the deck, three male members of the troupe – small yellow-brown, fur-clad people – strutted about beside their reindeer. On a lower deck, however, we were offered a simply delightful view! A mother with her infant, whom she pressed delicately to her breast, and a sweet four-year old girl."[10] The exhibition drew massive crowds, and Hagenbeck went on to display families of Sudanese, Sri Lankens, and Somalians. The display of these families quickly caught the attention of the Berlin Anthropological Society, which began measuring them and using the displays for research.

After the decline of the "people shows," the natural setting displays were redirected to animals. To repeat, the display of non-human animals originated in Hagenbeck's initial forays in the display of humans. For Hagenbeck, the distinction between human and animal meant little in comparison to the gap between attendance figures. "Becoming animal" was scrapped for the more pertinent "becoming spectacle." This logic finds all the more relevance in Hagenbeck's contemporary P.T. Barnum.

The zoo (animal), the natural history museum (nature) and the art museum (culture) share a common ethnographic legacy of displacing and displaying the exotic "other." Often artists interrogate what happens when an institution acknowledges this legacy and scrupulously interrogate its colonialist forms of representation. These questions become all the more important as institutions founded on these relationships begin to reform themselves. It has also been the bedrock of artist Mark Dion's work for over fifteen years.

An ardent student of natural history, Dion has developed numerous projects interrogating the foundations of scientific evaluation and display. He has been a major contributor to what is now a common genre in contemporary art, that of the exploded *wunderkammern,* the hybrid zoo, and the experimental travel log.[11] Borrowing as much from early naturalists such as the taxonomist Carl Linnaeus (1707-1778) and underrated evolutionist Alfred Russel Wallace (1823-1913) as from artists Robert Smithson and Martha Rosler, Dion uses the techniques of "truth" display more commonly found in science museums to imply a more complex system of contestation.

In *Collectors Collected* (1994), Dion investigated the history of the Spanish collectors who participated in the *Expedicion Al Pacifico* (1862-66) and how they transformed the numerous collections of Madrid. His reverse investigation highlighted the collector versus the collected, and Dion hoped to "exhibit these figures as they would have exhibited people of another culture in the ethnographic systems of their time."[12] *Collectors Collected* exposes the underlying ideologies that tie human and animal together in our civic institutions. Dion's tactical use of the diorama, vitrine, (19th-century) study tables, and diagrams all play into his aesthetic reversal.

For *Becoming Animal,* Dion has produced an aviary titled *Library for the Birds of Massachusetts* (2005). Replete with zebra finches and a towering dead tree with books, bird cages, and a tar-like substance piled on its branches, *the Library* becomes a transitional social space where visitors can re-imagine the direction of the zoo and art and natural history museums. Most notably the tree (of knowledge) is dead, and encyclopedic books littering the installation seem to matter little to the chirping birds.

However, if we imagine a "becoming animal" zoo, what would it look like? This question is not easily answered, but artist/scientist Natalie Jeremijenko has a modest proposal in her ongoing *Ooz* project. *Ooz* is "zoo" spelled backwards or, as Jeremijenko states, "it is a reverse-engineered zoo." The Ooz projects provide simple interfaces for humans and animals to communicate and exist in contexts where the animals choose to stay (such as a pond where birds come and go at their leisure). For a commission in Zeewolde, the Netherlands, Jeremijenko produced a robotic goose that swims in a pond. Visitors sit in an interactive chair on the side of the pond and move their bodies to manipulate the gestures of the robot. These interactions facilitate communication between the robot goose and the live geese swimming in the pond. If the robot goose ruffles its feathers, the live geese react in one way;

if it stretches its neck, they react in another. As opposed to a voyeuristic relationship, the *Ooz* projects encourage reciprocity and facilitate becoming: becoming goose, for example.

Becoming Animal

Giorgio Agamben's book *The Open* commences with a description of a thirteenth-century Hebrew bible illustration depicting the messianic dinner of the righteous on the last day. Rather than possessing the heads of humans, the righteous are a motley assemblage of animals: leopard, eagle, fox, donkey, and lion. In the end, the Hebrew Bible appears to indicate, animals and humans will be one. Whether or not this messianic prophecy holds true, it will serve as the ending to this story.

As we head into that obscurity that is the future, the artists featured in *Becoming Animal* provide clues into the unforeseen and, at times, destabilizing moments that await us. Whether they are focusing on the "other," the natural, the ecological, or the zoo, the artists provide a critical lens to witness how far we have traveled down the path of becoming. Although we can cling to the distinctions that separate us from nature, animals, or beauty, we can alternatively let go, relax, and become something altogether more complex.

(Footnotes)

1 For a more thorough analysis of "becoming", see the accompanying essay by Christoph Cox.

2 I cite David Cronenberg's film and not the original because the remake differs substantially from the original. Cronenberg perfectly captures the anxiety of hybridity while Price produces a comical collage of human and fly body parts.

3 Giorgio Agamben, *The Open: Man and Animal*, Stanford University Press, Stanford, California, p. 41.

4 Ibid, p.46.

5 High treats Echo and Flowers with homeopathic medicines particular to each of their diseases. High has long treated herself with homeopathic medicines as well.

6 Food and Agriculture Organization of the United Nations (FAO), FAOSTAT *on-line statistical service*, (FAO: Rome, 2004). Available at http://apps.fao.org.

7 Donna J Haraway. *Simians, Cyborgs, and Women: The Reinvention of Nature*. London: Free Association Books, 1991, p.8.

8 Neil Harris, *Cultural Excursions: Marketing Appetites and Cultural Tastes in Modern America*, The University of Chicago Press, Chicago and London, 1999, p. 15.

9 Nigel Rothfels, *Savages and Beasts: The Birth of the Modern Zoo*, John Hopkins University Press, Baltimore and London, 2002. p. 82.

10 Ibid.

11 Previous artists who have paved the way include Dion's professor Hans Haacke, Robert Smithson, and contemporaries Fred Wilson and the Museum of Jurassic Technology.

12 Mark Dion quoted in *Mark Dion*, Phaidon Press, Lisa Graziose Corrin, Miwon Kwon, Norman Bryson, London, 1997, p. 80.

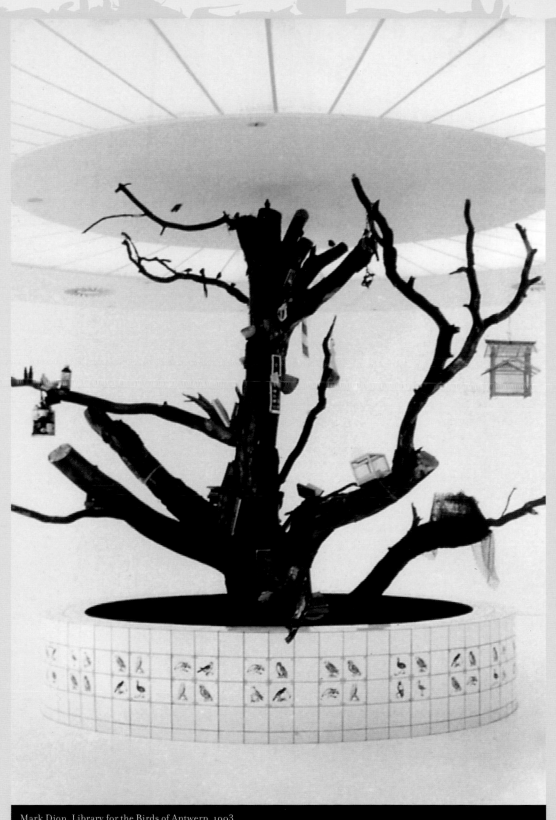

Mark Dion. Library for the Birds of Antwerp. 1993.

CHRISTOPH COX
OF HUMANS, ANIMALS, AND MONSTERS

I. Pre-Post-Erous Humans

An art exhibition that unsettles the boundary between humans and animals presents a paradox. Art – and culture in general – is supposed to be precisely that which defines the boundary in the first place. Whatever our similarities to animals, the argument goes, artistic creativity and aesthetic appreciation are uniquely human. But what happens when tarantulas, wolves, and horses don video cameras to document their daily strolls? When a sculpture imitates the mating ritual of a Panamanian frog? When zebra finches teach us how to read their history and culture, and pigeons train us to communicate with them?

Over the past century and a half, the human/animal divide has been steadily crumbling. Evolutionary biology has thrown human beings back among the animals and has reconceived our exemplary gifts—reason, speech, language, self-consciousness, etc.—as simply "the means by which weaker, less robust individuals preserve themselves—since they have been denied the chance to wage the battle for existence with horns or with the sharp teeth of beasts of prey."[1] Cognitive neuroscientists and ethologists have recently suggested that the aesthetic impulse is, ultimately, nothing but a survival mechanism we share with such lowly creatures as herring-gull chicks.[2] Moreover, from Kafka's *Metamorphosis* to *Spiderman 2*, the cultural imagination of modernity has been filled with becomings-animal of all sorts: vampires, werewolves, human flies, elephant men, dog-faced boys, Playboy bunnies, plushies and more. Against this backdrop, *Becoming Animal* suggests that we need to rethink our traditional relationships—biological, ethical, political, aesthetic, affective—to animals and, hence, to reconsider who and what we are.

So who are we, we human beings? To this perennial question, philosophers, scientists, and theologians have offered countless answers and have haggled endlessly about them. But nearly all grudgingly admit that, whatever else one wants to say about us, we human beings are decidedly *hybrid* things—neither this nor that, but both, or something in between. For much of our history, humans have been thought of as beings that straddle the boundaries between the animal and the divine, matter and the immaterial, nature and reason. The ancient Hebrews set the tone, conceiving man (adam) as a composite of earthly soil (adama) and divine breath. Plato agreed, taking humans to be an irreconcilable and morally unfortunate combination of *soma* and *psyche*, body and mind. These opening moves shaped Western philosophical and religious discourse for millennia. At the beginning of our modern era, they animated the ontological dualism of René Descartes and the moral dualism of Immanuel Kant, both of whom insisted that we human beings live simultaneously in two worlds, one physical, the other metaphysical. "Plac'd in this isthmus of a middle estate," wrote Alexander Pope in 1732, man "hangs between . . . in doubt to deem himself a god or beast . . . created half to rise, and half to fall . . . the glory, jest, and riddle of the world."[3]

Since Darwin, we are less inclined to stress our links to the divine and more likely to acknowledge animals as our kin. But, in the past few decades, another term has come to fill the void left by the death of God: the machine. In our cybernetic age, human beings are no longer considered to be hybrids of body and soul, beast and God. We are now fusions of flesh and machine, wetware and software. But this combination is not like the others. For, instead of separating human beings from the rest of nature, it places us firmly within it, suggesting that we are akin not only to animals but also to vegetables and minerals. According to radical biologists, computer scientists, and philosophers today, our attachments to cell phones, laptops, pacemakers, dentures, eyeglasses and automobiles are as natural as the calcium-carbonate shells of pearl oysters or the phosphatic fecal pellets with which tropical termites build their nests. Instead of existing as dumb, inert products of human creativity, machines are seen as having an independent evolution of their own, using human beings as their means of reproduction. Apples, tulips, and grasses are said to have seduced humans into aiding their

efforts to survive and flourish. And computer programs are said to "live," "evolve," "perceive" and "think."[4]

In short, we have become—or are becoming—post-human.[5] What was once thought to represent our break with nature has been shown to be of a piece with the rest of the animate and inanimate world. Of course, in this light, the term "post-human" is a misnomer, for what has been challenged is precisely the progressive temporal language of before and after, lower and higher. The post-human, then, is at the same time pre-human. The post-human turn invites us to reconsider our relationships to both of our evolutionary neighbors: not only have we become machine, we have become animal as well.

II. Becoming Non-Animal

Animals are uncanny creatures. Like us, they eat, sleep, defecate, copulate, build, perceive, desire, and maybe even think, talk, and have rights. We admire them, paint and photograph them, emblazon them on flags, shields, and currency, and we treat some of them like best friends and members of our families. From Aesop's Fables to Mickey Mouse and *The Far Side*, our stories are filled with humanized animals who reflect us back to ourselves. "There is something charming about an animal become human," the philosopher Simon Critchley aptly notes; but, by the same token, "when the human becomes animal, then the effect is disgusting."[6]

We are surely a kind of animal. Yet we are also repulsed by the thought that we might be *merely* animals, and have spent an enormous amount of time and intellectual energy convincing ourselves that we are something different. It is not much of an exaggeration to say that all of Western morality has been an effort to curb, even to deny, our animal nature—what Plato called "the wild beast in us."[7] The same can be said of religious doctrine, philosophical speculation, political thought, and biological classification: all have been enlisted in the effort to make the case that we are something more, better, and higher than the animal kingdom.

The book of Genesis offers not one creation story but two, each of which highlights, in a different way, the preeminence and uniqueness of human beings in the universe.[8] In the first, God creates the cosmos according to a clear and steady scheme. He begins by ordering inanimate nature (earth, sea, and sky), moves on to create plants, then generates fish, fowl, and land animals, and finishes his work by conjuring a pair of human beings, one male, the other female. Created in God's image and after his likeness, the human beings are given "dominion over" the entire animal kingdom (though, curiously, they are asked to eat only plants). The second account is rather different. From the soil of a barren landscape, God first creates a solitary human being, then plants a garden, sends rivers flowing through it, and places the lone human in the garden "to dress it and to keep it." Noting that "it is not good that the human should be alone," God sculpts the soil into an array of animals and presents them to the human for him to name and, presumably, to consider as a potential counterpart and mate. When the human finds no suitable partner among the animals, God creates, from the human's side, a woman to be his wife. The first version gives us an initial glimpse of what would later be called the scala naturae, the hierarchical ladder of being that runs from mineral to vegetable to animal to man. In the second, the creation of human beings is God's first order of business, and the rest of nature is built around them for their use and their pleasure.

According to Genesis, the first human act is the naming and classifying of animals, an event that is repeated a few chapters later when the earth is again plunged into watery chaos and Noah makes his inventory of the world's creatures. Among the Greeks, Aristotle was the first great taxonomist, and his basic classificatory scheme dominated Western biological discourse until Cuvier and Darwin. Unlike Plato and most other philosophers, Aristotle was a serious biologist whose work was not merely speculative but also empirical, and whose surviving corpus includes a half-dozen books on zoology. It is from Aristotle that we get the idea of the *scala naturae*, the idea that nature can be sorted into hierarchical types. According to Aristotle, nature reaches its perfection in human males, and the rest of the animal kingdom forms a downward ladder from women to sea urchins. Plants form an even lower rung of the ladder, though, tellingly, neither Aristotle nor any other ancient writer showed any interest in offering hierarchical classifications of plants, which, after all, do not seem to threaten the supremacy of the human.[9]

The *scala naturae* was not Aristotle's only gift to biological thought. Equally important was his assumption that biological types are fixed and eternal. Every creature has an essence, he claimed, and variation is to be explained as a deviation from that essence. "[F]or any living thing that has reached its normal development and which is unmutilated," Aristotle wrote in *De Anima*, "the most natural act is the production of another like itself, an

animal producing an animal, a plant a plant."[10] For Aristotle, then, there is no becoming-plant, -animal, or –human. There is only being—and reproducing—what one is.

Aristotle's hierarchy is political as well. More baldly than Genesis, he declares that "after the birth of animals, plants exist for their sake, and that the other animals exist for the sake of man, the tame for use and food, the wild . . . for the provision of clothing and other instruments."[11] Indeed, drawing a line between humans and animals did not only have the aim of making us feel *good* about ourselves by revealing our spiritual superiority. It also helped us not to feel *bad* about ourselves when we hunted, ate, domesticated, or exterminated the earth's creatures.

The Christian tradition was no less kind to animals. Christians often pictured the Anti-Christ as a beast or, worse yet, as some monstrous hybrid of animal and man. More so even than Judaism, Christianity was decidedly anthropocentric and opposed to naturalism, insisting that there is an unbridgeable divide between the human and the animal. "The beast, lacking a rational soul, is not related to us by a common nature," wrote Augustine. Notwithstanding the modern vogue for the bird-loving Saint Francis of Assisi, any alternative views have conventionally been deemed heresy or paganism. "Doth God take care of oxen?" asked Paul rhetorically, to which the answer was obviously "no!" Indeed, as late as the mid-19th century, Pope Pius IX rejected a request to endorse a Society for the Prevention of Cruelty to Animals. "[A] society for such a purpose," he declared, "could not be sanctioned in Rome." Cardinal Newman agreed, remarking that "[w]e have no duties toward the brute creation; there is no relation of justice between them and us We may use them, we may destroy them at our pleasure . . . provided we can give a rational account of what we do." [12]

Early modern philosophers found yet another way to mark the radical discontinuity between humans and animals. For Descartes, Rousseau, and others, humans were no more similar to animals than they were to clocks or robots. Animals, they insisted, were simply machines or automata, capable of complex behavior but lacking a soul, reason, or feeling. "[I]t is nature that acts in [animals] according to the arrangements of their organs," wrote Descartes, "just as we see how a clock, composed merely of wheels and springs, can reckon the hours and measure time . . . " [13] While disagreeing with Descartes about most other things, on this Rousseau concurred. "I see nothing in any animal but an ingenious machine," he wrote, "to which nature

has given senses to wind itself up, and to guard itself, to a certain degree, against anything that might tend to disorder or destroy it."[14]

This distancing of animals—and nature in general—from human beings is what enabled the great classificatory schemes of the 17th and 18th centuries. Earlier taxonomies, such as Edward Topsell's *Historie of Foure-Footed Beasts* (1607), were blatantly anthropocentric, classifying animals according to such distinctions as edible/inedible, wild/tame, useful/useless. But the Classical Age gradually moved toward a more detached and objective classification that sorted animals and plants with regard to their internal structural characteristics according to strict relations of identity and difference.[15]

Despite their detachment and precision, however, the great early modern taxonomists continued to accept the anthropocentric and essentialist view that nature was a graded hierarchy, each step of which marked out an essential type that was radically discontinuous with its neighbors. It was Darwin who finally dealt the death blow to this idea. Darwin's theory of natural selection insists that there is a basic continuity in nature, not just among species, but among all living things, who ultimately share a common ancestry. For Darwin, there are no essential types in nature, only individuals with more or less similar characteristics. That is, natural selection works by difference and mutation, not by identity or resemblance. Indeed, if there were essential types, evolution could never have gotten off the ground, for it proposes that—given variations, mutations, geographical isolation, time, and other factors—species differentiate, becoming new species. For Darwin, a species is a statistical abstraction, a bell curve that, at the extremities, shades off into other species. As one writer recently put it: "We are all mutants. But some of us are more mutant than others."[16]

Not only did Darwin eliminate the boundaries between species; he also flattened the ancient hierarchy that placed human beings at the top, and he denied that evolution is in any way progressive, that human beings are in any way better than their forebears or any other species. In his copy of Robert Chambers' *Vestiges of the Natural History of Creation*, Darwin famously scribbled the phrase "never use the words higher or lower!" and remarked to a friend that "no innate tendency to progressive development exists [in nature]."[17] Natural selection is local and temporary, lacking any long-range aim or goal. And the complexity of human beings and "higher" animals represents only one of nature's possibilities, by no means the best or highest. Complex creatures simply represent life's diversification in the

only direction available to it.[18]

In the wake of Darwin, several Victorian writers took up these positions and pushed them to the extreme. The novelist and heretical biological theorist Samuel Butler insisted that the evolutionary continuum links human beings not only to animals but also to vegetables and machines.[19] Another Victorian novelist, H.G. Wells, explored the now permeable boundary between humans and animals. Wells was a protégé of "Darwin's Bulldog," T.H. Huxley; and Wells himself taught biology before launching his career as a writer. In his gruesomely fascinating early novel *The Island of Dr. Moreau*, the title character sets out experimentally to reproduce the course of evolutionary history: to fashion animals into human beings. "These creatures you have seen," he explains to a horrified visitor, "are animals carven and wrought into new shapes. To that, to the study of the plasticity of living forms, my life has been devoted." Moreau begins with sheep, but quickly decides that "they are no good for man-making." "Then I took a gorilla I had," Moreau continues, "and upon that, working with infinite care and mastering difficulty after difficulty, I made my first man."

Moreau is ultimately driven by the same revulsion at our "animal nature" that has marked so much of Western civilization. Animals, he declares, are motivated solely by feelings of pain and pleasure, and are beholden to their desires and cravings. But just as moral education amounts to "an artificial modification and perversion of instinct," so, too, Moreau believes, can one physically transform animals into rational beings. He is ultimately disappointed, for, despite his successes at physical moulding and training, the animal nature invariably returns. "First one animal trait, then another, creeps to the surface and stares out at me. But I will conquer it yet!" cries Moreau. "Each time I dip a living creature into the bath of burning pain, I say, 'This time I will burn out all the animal; this time I will make a rational creature of my own!' After all, what is ten years? Men have been a hundred thousand in the making."[20]

What horrifies Moreau is animality itself and the animality of humanity. What horrifies his visitor, Prendrick, is something else: the monstrous hybrid, the uncanny in-between, the indiscernible zone between human and animal.

III. The Monstrous: Becoming-Animal
The fascination with monsters—that is, with human and animal oddities and hybrids—is as old as human civilization. Indeed, a history of the monstrous would constitute a veritable history of culture and civilization, for the monstrous marks the boundary of culture, where it shades off into nature or some other form of radical otherness against which cultural identity is defined. Though the discourse on monstrosity is wildly heterogeneous, this culture-defining property is constant from ancient Greek, Babylonian, and Roman reports of monstrous races to contemporary discussions of animal and human cloning, stem-cell research, and "partial-birth abortions."

From his travels throughout the Middle East and North Africa, the historian and proto-anthropologist Herodotus brought back tales of human beings who live underground and screech like bats, goat-footed men, headless people, and humans who hibernate like bears. Medieval accounts were equally wild. They told of humanoid creatures with spider legs or bird talons, horse-headed humans and bodiless heads. Early modern colonial exploration gave rise to further accounts of monstrous beings and races who seemed to exist, like Shakespeare's Caliban, on the cusp of humanity. Such accounts and assessments were considered credible enough that, in the 1758 edition of his *System of Nature*, Linnaeus included the species *Homo monstrosus*, which included satyrs, pygmies, and other borderline-human creatures.[21]

These curiosities, and instances closer to home of malformed embryos and infants, had to be accounted for. The Greek philosopher Empedocles explained the strange cases reported by Herodotus with a novel theory of evolution. Plants and animals originally made their appearance in the world not as wholes but as detached parts. "Here sprang up many faces without necks, arms wandered without shoulders, unattached, and eyes strayed alone, in need of foreheads." These parts eventually fell together by chance, giving rise to all sorts of monstrous hybrids. "Many creatures were born with faces and breasts on both sides, man-faced ox-progeny, while others sprang forth as ox-headed offspring of man." Eventually, the fittest of these—the flora and fauna we know—survived, though one could occasionally still find other combinations.[22] Empedocles is also credited with holding a view that remained credible and popular well into the 18th century: that the imagination of a pregnant woman directly affected the formation of the fetus, such that gazing upon images or statues of monsters could produce monstrous deformities.[23]

Aristotle's view was less extravagant but fully in accord with his conception of natural hierarchy and essential types. "Anyone who does not take after his parents," he wrote, "is really in a way a monstrosity, since in these cases

Nature has in a way strayed from the generic type." Indeed, for Aristotle, the female, insofar as she is a "deformed male," is the first instance of such monstrosity, but one "required by Nature, since the race of creatures has got to be kept in being." Aristotle acknowledges that, in some cases, human beings are born with the appearance of animals, with "the head of a ram or an ox." Such instances, he explains, occur because the biological material provided by the woman is insufficiently mastered by the form-giving power of the man, so that "what remains is that which is most 'general,' and this is the (merely) 'animal.'"Aristotle is careful to say that there is no real becoming-animal here. Rather, these monsters are related to animal forms by "resemblances only."[24]

The Judaeo-Christian tradition was even more obsessed with monsters, the emergence of which it explained not by natural but by divine or supernatural causes. Pagan religions and mythologies were, of course, replete with animal-headed gods, bestiality, and cross-species metamorphoses of all kinds. But Jews and Christians shunned such "unnatural" unions and becomings. In Genesis, God's decision to blot out creation with a flood is, in part, prompted by the coupling of supernatural giants with human women.[25] Within Christianity, monsters were considered by some to be a separate race of beings created by the devil. More commonly they were taken to be indications of the wrath of God or as divine warnings. (*Monstrum*, Augustine pointed out, is etymologically related to *monstrare*, to show, and *monere*, to warn.) God's wrath could be incited by sex acts such as bestiality, sodomy, or masturbation, which, like the monstrous, improperly confounded the divine organization of nature. But monsters were also taken to be prophetic or allegorical. Martin Luther, for example, explained the sighting of a monstrous "monk-calf" on the banks of the Tiber River as an elaborate sign of God's rejection of the papacy and the Catholic priesthood. [26]

This fascination with monsters was carried on by the popular and scholarly writing of the European Renaissance and Enlightenment. Yet now the interest was more secular, often hearkening back to ancient texts that offered naturalistic explanations for the existence of animal and human oddities. The 16th and 17th century "wonder literature" regularly included monsters and prodigies in catalogues of natural curiosities intended for pleasure reading and popular entertainment.[27] By the 18th century, philosophers such as Leibniz and Diderot had placed monsters into the *scala naturae* as "middle" or transitional species. "[T]he most apparently bizarre forms," wrote a contemporary, "serve as a passage to neighboring forms . . . far from

disturbing the order of things, they contribute to it."[28] Once the objects of theological speculation, monsters had become the subjects of scientific analysis.

P.T. Barnum's enormously popular displays of circus "freaks" kept alive the tradition of wonder literature and the curiosity cabinet. Yet Barnum the showman had also jumped on the bandwagon of a nascent evolutionary theory. In the early 1840s, nearly two decades before Darwin's breakthrough, Barnum advertised his side shows as offering missing links in the great chain of being. There one could find:

> the preserved body of a Feejee mermaid . . . the Ornithorhincus, or the connecting link between the seal and the duck; two distinct species of flying fish, which undoubtedly connect the bird and the fish; the Siren, or Mud Iguana, a connecting link between the reptiles and fish . . . with other animals forming connecting links in the great chain of Animated Nature.[29]

Barnum's freak shows can easily be read as cruel spectacles that primarily serve to affirm the normality of their spectators. Yet historian Erin O'Connor suggests another reading, one more akin to Barnum's own. In the freak show, O'Connor writes, "[m]onstrosity does not register defect as disease; instead it makes human aberration into an advertisement for a new embodiment."[30]

This view was shared by biologists contemporary with Barnum; and, indeed, the 19th-century discourse on monsters played an important role in the development of evolutionary theory. The influential French biologist Étienne Geoffroy Saint-Hilaire and his son Isadore established the field of teratology (literally, the study of monsters), which survives today as a branch of embryology and oncology. Instead of starting from actual "normal" bodies and classifying alternatives as "abnormal," the elder Geoffroy began from what he termed "the anomalous," a virtual field of pure morphological possibilities from which every actual body derives. "Monstrosities," he argued, simply represent one of many actualizations of this virtual field; and, in this respect, they are no different from "normal" bodies. What are called "monstrous" forms are stages in the "normal" development of the fetus, and the existence of such forms simply represents an interruption or diversion from the course of this "normal" development. The "monstrous" form of one species was the "normal" form of another.[31]

Building on the work of the Geoffroys, Camille Dareste founded the science

of teratogeny, which, like the research of Dr. Moreau, sought experimentally to reproduce monstrosities in the laboratory with the aim of building a "science of all possible bodies" in the "unlimited variability" of their forms. More radically even than the Geoffroys, Dareste considered all forms to be on par with one another, and refused to take the normal body as any kind of natural state or aim. "[I]t is impossible," he wrote, "to establish in any definitive way the limits of the possible."[32]

These claims influenced the work of Darwin, who liberally cited Etienne and Isadore Geoffroy Saint-Hilaire in *The Origin of Species*, and who later called Dareste's research "full of promise for the future." For Darwin, contra Aristotle, evolution was driven by difference, variation, and mutation, and evolution was the process by which species become other. Hence it is not surprising that Darwin, too, noted the evolutionary importance of "monstrosities," which, he remarked "cannot be separated by any clear line of distinction from mere variations."[33]

This effort to replace ancient theories of being and identity with theories of becoming and difference characterizes a vital strand of contemporary philosophical thought. Emmanuel Levinas, Michel Foucault, Jacques Derrida, Luce Irigaray and others have made important contributions to this project. But no one has carried it further than Gilles Deleuze, whose philosophical position is richly informed by biological thought, and who often singles out Geoffroy as an important antecedent to his novel theory of the body and of matter in general. For Deleuze and his frequent collaborator, Félix Guattari, there are no essential divisions within nature, no absolute differences between minerals, vegetables, animals, and humans. Rather, matter is a vast continuum, a field of virtual forces, intensities, thresholds, and powers that, under particular conditions, is actualized in the things and bodies we know. But these things and bodies are not fixed, stable, or given once and for all. They themselves are bundles of forces and capacities that are constantly undergoing changes prompted by encounters with other entities into which they enter relationships. For Deleuze and Guattari, then, things and bodies are not so much beings but becomings.

Like Geoffroy, Deleuze and Guattari do not define a body by its form, its usual functions, or its superficial resemblances to other bodies. Rather, a body is materially related to all other bodies, and its distinctiveness has to do with the particular selection of capacities and powers it actualizes. Human beings are, of course, particular sorts of beings with distinctive sets of capacities. Yet the human being is not a fixed essence. Like all other entities, human beings are constantly engaged in relations of becoming. And these relations of becoming open us up to other modes of existence. For Deleuze and Guattari, life lived to its fullest is a life that actualizes as many capacities and powers as possible, a life that makes the greatest number of connections to other things and alters itself in the process. Hence, Deleuze and Guattari encourage us to explore becomings beyond those that characterize the narrowly human.

Crucial among these, for Deleuze and Guattari, is becoming animal. If, for Aristotle, "Man" represented the paradigm of the human, then becoming other will begin with a becoming-woman, the first deviation from man. Becoming-animal represents an even further and more radical step, examples of which Deleuze and Guattari find all over the place: in the writing of Kafka and Melville, in the paintings of Francis Bacon, in the music of Mozart and Messiaen, in films such as *Willard* and *Taxi Driver*, and in countless incidents of everyday life. "Becoming animal" does not mean imitating an animal. Again, it is not about given animal forms but about animal capacities and powers. To become animal is to be drawn into a zone of action or passion that one can have in common with an animal. It is a matter of unlearning physical and emotional habits and learning to take on new ones such that one enlarges the scope of one's relationships and responses to the world. [34]

In such becomings, both animal and human become other than what they are or were, something in between. Natalie Jeremijenko's *Ooz*, for example, does not translate human speech into birdsong or vice versa; rather, it creates a common space of action and communication between birds and humans. Brian Conley's *Pseudanuran Gigantica* is not a flesh and blood amphibian but a bizarre technological device that adopts the habits of the Tungara frog in an effort to seduce human visitors. The finches in Mark Dion's aviary are no longer purely natural beings but intersections of nature and culture, as are its human viewers, whose cultural habits Dion displays as natural history.

Likewise, the uncanny, monstrous creatures presented by Ann Sofi-Sidén, Patricia Piccinini, Jane Alexander, Motohiko Odani, and Kathy High summon in us sympathies and identifications that draw us into affective relationships with the non-human. Like Barnum's freaks and the monsters of Dareste and the Geoffroys, these hybrids and transgenics are "advertisements for a new embodiment." They do not solicit our pity but summon our ontological, ethical, and aesthetic curiosity, provoking us to comport ourselves toward them as kin. The "family" of Piccinini's title refers not only to her suckling canine-

porcine-humanoid creatures but to us as well, and to the morphological and evolutionary continuum we share with these animated masses of flesh. Instead of focusing on filial relationships within species, Kathy High highlights the inter-species alliances and symbioses that also characterize the natural world: the blocks of becoming that can be formed between rats and human beings in the exchange of genetic material. These relationships constitute what Deleuze and Guattari call "machinic heterogenesis," a becoming that operates in transgression not only of species boundaries but of boundaries between nature and artifice, science and art.[35]

The post-human world opened up by *Becoming Animal* is surely unsettling and is likely to be repugnant to some, for we are fond of our species and the rung on the ladder we still imagine ourselves to inhabit. After millennia of fearing monsters, we cannot expect to learn to love them overnight, let alone to wish to become them. But, whether we like it or not, Aristotelian and Judaeo-Christian conceptions of human identity and superiority have been largely discredited. Since Darwin and ever more so today, we find ourselves in a new relationship with animals and the rest of nature. We have, indeed, become animal — and vegetable, mineral, and machine as well. No doubt there are still reasons to worry about the teratogenic experiments of Dr. Moreau, Dareste, and contemporary biotechnology. But the erasure or problematizing of distinctions between the human and the animal has its ethical benefits as well. If Deleuze and Guattari are right, becoming animal expands our possibilities for being and acting in the world. And, as *Becoming Animal* reveals, this process increases our sympathies with — and relationships to — our fellow creatures, who are no longer essentially other than us but creatures from whom we can learn about the true, the good, and the beautiful.

Christoph Cox is Associate Professor of Philosophy at Hampshire College. The author of *Nietzsche: Naturalism and Interpretation* and co-editor of *Audio Culture: Readings in Modern Music*, Cox is editor-at-large at Cabinet magazine and writes regularly on contemporary art and music for *Artforum*, *The Wire* and other magazines.

(Footnotes)

1 Friedrich Nietzsche, "On Truth and Lies in a Nonmoral Sense," in *Philosophy and Truth: Selections from Nietzsche's Notebooks of the 1870s*, ed. and trans. Daniel Breazeale (New Jersey: Humanities Press International, 1979), p. 80.

2 See V.S. Ramachandran, "The Artful Brain," in *The Emerging Mind* (London: Profile Books, 2003), pp. 46–69.

3 Alexander Pope, *An Essay on Man*, ed. Maynard Mack (London: Methuen & Co., 1950), Epistle II, pp. 53–55.

4 For exemplary texts on these developments, see Lynn Margulis and Dorion Sagan, "Second Nature: The Human Primate at the Borders of Organism and Mechanism," UMass Magazine (Fall 1999): http://www.umass.edu/umassmag/archives/1999/fall_99/fall99_f_2ndnature.html, and *What is Life?* (Berkeley: University of California Press, 1995), especially pp. 213–43; Donna Haraway, "A Cyborg Manifesto," in *Simians, Cyborgs, and Women: The Reinvention of Nature* (New York: Routledge, 1991), pp. 149–81; Evan Eisenberg, *The Ecology of Eden* (New York: Alfred A. Knopf, 1998); Michael Pollan, *The Botany of Desire: A Plant's-Eye View of the World* (New York: Random House, 2001); Manuel De Landa, *A Thousand Years of Nonlinear History* (New York Zone Books, 1997); Christopher Langton, "Artificial Life," in *Artificial Life* (Redwood City, CA: Addison-Wesley, 1989).

5 For different assessments of this development, see N. Katherine Hayles, *How We Became Posthuman* (Chicago: University of Chicago Press, 1999) and Francis Fukuyama, *Our Posthuman Future* (New York: Farrar, Straus, and Giroux, 2003).

6 Simon Critchley, *On Humour* (London: Routledge, 2002), p. 34.

7 Plato, *The Republic*, trans. Francis Cornford (New York: Oxford University Press, 1945), Book IX, 571c.

8 I quote from the King James Bible, with some modifications drawn from Everett Fox, *Genesis and Exodus: A New English Rendition with Commentary and Notes* (New York: Schocken, 1999).

9 See G.E.R. Lloyd, "The Development of Zoological Taxonomy," in *Science, Folklore, and Ideology: Studies in the Life Sciences in Ancient Greece* (Cambridge: Cambridge University Press, 1983), p. 43.

10 Aristotle, *De Anima*, trans. J.A. Smith, 415a26, in *The Basic Works of Aristotle*, ed. Richard McKeon (New York: Random House, 1941).

11 Aristotle, *Politics*, trans. Benjamin Jowett, 1256b, in *Basic Works*.

12 The quotations from Augustine, Paul, Pope Pius IX and John Henry Newman are drawn from John Passmore, "The Treatment of Animals," *Journal of the History of Ideas* 36 (1975): 197, 196, and 203. See also Keith Thomas, *Man and the Natural World* (New York: Pantheon, 1983), chap. I.

13 René Descartes, *Discourse on Method*, in *Descartes: Philosophical Writings*, trans. and ed. Elizabeth Anscombe and Peter Thomas Geach (Indianapolis: Bobbs-Merrill, 1971), pp. 41–43.

14 Jean-Jacques Rousseau, *A Discourse on the Origin of Inequality* in *The Social Contract and Discourses*, trans. G.D.H. Cole (New York: E.P. Dutton, 1950), p. 207.

15 On this, see Thomas, *Man and the Natural World*, chap. II, and Michel Foucault, *The Order of Things*, trans. Alan Sheridan (New York: Random House, 1970), chap. 5.

16 Armand Marie Leroi, *Mutants: On Genetic Variety and the Human Body* (New York: Viking, 2003), p. 19.

17 Charles Darwin, quoted in Ernst Mayr, *One Long Argument: Charles Darwin and the Genesis of Modern Evolutionary Thought* (Cambridge, MA: Harvard University Press, 1991), p. 62, and Stephen Jay Gould, *Full House: The Spread of Excellence from Plato to Darwin* (New York: Harmony Books, 1996), 137. On Darwin's anti-progressivism, also see Mayr, *Toward a New Philosophy of Biology* (Cambridge, MA: Harvard University Press, 1988), p. 43 and Gould, *Hen's Teeth and Horse's Toes* (New York: W.W. Norton, 1983), pp. 155–56, 170.

18 See Gould, Full House, pp. 38, 167ff.

19 See Samuel Butler, "Darwin Among the Machines," in *The Notebooks of Samuel Butler*, ed. Henry Festing Jones (London: Hogarth, 1985), pp. 42–47, *Erewhon* (London: Penguin, 1970), chs. 23–27, and my "Thinking Like a Plant: Prolegomena to a Philosophy of Vegetables," *Cabinet 6* (2002): 95–98.

20 H.G. Wells, *The Island of Dr. Moreau*, in *Three Novels* (London: Heinemann, 1963), chap. 14.

21 See Annemarie de Waal Malcfijt, "Homo Monstrosus," *Scientific American* 219 no. 4 (1968): 112–18.

22 G.S. Kirk and J.E. Raven, *The Presocratic Philosophers: A Critical History with a Selection of Texts* (Cambridge: Cambridge University Press, 1962), pp. 336–40.

23 See Marie Hélène Huet, *Monstrous Imagination* (Cambridge, MA: Harvard University Press, 1993).

24 Aristotle, *Generation of Animals*, IV, quoted in Huet, *Monstrous Imagination*, pp. 3–4.

25 Genesis 6:4–7.

26 See Malefijt, "Homo Monstrosus," p. 115; Katherine Park and Lorraine J. Daston, "Unnatural Conceptions: The Study of Monsters in Sixteenth- and Seventeenth-Century France and England," *Past and Present* 92 (August 1981): 20–54; and Arnold Davidson, "The Horror of Monsters," in *The Emergence of Sexuality* (Cambridge: Harvard University Press, 2001), pp. 93–124.

27 See Park and Daston, "Unnatural Conceptions" and *Wonders and the Order of Nature: 1150–1750* (New York: Zone, 1998).

28 Jean Baptiste Robinet, quoted in Canguilhem, "Monstrosity and the Monstrous," *Diogenes* 40 (1962): 36.

29 P.T. Barnum, quoted in Arthur O. Lovejoy, *The Great Chain of Being* (Cambridge, MA: Harvard University Press, 1936), p. 236.

30 Erin O'Connor, *Raw Material: Producing Pathology in Victorian Culture*, quoted in Melinda Cooper, "Regenerative Medicine: Stem Cells and the Science of Monstrosity," *Medical Humanities* 30 (2004): 16.

31 See Canguilhem, "Monstrosity and the Monstrous," p. 37.

32 My accounts of, and quotations from, Etienne and Isadore Saint-Hilaire and Camille Dareste are drawn from Cooper, "Regenerative Medicine," pp. 13–16.

33 Charles Darwin, quoted in Cooper, "Regenerative Medicine," p. 16.

34 On becoming-animal, see Gilles Deleuze and Félix Guattari, *A Thousand Plateaus*, trans. Brian Massumi (Minneapolis: University of Minnesota Press, 1987), chap. 10.

35 See Deleuze and Guattari, *A Thousand Plateaus*, p. 238 and Guattari, "Machinic Heterogenesis," in *Chaosmosis: An Ethico-Aesthetic Paradigm*, trans. Paul Bains and Julian Pefanis (Bloomington: Indiana University Press, 1995), pp. 33–57.

JANE ALEXANDER

Jane Alexander was born in Johannesburg in 1959, the daughter of a German father who fled anti-Semitism in his own country. Since 1981, her photomontages, sculptures, and videos have addressed her experience of Apartheid in South Africa, an experience intensified by her family's own struggles in Nazi Germany. The work speaks to the deep effects of alienation and silence. Alexander remains in South Africa and has taught at the Michaelis School of Fine Art at the University of Cape Town.

In her photomontages and sculpture, Alexander places blank-eyed figures in desolate landscapes. Her most prominent early work, a sculpture titled *Butcher Boys* (1985-86), consists of three life-sized horned figures sitting on a bench. Their mouths are sealed, and their spines erupt from their flesh. *Butcher Boys*, sculpted from reinforced builder's plaster and painted in oil, was produced during one of the darkest periods of Apartheid. The demonic figures embody the stark brutality of the Apartheid state and its advocates. Their casual poses and blank, staring eyes highlight the equally casual disregard for humanity that typified daily life in South Africa at the time.

In more recent work, the beastly figures of the *Butcher Boys* have mutated into vulnerable adolescents and children. A series of photographs and sculptures from 1998, *Bom Boys* depicts nine children wearing hoods or masks; these include masks of a vulture, a rabbit, a smiling mask with long donkey's ears, and a blindfold. Like the *Butcher Boys*, these characters stare blankly and appear incapable of speech, rendering them equally inscrutable. Alexander took the term "Bom Boys" from graffiti written near Long Street in Cape Town, a neighborhood she resided in for ten years. Despite being a "white" area, according to the Group Areas Act of the time, Long Street was an illegally integrated area during Apartheid. Long Street today is a busy international commercial district, drawing tourists and the disaffected citizens of Cape Town in equal measure.

In Alexander's series of photomontages *African Adventure: Cape of Good Hope* (1999-2001), the Bom Boys are joined by other displaced and alienated figures. The five sets of three images illustrate several journeys through blasted landscapes from the countryside into the city of Cape Town. In the image entitled *Vissershok* (2000), animals and humans linger near an oil drum in a barren wasteland as birds of prey wheel in the sky. A related series *To Work* (2000) depicts an imaginary journey from a dilapidated shantytown on the outskirts of Cape Town to an industrial sector, where many of the shantytown's residents work. In *The Adventure Center* (2000), scavenging humans and animals infest various tourist attractions on Long Street, ghosts that haunt South Africa's present.

Alexander moves away from geographic specificity in *Post Conversion Syndrome (In the Wild)* (2003), *Post Conversion Syndrome (In Captivity)* (2003), *Missing* (2004), and *Dig It All Yummy* (2004). Although the blank-eyed figures recur, the environments have become more ambiguous. Alexander writes, "Less geographically and socially specific than *African Adventure: Cape of Good Hope*, [these photomontages] refer to local and broader issues related to the continent that inform much of my current work." Alexander is reluctant to discuss the content of her work, preferring to allow for multiple meanings with broad geographic implications. The work transcends the South African political context and speaks to the global human condition.

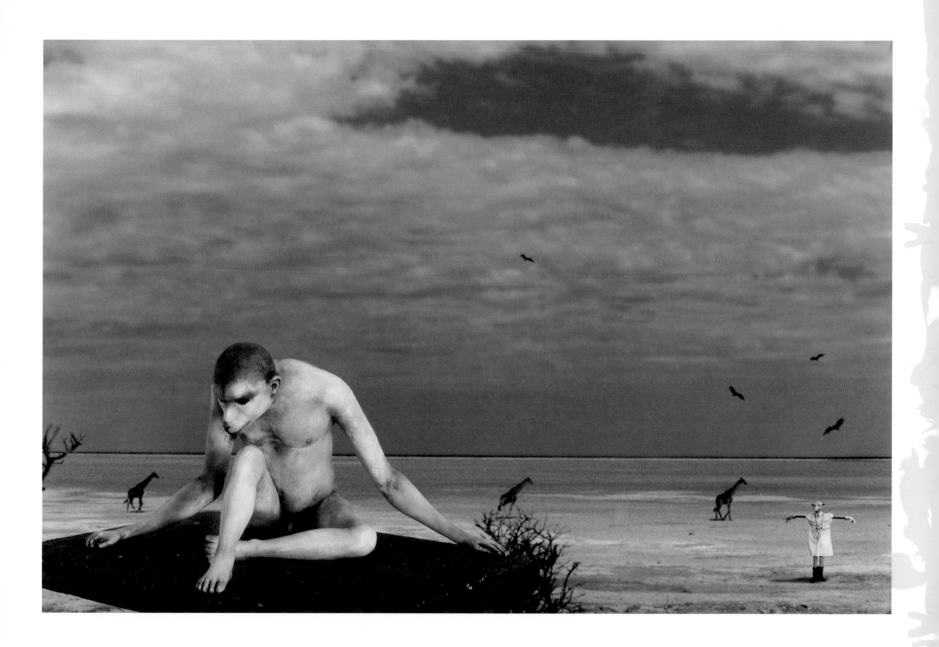

Jane Alexander, *Post Conversion Syndrome (in the wild)*, 2003.

Becoming Animal

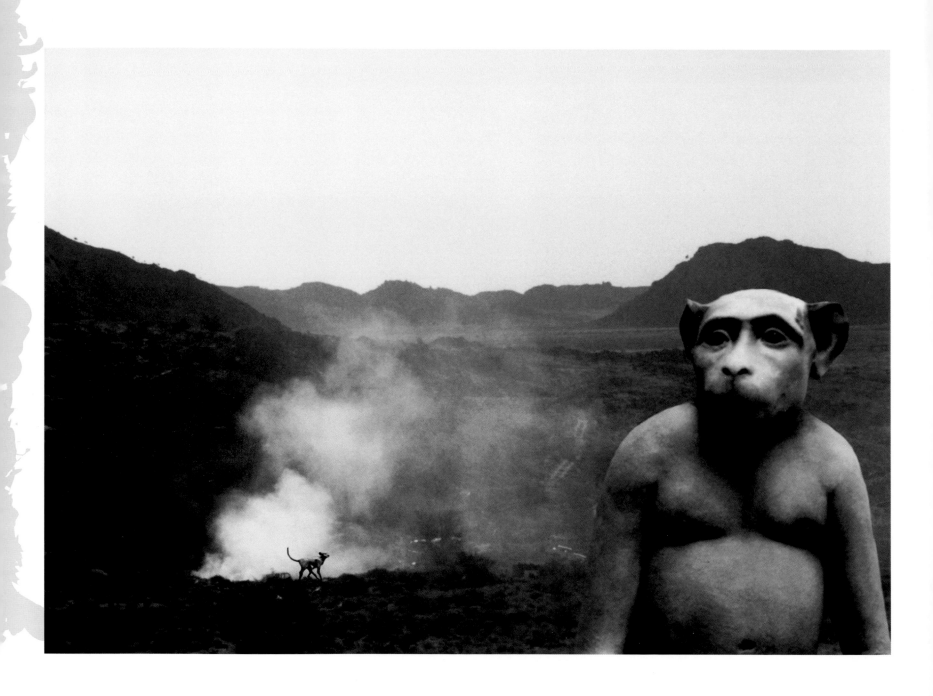

Jane Alexander, *African Adventure: Cape of Good Hope; Harvestime*, 1999.

Becoming Animal

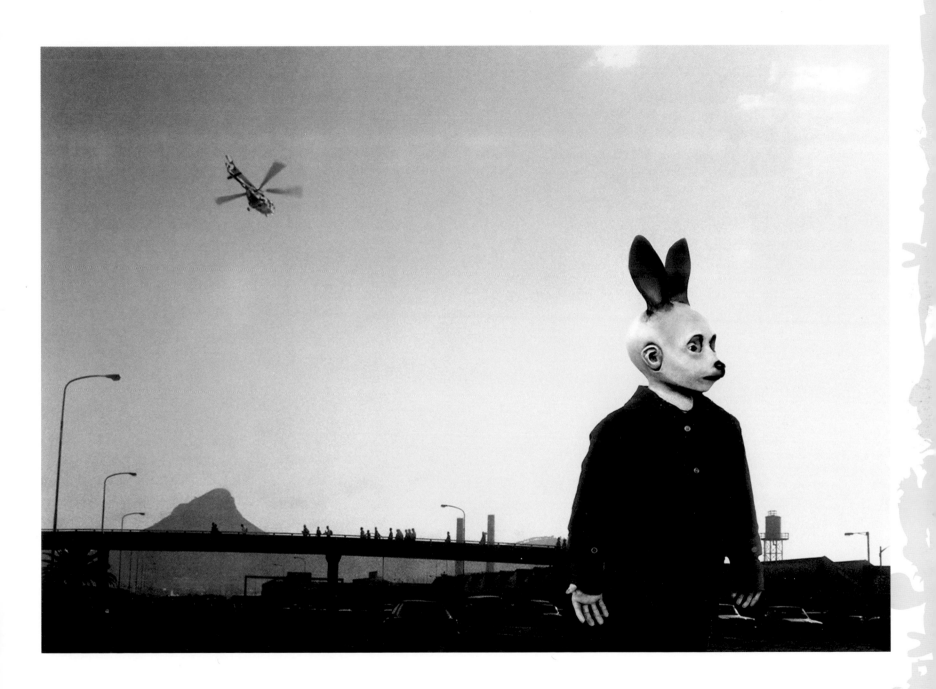

Jane Alexander, *African Adventure: Cape of Good Hope; Bom Boys, Lonely Boys, Fancy Boys, Sexy Boys; National Road 1 Bom Boy with workers and traffic*, 1999.

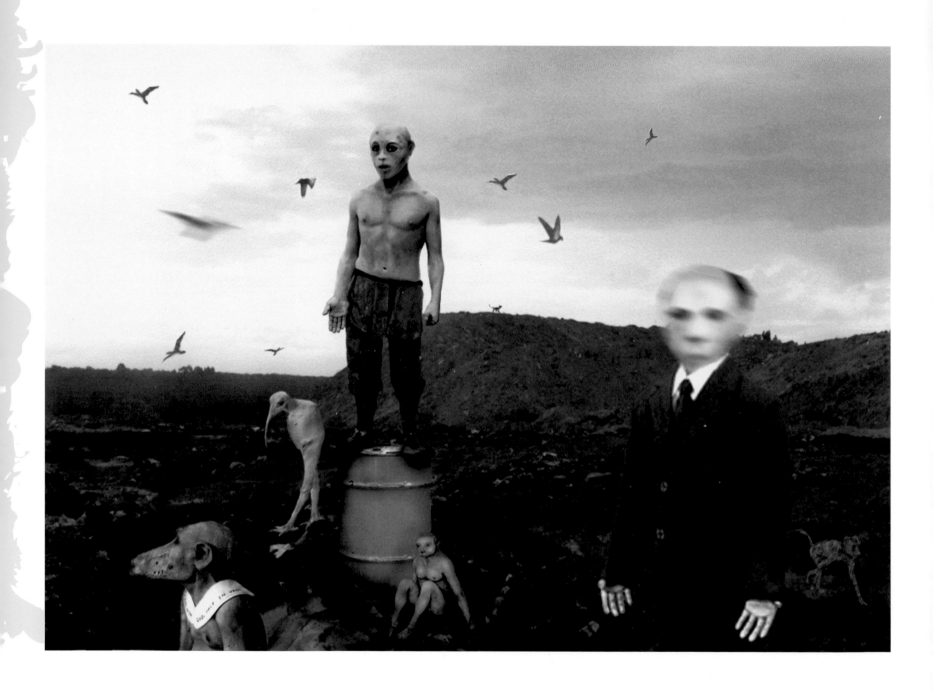

Jane Alexander, *African Adventure: Cape of Good Hope; Vissershok*, 2000.

Becoming Animal

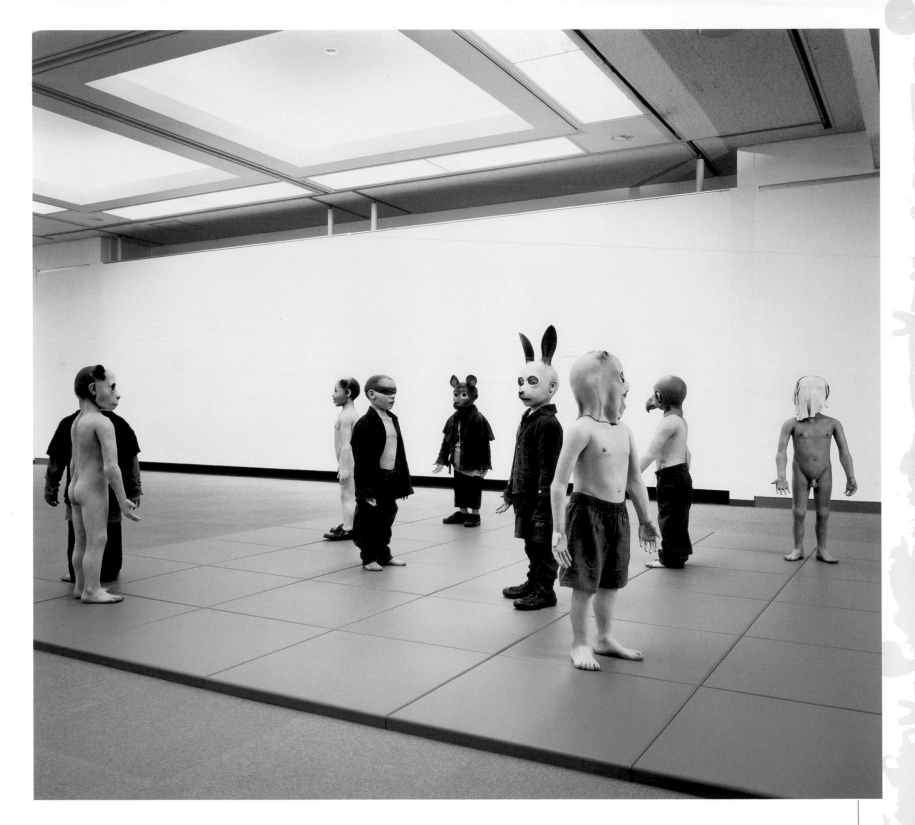

Jane Alexander, *Bom Boys*, 1998.

Photo: Courtesy of the Tobu Museum, Tokyo.

RACHEL BERWICK

A naturalist, environmentalist, and artist, Rachel Berwick manipulates a broad range of media to destabilize the binary, often oppositional relationship of humanity to nature. In emphasizing incidents of animal extinction, Berwick brings forward the loss that accompanies this moment, and relates it to other cultural events: the lost languages of the South American Maypure tribe, for example.

For her 1997 project *may-por-é*, Berwick taught a pair of parrots to speak the dead language of the Maypure tribe, which disappeared hundreds of years ago from Venezuela. The Maypure language survived through the writings of Baron von Humboldt, whose scientific expeditions to South America in the late 18th century earned him the controversial distinction as the man who "re-discovered" South America. According to the often-told legend, Humboldt learned Maypure from a parrot he claimed was the last remaining speaker of the tribe's language. The validity of this tale remains questionable; however, Humboldt did produce a convincing list of phonetic notes detailing the language. From Humboldt's rudimentary notes, Berwick worked with a behaviorist and linguist in order to teach the two uncertain parrots this language. In *may-por-é*, the parrots lived in an aviary enclosed in white Plexiglas. The visitor could faintly hear the obscure sounds of the birds. The Plexiglas sheltered the birds, but also provided a vivid screen on which the parrots' large shadows were projected.

Berwick blends history, nature, and mythology, always anchoring her work in real-world consequences. In her installation *A Vanishing* (2003), she explored the 1914 extinction of the passenger pigeon. The installation consisted of 600 cast amber passenger pigeons suspended on brass rods arranged in a grid. The number of amber birds decreases from the outside of the installation until one pigeon remains in the center: Martha, the last passenger pigeon, who died in captivity at the Cincinnati Zoo. This meditative work evokes the sense of gradual loss of a bird that once dominated the skies of North America as its single largest bird population.

For *Becoming Animal*, Berwick presents *Lonesome George* (2005), an installation focusing on the fate of the Galapagos Island tortoise species, *Geocheleone Abingdoni*. George is the last of his subspecies on the Galapagos Island of Pinta (also referred to as the Island of Abingdoni). In this installation, the visitor first encounters a series of 14 x 16' sails gradually inflating with gusts of air. As visitors round the sails, they encounter two videos of a tortoise. In the first video, the tortoise, barely moving, stares at the camera. His throat expands and contracts as he breathes. In the second video, the tortoise walks up to the camera and then retracts into his shell. At the moment he retracts, fans suddenly blow wind into the sails, exhaling.

The billowing sails in *Lonesome George* may call to mind the 19th-century whaling ships that hunted the Galapagos Island tortoises to near extinction, or perhaps the ships of the 1906 exploration team from the California Academy of Arts and Sciences that knowingly took what they thought to be the last of these tortoises for study. George, however, survived on the island until he was miraculously located in 1971 by National Park wardens. As each tortoise breath seemingly fills the sails and propels these ships, we become aware of time: *Lonesome George* will inevitably die and, with him, an entire subspecies.

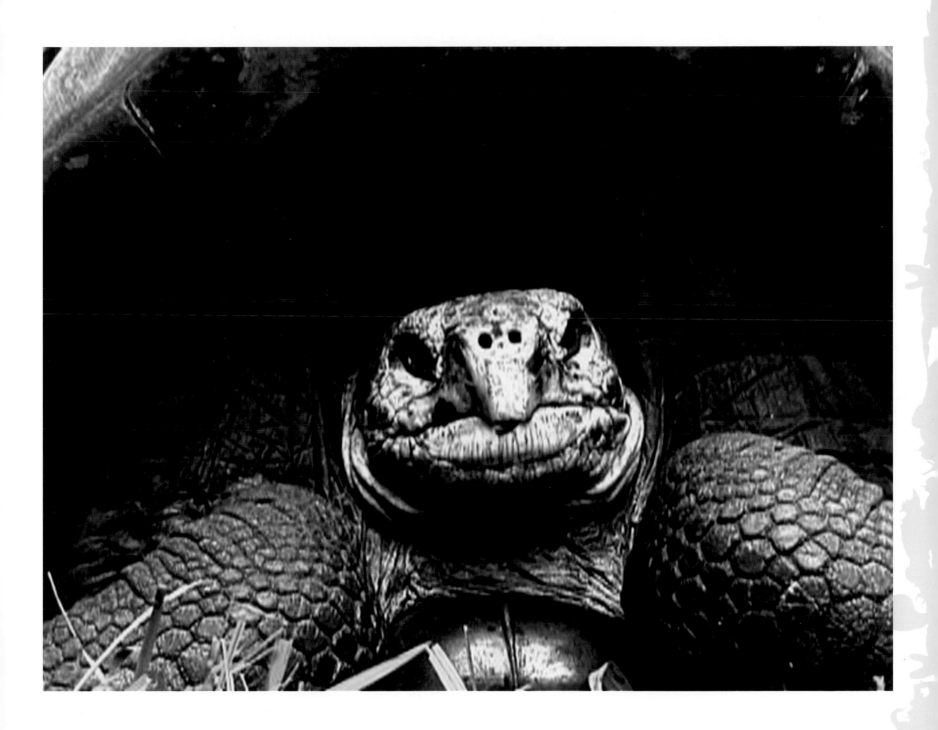

Rachel Berwick, *Lonesome George*, 2004.

Becoming Animal

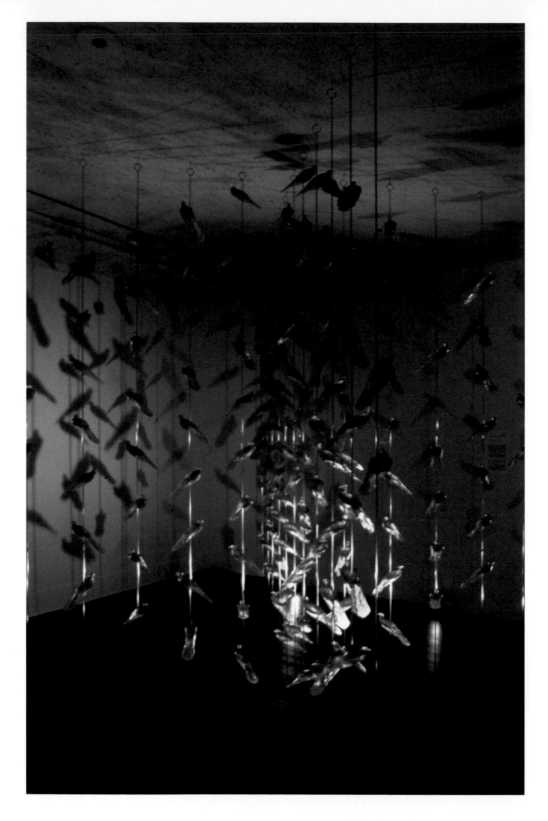

Rachel Berwick, *A Vanishing*, 2003.

Becoming Animal

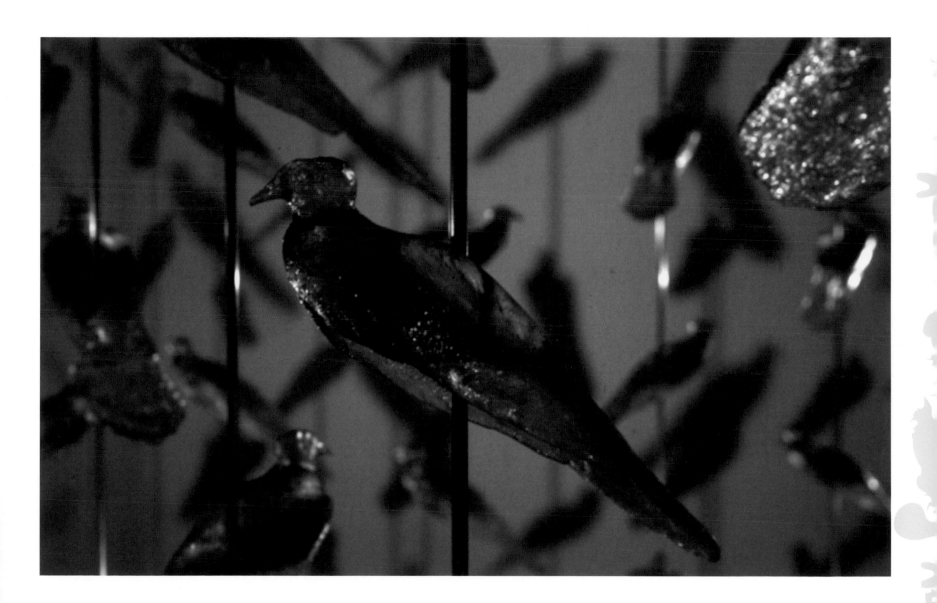

Rachel Berwick, detail, *A Vanishing*, 2003.

Becoming Animal

Nato Thompson: In much of your work – *may-por-é* (1997), *A Vanishing* (2003), and *Lonesome George* (2005), for example – the sense of human loss connects directly to real world extinction. How do you see these as intertwined?

Rachel Berwick: I have always been interested in the subject of loss. In my work I focus on how we deal with loss, the desire to recover that which is lost, the impossibility of that and, finally, the importance of the attempt in the face of failure.

Extinction, whether it is of a language, a species, or culture, is the embodiment of loss. In each of the pieces that you mention, the relationship between human loss and extinction is manifest differently.

In *may-por-e'*, my interest began with the fact that a parrot could become the sole conduit through which an entire tribe and its language could/might be recovered.

In *A Vanishing* and *Lonesome George*, however, my point of interest was with the fact that Martha (a passenger pigeon) and Lonesome George (a Galapagos tortoise) had become the last survivors of their kind. These two installations are shaped by this: the fact that being the last, they are at once extinct and living; present and absent; present and past.

Plate I – *Turtle*

Nato Thompson: Your projects require an immense amount of field work before they even get formulated as installations. How do you balance these two phases of your work?

Rachel Berwick: Each of my projects begins with a lot of research in libraries first, then with specialists in various fields and so on. This process of gathering information helps me to identify an area of interest. It also helps me to gain access to the places and people who specialize in this field of interest. This part of my process takes a long time, months or in some cases years before I decide (if I decide) to bring it into the studio.

At that point my research is no less intensive, but the emphasis is different. Once I decide to bring an idea into the studio I spend a lot of time trying to locate materials and processes that lend themselves to the idea. In every case the information that I have gathered determines the materials and processes I will use.

The result of this way of working is that my studio practice changes sometimes drastically, with each project. The most obvious example of this was with "*may-por-e'*" when I was training parrots to speak the maypure' language. So my studio practice was shaped around the needs and wants of my two parrots and their language lessons. Simultaneously I was building an aviary that would be a warm and loving place for my parrots while also serving my conceptual agenda for the work.

I guess that what it comes down to is that the information determines the material, and the material determines the studio practice for any given project.

Nato Thompson: In your installation *Lonesome George*, the breaths of the tortoise operate almost like a clock where the visitor gains an immediate sense of time (or rather lack thereof). How do you balance the poetically ambiguous and your implicit sense of urgency with these issues of extinction?

Rachel Berwick: Each of my projects is laden with so much information on every level. This is what drives my working process as I described above. However, once it goes into an exhibition I think it's important to allow the viewer the space and time to negotiate the work (and information) on a more visceral level. All the information is there, but it might be embodied in the material, space, or interactions of several elements within my installation. I prefer to provide the viewer with opportunities for discovery on different levels.

Nato Thompson: Like a few of the other artists in the exhibition, such as Mark Dion and Natalie Jeremijenko, your work could fit relatively comfortably in a natural history museum or artistic context. Do you find yourself moving between these worlds?

Rachel Berwick: Absolutely. However, I don't usually end of exhibiting the work in these contexts. It seems that most of my work with the natural history museum or scientific context is related to my process of research and making, and not so much the exhibition context. I don't know how I feel about that. It's an interesting problem to me.

Nato Thompson: What does *"becoming animal"* mean to you?

Rachel Berwick: You know, I've always had more empathy for animals than I have for humans.

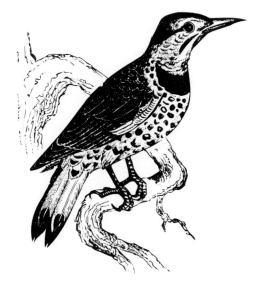

Plate II – *Flicker*

BRIAN CONLEY

While working toward a degree in experimental psychology at SUNY Binghamton, Brian Conley also served as a National Science Foundation research assistant. Since then he has received an MFA in sculpture as well as a doctorate in philosophy from the University of Minnesota. His interests in philosophy, art and language continue to shape a broad range of activities, which include sound art, performance, sculpture, and installation. In 1998, he founded the international art and culture magazine *Cabinet* with Sina Najafi.

Conley's work is not solely concerned with questions of animal consciousness, though this subject continues to inspire many of his theory-based projects. In *Crocodylus/Salmo* (2002), a proposal for a massive public-art installation, Conley developed the idea for an inflatable sculpture, to be anchored seaside, whose biomorphic bulges suggest marine life but without specific reference. The shape is derived from an anatomical model of the brain of a crocodile grafted onto that of a salmon. This exaggerated entity was not culled from a science fiction novel, but grew out of Conley's thinking about biomedical technologies that allow cloning, gene-splicing, and cross-species organ-grafting. The looming hybrid – a playful inflatable – is the shape of the future.

In his *Decipherment of Linear X* (2004) at Pierogi Gallery in Brooklyn, Conley used his own error as a source of inspiration. While walking through the woods in upstate New York, Conley happened upon an intricately carved piece of wood. Since the markings looked like a written language, Conley speculated that they belonged to American Indians. He was to learn, however, that the marks derived from a species of beetle called the Scolytidae. Conley enjoyed this complication and decided to continue his research. He cordoned off the site using archeological methods, then solicited the assistance of experts in the fields of animal intelligence and archeo-linguistics. Could the markings of the Scolytidae beetle actually be deciphered by humans?

Surprisingly, the markings resembled those of one of the oldest known languages, Minoan Linear A and B, used in Crete between 1600 and 1100 BC. Conley named his found beetle language Linear X, and produced an elaborate exhibition consisting of ceramic tablets made by rolling the sticks over clay, along with close-up photographs of the individual marks. He also produced an academic journal which included a thorough catalogue of his investigations as well as accompanying essays by experts in artificial intelligence, history, linguistics, biology, fiction and poetry.

Conley's interests in the limits and possibilities of human/animal communication appear again in his large-scale commission for the ArtPace Foundation for Contemporary Art in San Antonio, *Pseudanuran Gigantica* (2001) – translated "giant fake frog" – on view at MASS MoCA. Entering the gallery, viewers encounter a deflated orange cloth sack lying on the floor. Approaching the object, the viewer triggers a motion detector, and the sack begins to burble and inflate as the accompanying blowers rush air into its interior, transforming itself into a massive orange balloon that emulates the engorged throat of an excited male Tungara frog. The air then slowly exits through a series of acoustic devices including church organ pipes, animal calls, and reeds, producing a low resonant moan acoustically modeling – at a vast scale – the mating call of a frog. The elemental call – possibly the most vital use of communication – and the gargantuan scale capture the viewer/listener in an ancient aria.

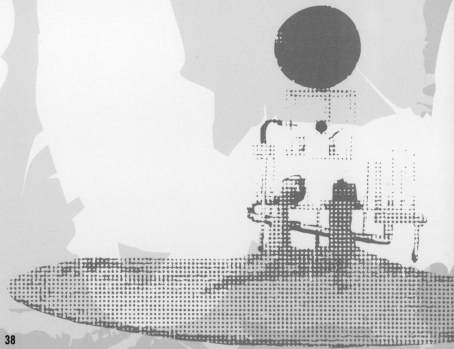

Brian Conley, *Crocodylus/salmo*, 2000

Becoming Animal

Brian Conley, *Linear X symbol detail*, 2004.

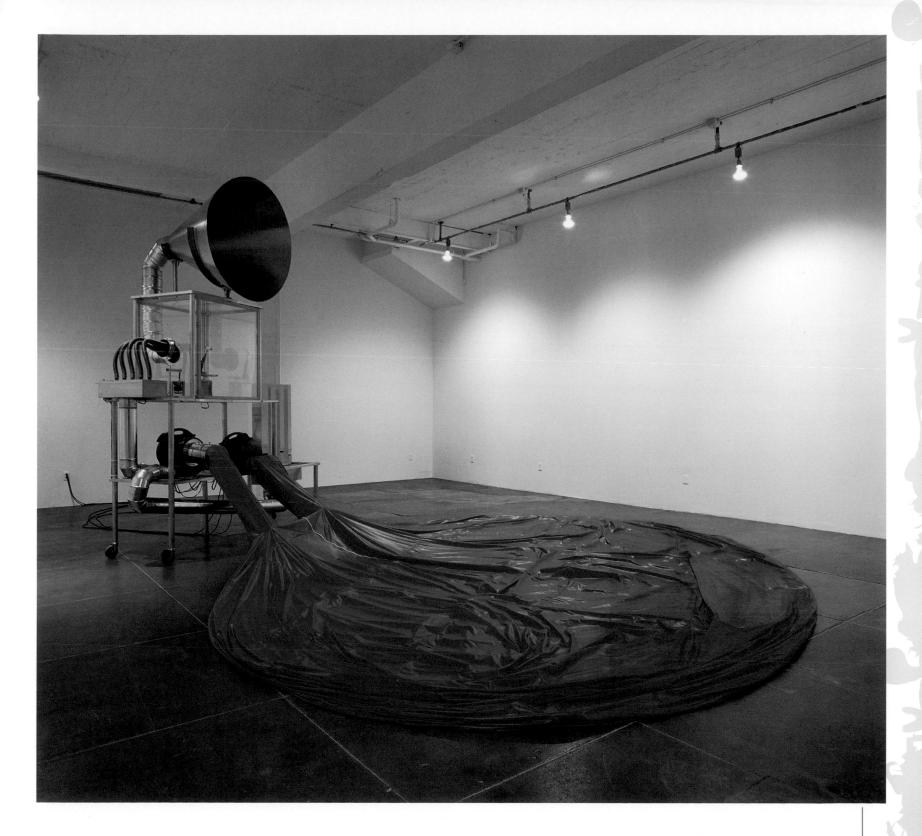

Brian Conley, *Pseudanuran Gigantica*, 2001

Originally Commissioned by Artpace San Antonio. Photo: Artpace San Antonio

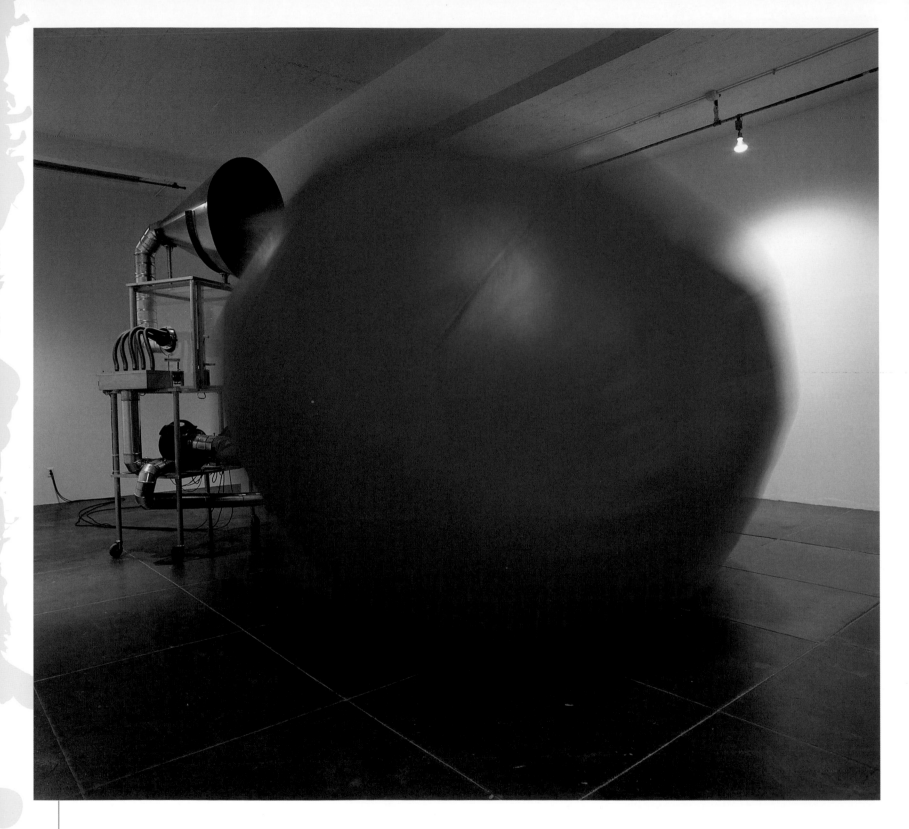

Brian Conley, *Pseudanuran Gigantica*, 2001

Originally Commissioned by Artpace San Antonio. Photo: Artpace San Antonio

Becoming Animal

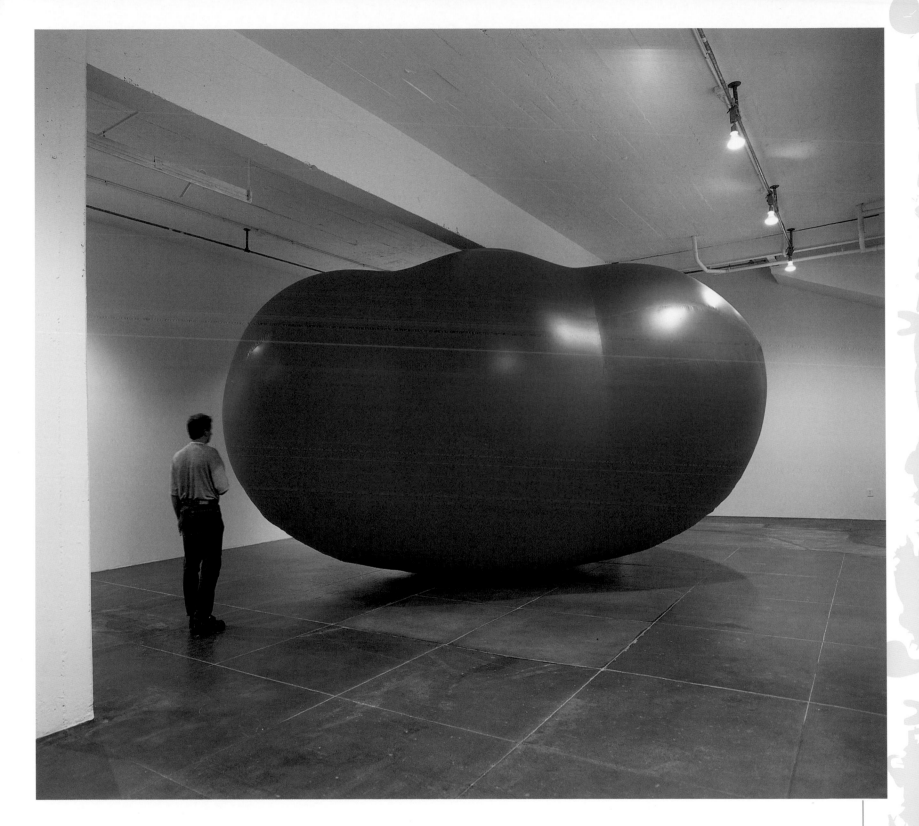

Brian Conley, *Pseudanuran Gigantica*, 2001

Originally Commissioned by Artpace San Antonio. Photo: Artpace San Antonio

Nato Thompson: Out of high school you spent several years as an animal researcher. How has this period of your life influenced your work on animal consciousness today?

Brian Conley: In the early '70s I worked in a laboratory that ran learning experiments on animals representing different positions on the evolutionary scale. I was asked to monitor a series of experiments on goldfish, involving a large bank of computers and transparent tanks of water connected by cables. The tanks were equipped with a low barrier in the middle, a red light on one end and a green light on the other. A goldfish was dropped into each tank. When the red light came on, the fish had to negotiate the barrier and hit the red light with its mouth; when the green light came on, it had to do likewise.

These were Pavlovian/Skinnerian learning experiments in negative conditioning, which means that the subjects were not reinforced through reward for their successful behavior but were punished for unsuccessful behavior. To this end an electrode was placed in the water and a shock administered when the sought-after behavior did not occur. The other key feature was that the researchers were interested in learning under the influence of drugs. The fish were given various doses of substances from cocaine to sedatives to morphine, which were diffused directly into the water. The entire test was automated. I simply made sure everything was working properly, and wrote down how many times and how quickly the fish hit the lights. A statistical analysis was made by the researchers and an interpretation generated, which I was told would ultimately illuminate some dimension of human learning.

The lab, in a Pynchon-like twist, was run by a Dr. Bliss. I occupied the pivotal position between researchers and fish. This relationship became particularly poignant at the end of each experimental cycle, when I was asked to discard the fish so that they could not be reused for the same experiment. I was in multiple ways responsible for the animals involved, even deciding the terms of their lives and deaths. In my confusion about what to do in this situation, I devised a rather limited plan to not simply kill the fish but to "terminate their life cycle" in a more "natural" way, by reinserting them in something

approximating an ecosystem. I bought a tank and a carnivorous fish that at the end of the experiments ate the participants. This ill-conceived fantasy ecosystem broke down when the predator fish grew so large so quickly that it broke its tank and jumped out. These experiences raised questions about the nature of animal intelligence, its relation to human intelligence, and the morality and efficacy of such research. At the time I believed in animal testing, in the beneficence of the researchers, and in science itself. However, I continued to wonder how human learning could be explored through research on fish – especially goldfish, which are bred in artificial environments as living toys for children. I could not get answers from the people I worked under, partly because such information would be embedded in dense theoretical presuppositions too difficult to unpack in discussions between teacher and undergraduate, but also because I was expressing a potential critique of the research methods and of science as unfettered good. I began to realize that I needed to study theory-construction in science, on the one hand, and animal intelligence on the other. This eventually led me into analytic philosophy and the Minnesota Center for the Philosophy of Science, where I focused on epistemology and the mind/body problem.

Plate III – Goldfish

Nato Thompson: Obviously, the sound emitted from the exhaling balloon evokes the frog's mating call, and the engorged organ is fairly suggestive as well. How do sex and animality play into this project?

Brian Conley: The sound emanating from "PG" is visceral; its vibrations can be felt inside the body. The drone has two emotional trajectories. One is a calling-out into a cold place from a state of unrequited desire: the sound of submerged lust soliciting a remembered but estranged, generalized other. The second sonic trajectory embodies loss, grief, and mourning: a ululating or ritual wail. In other words, sex and death move through each other, producing a slowly shifting relentless vocalization, a cyclical morphing call for consummation.

Nato Thompson: In your work *Pseudanuran Gigantica* the inflation of the

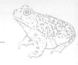

airbag overpowers the viewer; how do you expect the viewer to feel in this situation?

Brian Conley: The scale of the airbag establishes an immediate realignment of the relation of viewer to object. The viewer is dwarfed, halted in his or her tracks, dominated in a brief and intimate encounter. How this affects the viewer depends on the larger question of how the viewer thinks about the object itself.

On the surface, the object looks like a three-dimensional scientific model of some unfamiliar organism, perhaps some diagrammatic or schematic structure displaying various essential functions. Or perhaps it is simply a machine or a large toy. These readings are confused, however, because the thing, in interplay with the viewer, shows signs of life – it moves, it makes sound, it breathes. It is animated.

Plate IV – *European Toad*

Given both literal and metaphorical readings, what is this object? Limiting oneself to literal readings, it could be a robot made by humans. It could be a self-constructing robot, or an animat displaying the rudiments of artificial consciousness. Making a short metaphorical leap, it could simply be a frog in alternate form, or even a metamorphosed human, like Gregor Samza's beetle, or perhaps a cyborg.

This object occupies multiple ontological states: machine, toy, puppet, robot, frog, human, animat, cyborg, monster, musical instrument, and perhaps manifest ghost. These readings hang in abeyance, allowing the viewer to determine who or what is seeking to mate with whom. But however this is answered it is clear the object has at least one desire: to be recognized, to make contact. And it has one object: the "human."

MARK DION

Mark Dion was born in New Bedford, Massachusetts, in 1961. He studied at Hartford Art School in Connecticut in 1981 and then transferred to the School of Visual Arts in New York. In 1984-85, Dion participated in the Whitney Independent Studio program, an experience that has informed his art-making since that time. A leading example of the program's critical approach, Dion exhibited his work in the 1997 Venice Biennale, the Tate Modern, and the Museum of Modern Art in 2004.

Mark Dion's elaborate institutional critique opens the fields of natural history, zoology, and conservation to visual scrutiny. He deploys the techniques of natural science — such as archiving, field studies, taxonomy, and taxidermy dioramas — in order to contest the border between nature and culture, and art and life. In his early work, Dion was motivated by environmental concerns, as in his *Selections from the Endangered Species List (the Vertebrate)*, or *Commander McBrag Taxonomist* (1989) with William Schefferine. Dion's detailed installation replicated a standard natural scientist's office with charts, butterfly net, and mounted deer head. The installation compared two versions of taxonomy: one that names living creatures as they are found, and the other that names them as they become extinct. In juxtaposing two classification systems based on opposite principles, Dion and Schefferine pointed to an intrinsic tension at the heart of the natural sciences. Like French sociologist Pierre Bourdieu who used the tools of sociology on the field of sociology itself, Dion places the scientific environment under the microscope. His penetrating aesthetic bridges both the empirical qualities of science and the more ambiguous tendencies of art.

Mark Dion's institutional critique consistently harkens back to the root of the museum: the cabinet of curiosity. He has produced numerous Wunderkammer projects including *Project for the Royal Home of Retirees, Bronbeek* (1993), *Collectors Collected* (1994), and *Curiosity Cabinet for the Wexner Center for the Arts* (1996). As a cornerstone of museological history, the 16th-century Wunderkammer serves as a framework for Dion to deconstruct the current museum (whether a museum of natural history, anthropology, or contemporary art). Since the current museum is an outgrowth of the history — and the point of the Wunderkammer was to display one's possessions - Dion continues to track these institutional tensions today.

For *Becoming Animal*, Dion developed *Library for the Birds of Massachusetts* (2005), which synthesizes his long line of tree projects, including *Library for the Birds of Antwerp* (1993), *Tar and Feathers* (1995), *Library for the Birds of New York* (1996), *Killers Killed* (1994), and *Library for the Birds of Connecticut* (1994). The metamorphic implications of the tree are extensive, but the obvious three are nature, knowledge, and the phylogenic tree of animal species (with humans at the top). In many of his tree projects, Dion collapses these metaphors by hoisting a cabinet of curiosity and library into the tree's limbs. In projects such as *Library for the Birds of New York* (1996), branches are cluttered with books on extinction, environmentalism, animal rights, bird-watching, and many other topics. Additionally, bird feeders, birdcages, hunting paraphernalia, bottles of industrial pesticides, fruit baskets, and birdseed dangle from the limbs of the dead tree. Dion's trees typically suffer from dry rot. With frail and decomposing branches, the tree of knowledge appears to crumble.

In other more ominous works, such as *Killers Killed* (1994) and *Tar and Feathers* (1995), Dion smothers the branches in a tar-like substance with the bodies of animals hanging from the limbs (tar is a popular source of aviary fatalities). Unlike the tree of knowledge, Dion's trees now provide a place to display the dead (cats, snakes, birds). The macabre atmosphere evokes environmental disasters, as well as (more abstractly) the grotesque implications of science gone awry, which have led to large levels of extinction in the animal kingdom.

Library for the Birds of Massachusetts will carry these gothic aspects as well. In addition, not since *Library for the Birds of Antwerp* has Dion actually had live finches fly inside his aviary. The visitor will be able to walk among the birds and get up close and personal with this towering tree of knowledge.

Mimicking the techniques of the natural history museum, Dion re-presents nature. His forceful production of artifice brings to light the ongoing representation of "nature" as a source of research. However, the *Library for the Birds of Massachusetts*, outstripping allegory alone, also provides a space to encounter the very real and living source of this dilemma, the animals.

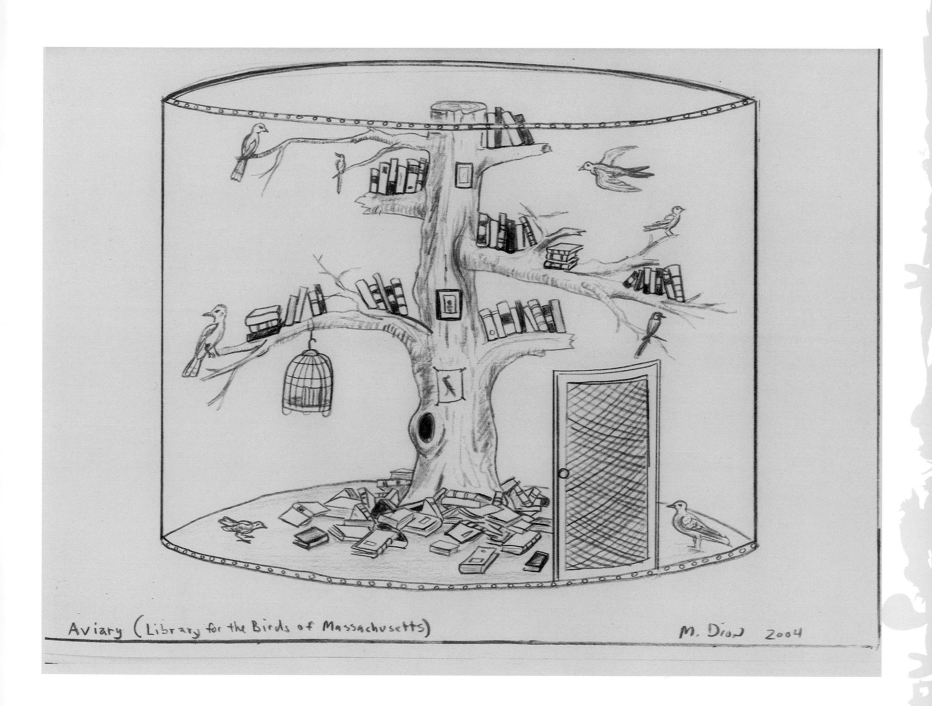

Aviary (Library for the Birds of Massachusetts) M. Dion 2004

Mark Dion, drawing, *Aviary (Library for the Birds of Massachusetts)*, 2004.

Commissioned by MASS MoCA

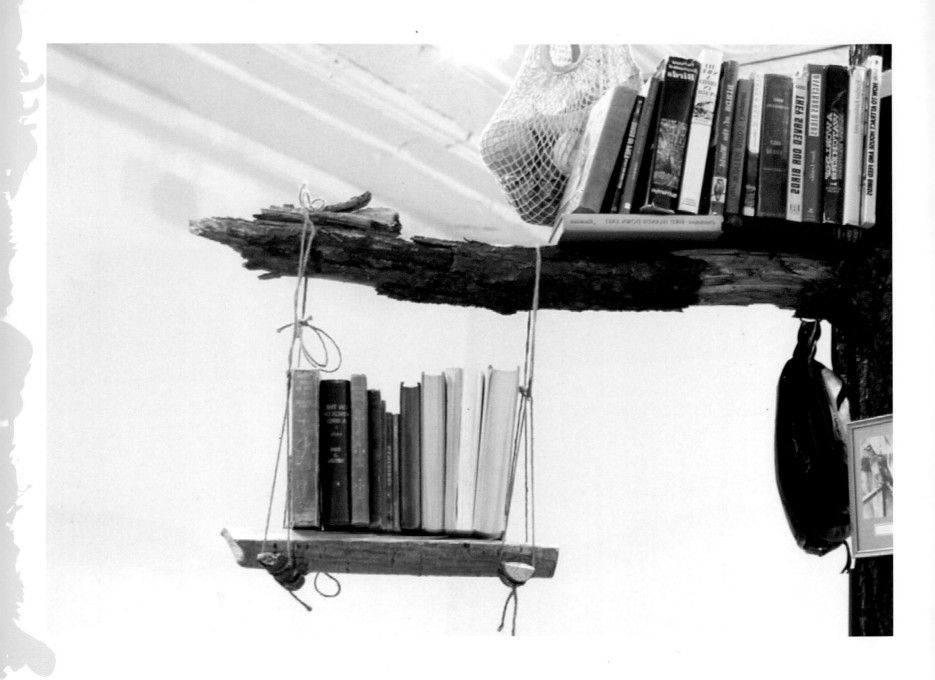

Mark Dion, detail, *The Library for the Birds of New York*, 1996.

Photo: Craig Wadlin

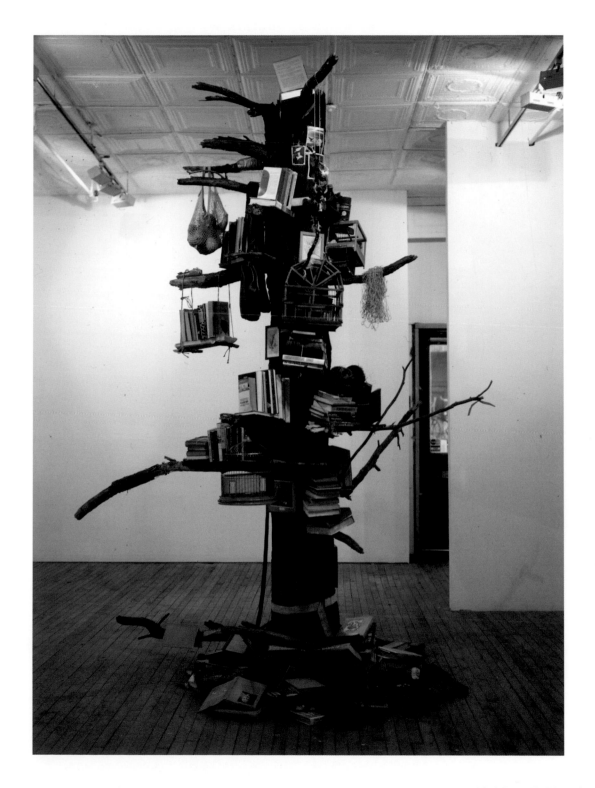

Mark Dion, *The Library for the Birds of New York*, 1996.

Photo. Craig Wadlin

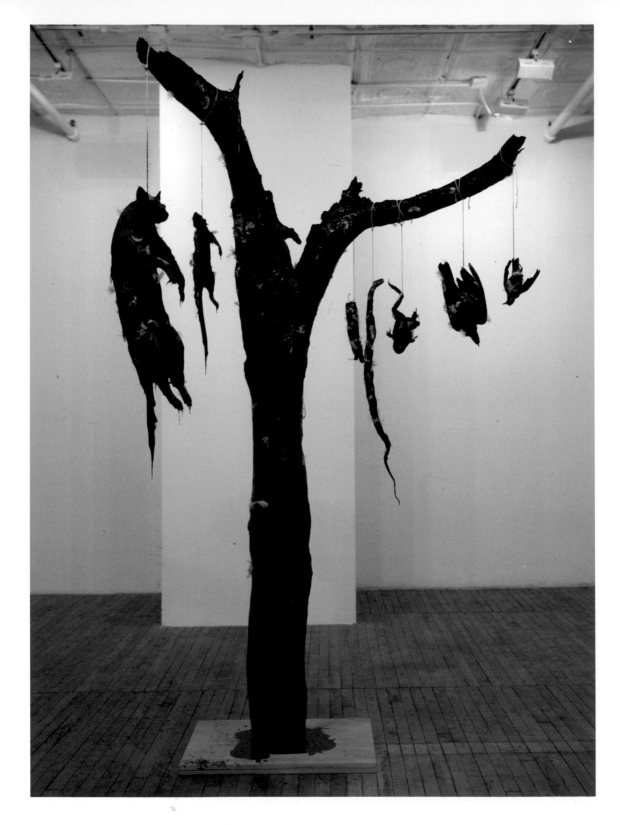

Mark Dion, *Tar and Feathers*, 1996.

Photo: Craig Wadlin

Becoming Animal

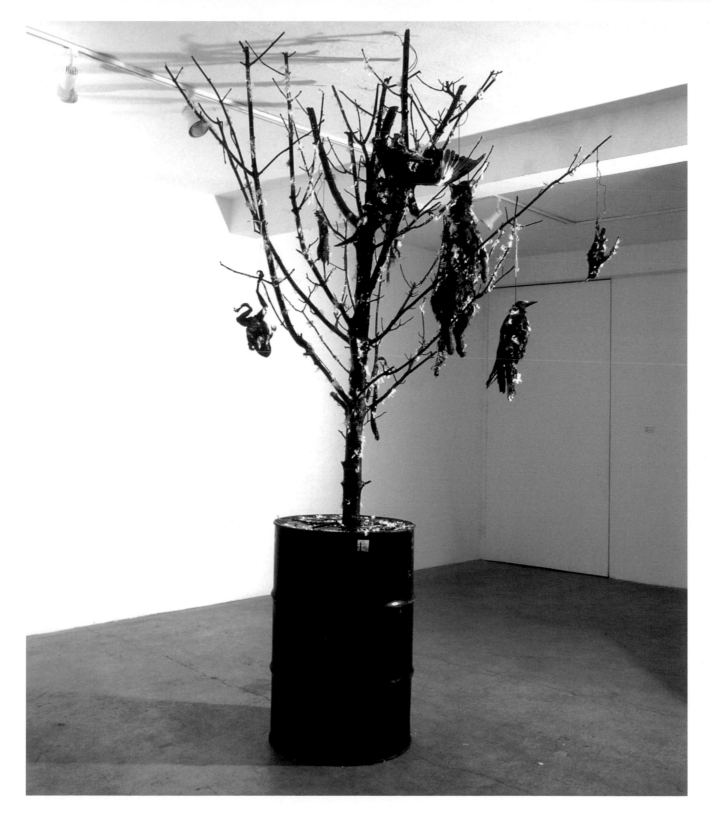

Mark Dion, *Killers Killed*, installation,

Marc Jancou Gallery, London, 1994

Nato Thompson: You have worked on several tree projects including *Library for the Birds of Antwerp* (1993), *Killers Killed* (1994), *Library for the Birds of Connecticut* (1994), *Tar and Feathers* (1995), and *Library for the Birds of New York* (1996); how has your thinking changed over the last ten years?

Mark Dion: Perhaps more than with any other body of work, the evolution of the Library for the Birds works and other tree-based works (there are at least seven radically different versions) reflect shifts in my thinking regarding the politics of nature. If one considers my work from the late '80s and early '90s, including collaborations with Bill Schefferine, a playful but serious didactics is present. Schefferine and I were idealistic. We felt certain that ecological calamity could be avoided by access to knowledge; that if people understood situations like the crisis in biodiversity, through habitat loss, they would act to alleviate the problem. Our didactic style expressed the notion that somehow the information is just not getting out. Now I am convinced that knowledge is not the issue and that there is a profound lack of will. I grossly miscalculated the power of ideology, desire, coercion, superstition, and pure greed. In the past ten years there are a lot more Wal-Marts and a lot fewer wetlands.

So the tone of my work has tended toward the more macabre and become laced with inky pessimism. Works like *Library for the Birds of New York*, which depict the tree of knowledge with a chronic case of root rot, embody my epiphany that when it comes to the environment, we are just not going to work things out. While there may be no spectacular environmental catastrophe, the earth will slowly become a less cultural and biologically diverse place, less wild, more impoverished, economically polarized, uglier and a less interesting place to live. For the things I care deeply about, the future looks pretty grim. The *Library for the Birds of Antwerp* expresses a sense of disenchantment in the face of wonder. The birds, so beautiful and vivacious, exist in Antwerp because of a long and pernicious colonial relationship between the city and central Africa.

Despite my gloomy outlook I must still have a molecule of optimism which is represented by the very desire or need to continue to produce work engaging these issues. I can't imagine throwing in the towel. I may be pessimistic, but I am far from cynical.

Nato Thompson: In your interview with Miwon Kwon in your Phaidon mono-

graph, you indicated a frustration with environmental movements for lack of analysis of class. How does this inform your work?

Mark Dion: Although on the fringe, I do identify myself as within something called the environmental movement. There is, however, a lot to be frustrated about concerning the environmental movement, some of which stems from its roots with the early 20th-century American Conservationists who, more often than not, were powerful white men interested in protecting their hunting privileges. Frustration also stems from the current face of the movement which, all too often, takes the form of property owners protecting the right to their quality of life. Although I do find a good amount of bone-headed thinking in the ecology movement, I am not so certain that it is more the sloppy or even destructive ideas which sometime arise in other social liberation movements.

Plate V
— *Collared Fly Catcher*

It is important to view green or ecology movement as a hybrid with its own complex episteme, some concepts emerging from science and others borrowed from philosophy, and some forged in grass-roots struggles. Unproductively we tend to see the movement as bifurcated; we see either deep ecologists who view human's war on nature as the central narrative, or social ecologists who see the domination and exploitation of some sectors of the society over others as played out, and in the realm of nature as a result. This constructs a cartoon of some ecologists concerned about wilderness and others about social justice, issues like environmental classism. It is about the country and the city dynamic Raymond Williams articulates.

Perhaps there is a problem with the Greens which stems from the two dominant scholarly discourses having let down the movement theory. Intellectuals in the fields of both science and critical theory (Philosophy and Cultural Studies) have failed to provide the activist wing of the movement with an adequate tool bag of analytical and critical instruments. Certainly in the women's movement, postcolonial struggles, queer movement, and anti-racism struggles, there were specific intellectuals beneficial to developing a vocabulary of empowerment. What about the Greens? Certainly in the scientific field there are figures like Rachel Carson, the Ehrlichs, Edward Wilson and, on the cultural studies front, important minds like Andrew Ross, Carolyn Merchant, Donna

Haraway and William Cronon who have made contributions; however, it does not seem that these ideas percolate to the front lines. Perhaps I am naïve in my expectations, or perhaps it is because environmentalists are constantly fighting off rear guard assaults, requiring extremely local and pragmatic tactics, and these battles are too specific to develop a theory of ecological justice. The Greens seem adept at tactics but lacking in strategy.

It is difficult for me to concretely frame how this situation shapes my practice, other than to express a somewhat schizophrenic approach. However, I find that sense of fragmentation ripe with possibility. I view my work as an expansive practice which is unified by a commitment to a core of concerns, best characterized as an investigation of the representation of nature. This practice materializes through a diverse field of expression which includes sculpture, installation, photography, writing, teaching and lecturing, as well as practical collaborations with institutions such as zoos, wildlife conservation organizations, museums, public art venues, and community groups. Since most projects employ the same set of conceptual tools and challenges, I do not view the various possible approaches to a project or problem hierarchically.

Nato Thompson: Your work deliberately references the natural history museum while at the same time using the techniques of contemporary art. Today, you can definitely see spaces, whether in art or natural history museums, where the questions you have been raising for the last fifteen years are being fleshed out. I wonder how you feel about developing an aesthetic that has such underlying potential for museums.

Mark Dion: My work is primarily concerned with institutional frameworks. The central theme of my practice has been an attempt to understand the social category of nature today, by imploring the institutions and individuals who claim to speak for nature. My work has never been "about nature," but rather has been concerned with ideas about nature. Any attempt to understand the shifting meaning and social status of nature necessitates a historical consideration of the subject in the realms of art, philosophy, natural science and

popular sentiment, which I guess makes me a dilettante. Institutions like museums and zoos are central to my investigation since they embody the "official story" of what gets to stand for nature at a particular time for a distinct group of people.

To be impossibly brief: the zoo, art museum, and natural history museum are of common descent. They are institutions which display treasure or trophies. There seems to be a tremendous shift between the Middle Ages and the Renaissance with regards to material riches. During the Middle Ages wealthy individuals established treasure troves, fortresses to protect and conceal possessions of value. The concept of display arises in the Renaissance with the cabinets of curiosity, where items amassed are also arranged and shown, made to do double duty: not only making one rich but advertising one's power, influence, and knowledge. This idiosyncratic model slowly gives way to groups of people: clubs or societies which begin to forge the enlightenment of museums, which then express the power and reach of nations rather than individuals. The presentation of captive animals is little different than the display of other riches or trophies. Keeping exotic animals functioned to define keeper, individual or nation, framing them as able to dominate, as having global reach and influence, and as possessing the ability to maintain a stable, harmonious environment. That was no small claim in war-ravaged Europe. Even today the status of zoos and museums is an important focus in war correspondence.

Plate VI
Sedge Warbler

There is another correlation between the art museum and the zoo: the things which are valued most are the rarest. There are very few Vermeers, and there are very few pandas. Both bring in the masses.

Zoos still, of course, function to express social power. Perhaps power is most masterfully exerted not through its ability to destroy or overtly dominate, but by its ability to protect, save or conserve. Nevertheless, zoos are particular places, they are front lines in the battle to distinguish ourselves from other animals, as well as to see ourselves in other animals.

SAM EASTERSON

Born in Hartford in 1972, Sam Easterson attended college at Cooper Union and received his Master's degree in landscape architecture at the University of Minnesota, Minneapolis. Perhaps his close study of the land made him curious about the views of those who know it most intimately, namely animals. The founder and director of *Animal, Vegetable, Video*, Easterson makes videos by affixing tiny custom-built cameras to animals and vegetables and recording what they see, a process that lends new meaning to the film term "POV" (point of view).

His first experiments with unusual vantages for video were not with animals, but with machines. For the 1996 Whitney Biennial, Easterson created *Blowout*, a video shot from inside a hot-air popcorn popper. Taking cues from the work of structural video artists of the 1960's, such as Stan Brakhage and Michael Snow, Easterson allowed the environment to determine the shot. The resulting camera footage – a whirling ballet of popcorn – became art.

It was Easterson's 1998 commission for the Walker Art Center in Minneapolis, *A Sheep in Wolf's Clothing*, that changed the direction of his work. The piece was simple: Easterson fitted a sheep with a helmet camera and set it loose to graze with its flock. The resulting footage, however, stunned Easterson; it not only captured the sheep's basic movements, but also the relationship between the camera-clad sheep and the rest of the flock. Apparently noticing the helmet-cam, the flock ostracized the altered sheep. Since this project, Easterson has continued to explore the perspective of animals, vegetables, and objects, but with less obtrusive cameras.

In his *Animal, Vegetable, Video* series, Easterson provides access to the perspective of animals. By attaching specially designed cameras based on the different needs of each creature, he captures video footage from their vantage points. Thus far he has collected footage from an armadillo, tarantula, wolf, alligator, chick, buffalo, cow, and even a tumbleweed (imagine a camera rolling over and over as a tumbleweed blows across a field). According to Easterson, "If people can see things from the animal and plant perspectives, they are less likely to harm them or their habitat."[1]

What the footage reveals is difficult to state with precision, but even a cursory look will provide intimate knowledge of an altered world: wolves tend to have their noses in the dirt, an armadillo's ears rotate and twitch when it encounters new plants, cows possess very large tongues and apparently delight in licking each other. Easterson has begun a long-term mission to collect these small insights in the hope of creating the largest collection of first-animal video footage.

(Footnotes)

1 Sam Easterson quoted in Marsha Wilson, "Animal cams offer strange world views", CNN.com, July 16, 2003.

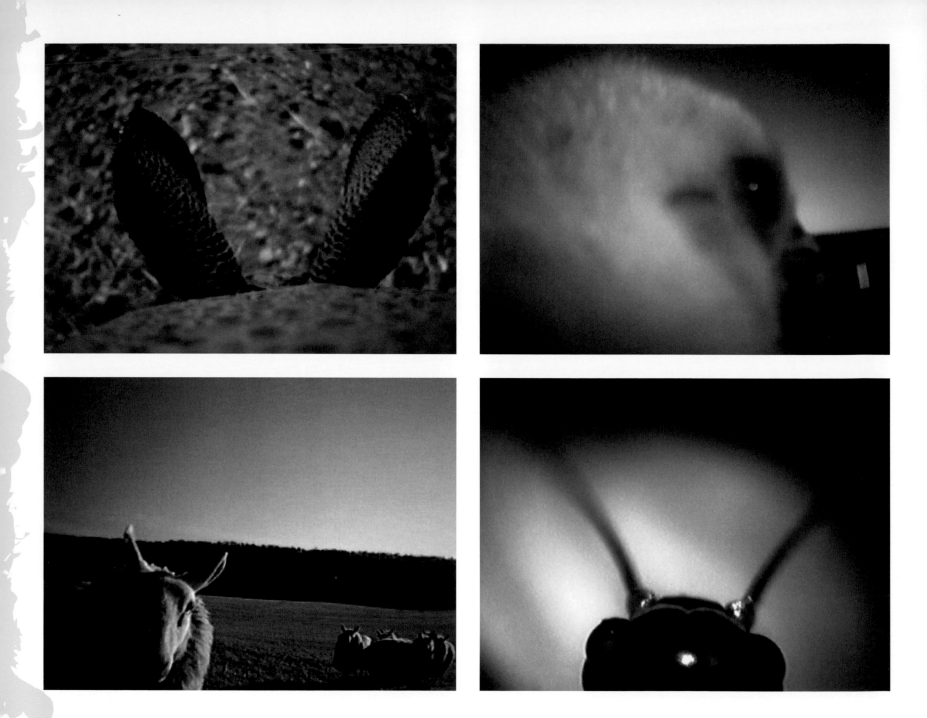

Sam Easterson, video stills, *Animal, Vegetable, Video*, 2001.

Becoming Animal

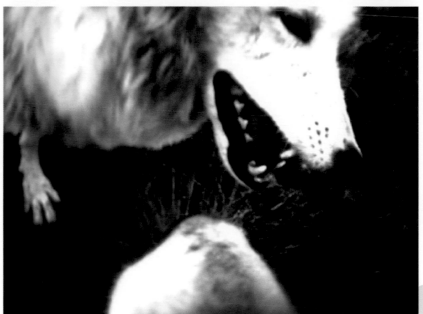

Sam Easterson, video stills, *Animal, Vegetable, Video*, 2001.

Nato Thompson: Do you feel yourself as a translator of animal language/behavior, an experimental filmmaker or simply a documentarian?

Sam Easterson: In general, I try to avoid working within one career title or another. Nothing has ever seemed to fit anyway. I often just say that I outfit animals and plants with helmet-mounted video cameras.

Nato Thompson: That is straightforward enough. Your response reflects what I find pleasurable about the videos. They are no-nonsense perspectives. What have you learned from the different animals you have worked with?

Sam Easterson: I believe that I have documented a lot of idiosyncratic behavior.

Nato Thompson: Any insights, for example, on the armadillo or wolf?

Sam Easterson: I learned that armadillos sniff a lot when they run and that wolves stop panting when they want to listen more closely to things.

Plate VII – *Six Banded Armadillo*

Nato Thompson: I find it enjoyable that you have so fluidly moved from popcorn popper, to sheep, to tumbleweed. You seem to imply a similar sentience to each object. Is this part of what your series *Animal, Vegetable, Video* implies?

Sam Easterson: I think it's especially funny to give sentience to objects and animals that are often overlooked. That's really what *Animal, Vegetable, Video* is about - giving a 'video voice' to those animals (and plants) that ordinarily might not have one. Hell, how many shark specials do we have to sit through on Animal Planet or the National Geographic Channel? Yes, I outfit sharks, alligators, wolves, etc. with helmet-mounted video cameras, but that footage is no more important to me than the slugs, mice, and crickets that I work with. I'm just trying to even things out a bit with *Animal, Vegetable, Video*.

Nato Thompson: What influences your decision on the animals you select?

Sam Easterson: I usually select animals based on the location and/or theme of the venue. When I first show a video, it is typically made in the region around where it is premiering. If I work on a traveling exhibit, I select animals based on the topic or theme of the show."

Nato Thompson: What can we expect in the future from Sam Easterson?

Sam Easterson: I recently opened up a small landscape design firm in Los Angeles called (SEED), Sam Easterson Environmental Design. (SEED) uses native and California-friendly plants to create drought-tolerant and eco-friendly residential and commercial landscape designs. In the coming years, I will be working hard on (SEED) projects.

Nato Thompson: What does "Becoming animal" mean to you?

Sam Easterson: Animals often let me see how funny they are. That means the most to me, that they would trust me with their material.

Plate VIII — *Snale*

KATHY HIGH

Kathy High works predominantly in video and film but also as a teacher, editor, curator, and installation artist. She produces films and video around issues of gender, animals, and technology and the effects that bioscience industries have on human-animal relationships. She serves as Chair of the arts program at Rensselaer Polytechnic Institute.

In 2000, High produced a series of short video vignettes under the title of *Everyday Problems of Living (a series)*. The videos, shot like home movies, combine the everyday biologic life of High's cats and dogs — peeing, eating, exercising or spitting up — with High's own personal anxieties. High overdubbed several videos with recordings of phone calls she made to tarot readers and animal psychics. In each call, High expresses a concern regarding health and death, whether for the cat, dog or sometimes herself. The camera, however, always stays focused on her pets.

In Doubting (2000), High talks with a tarot reader who draws the card "sorrow." While the camera focuses on a black cat chewing on a blanket, we hear High say, "I have been scared lately. I feel like I might die." Personal anxiety is compounded in the videos *Doused* (2000) — which shows High's dead body in a stairwell — and *Dried* (2000) — which shows High's dead body at the wheel of her car in a car wash with her dog barking in the passenger seat. The anxious symbiosis of High and her pets finds resonance in her later work as well.

High's film *Animal Attraction* (2001), for example, takes the theme further by investigating the curious life of an animal psychic in upstate New York. Frustrated with her own rowdy cat, Ernie, and bemused by the idea of an animal telepath, High phones a psychic. The conversation piques High's interest, and she drives to an upstate New York farm where animals such as donkeys, geese, horses, goats, chickens, dogs and cats are not only fed but communicated with.

Her forays into the psychic lives of animals take a more somber tone in her installation for *Becoming Animal, Embracing Animal*. Originally exhibited at Judi Rothenberg Gallery in Boston, Massachusetts (in collaboration with Video Space), *Embracing Animal* is set in a darkened ersatz laboratory with lab coats and animal cages illuminated by LED lights. Along the walls of the gallery are casts of rats' heads that honor what High describes as the 'dispensed ones'. In the center of the room are four three-foot test tubes with small LCD monitors playing at the bottom. By staring down into the tubes, the viewer is able to see a montage of High's video loops. The videos depict various states of becoming animal including Lon Chaney Jr. transforming into a werewolf, from the 1941 film *The Wolf Man*, and High adorned in a terrifying pig mask crawling naked, doing jumping jacks and suggesting cavorting with a dog. These strange glimpses at animal/human hybridity provide a surreal context to interpret the lives of the two lab rats that scurry in the adjoining cages.

The two rats, Echo and Flowers, were purchased online by High. They were purchased with preexisting conditions suitable for biologic experiments. By micro-injecting human DNA into lab rats like Echo and Flowers, scientists greatly reduce their autoimmune systems. The alteration occurs in the pronucleus of the rat embryo, a genetic shift which the rats pass on to their young, producing generations of experimental-ready rats. This state of genetic vulnerability appeals to scientists because it allows the rats to more easily carry disease, and thus be more useful as agents for finding cures.

Kathy High suffers from a chronic disease herself, and the cures for the diseases like High's are tested on rats like Echo and Flowers. The rats operate as living machines churning out antidotes and, indirectly, cures. It is this cross-biologic relationship that provides the impetus for *Embracing Animal* — the rats literally become human and Kathy High (and many others like her) becomes a rat.

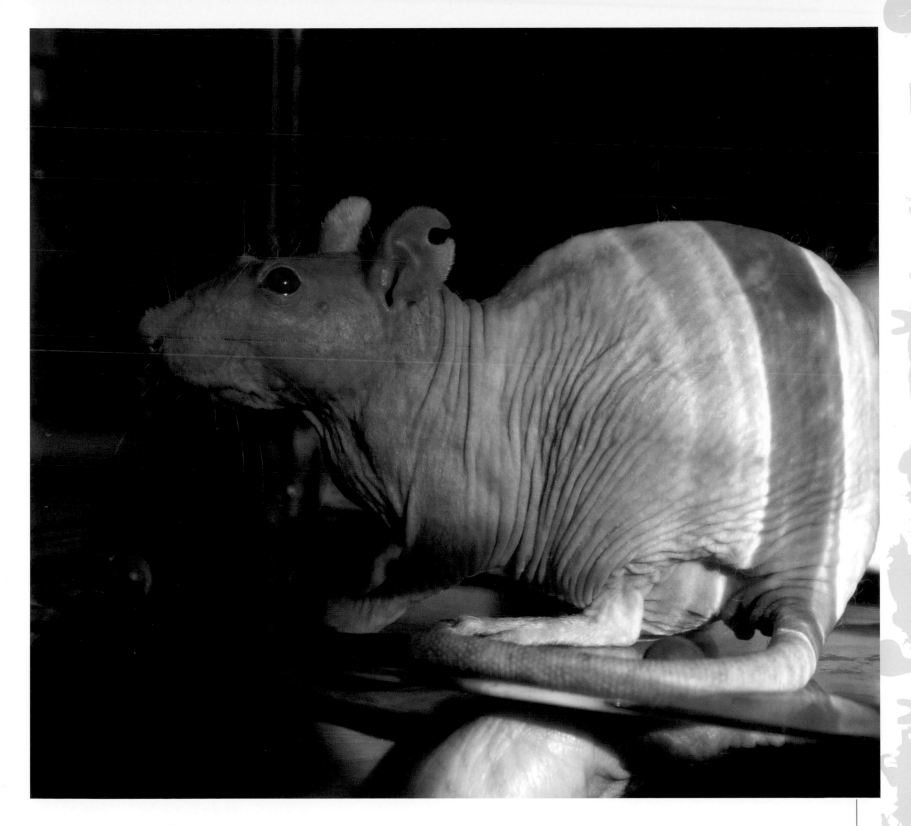

Kathy High, *Embracing Animal*, 2004.

Becoming Animal

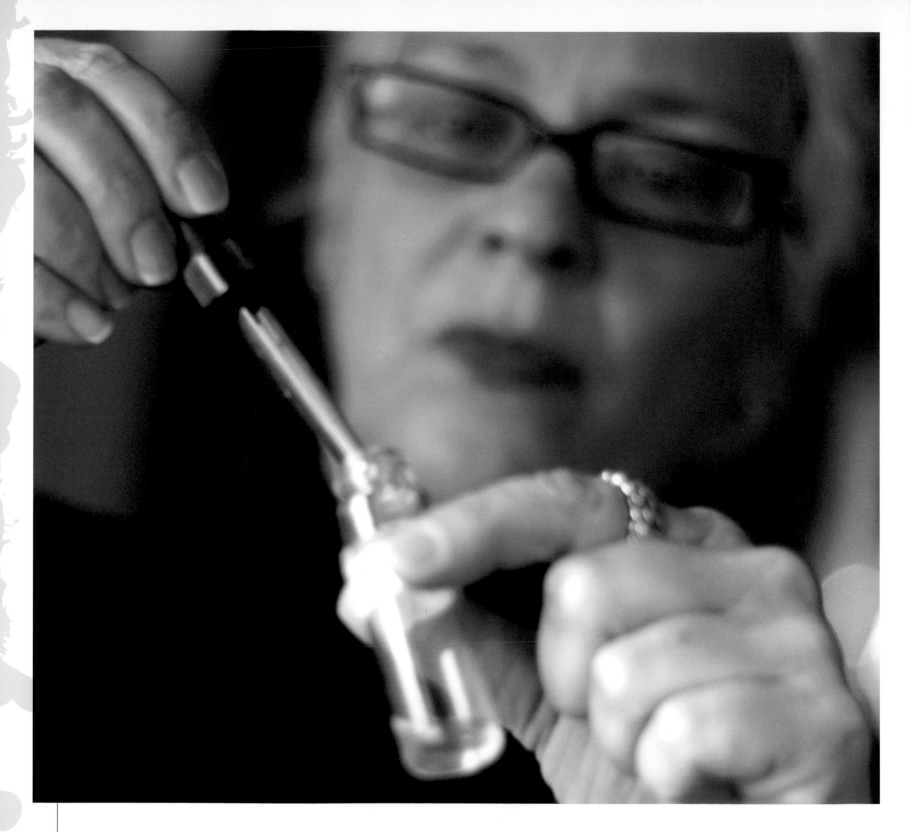

Kathy High, *Embracing Animal*, 2004.

Becoming Animal

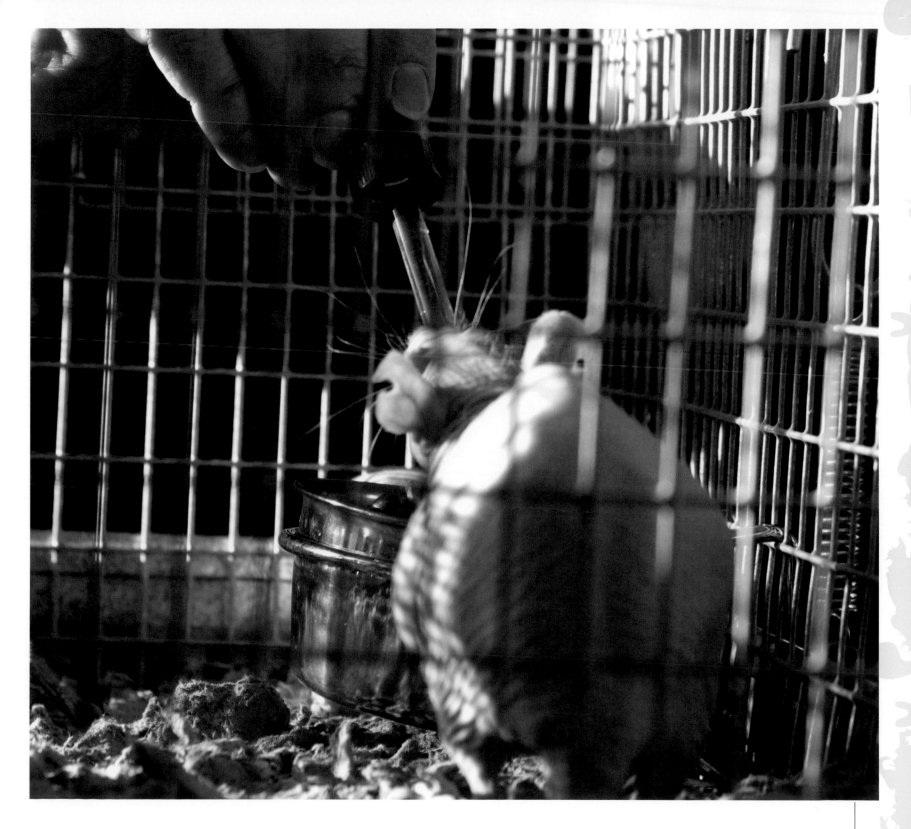

Kathy High, *Embracing Animal*, 2004.

Becoming Animal

Kathy High, video still, *Embracing Animal*, 2004.

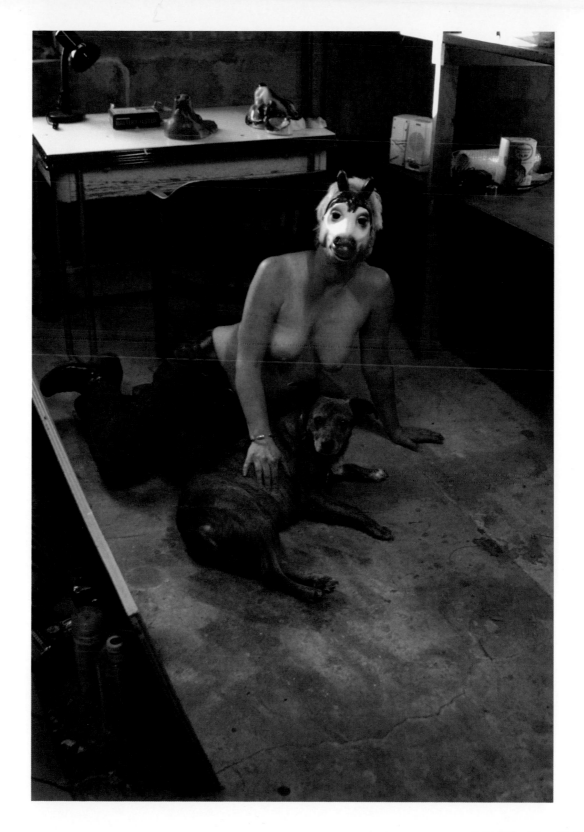

Kathy High, video still, *Embracing Animal*, 2004.

Nato Thompson: In your video Animal Attraction and Everyday Problem of Living, you often interact with a psychic, whether for yourself or your pets. What role do psychics play in your work?

Kathy High: I am always curious about events in the future, or knowing about the unknown. Who isn't? I use psychics, mediums, telepaths, and spiritualists because I want to believe in something "beyond" - another dimension, a parallel universe, with parallel beings. Perhaps we have a "psychic diaphragm" that keeps us separated by just a membrane.

I am also interested in the cultural implications of psychics and the sociological phenomena of New Age practices. Like an anthropologist, I study this paranormal area because I see the huge influence it has on our fractured and sometimes rootless culture in the States. It fulfills a need for many in our culture (women in particular) and creates a unique kind of bonding between people. Are these practices tapping into some ancient practice or just (like all religions) a projection of our desire for belonging? Are practitioners taking advantage of our identity crisis, or are they restoring a lost art?

Day-to-day I'm a very pragmatic, rational person, but even as a child I was fascinated by occult texts, and I practiced hypnosis, astral projection and telepathy. I don't know why I did that. Maybe it was from the influence of TV shows like Bewitched or The Prisoner and movies like Wizard of Oz. These programs were psychedelic, dreamlike programs of people who were constantly trying to escape, or adapt to strange surroundings they found themselves in. I could relate to these programs; this is how I felt about my own suburban surroundings. As a kid I felt there *had* to be something else. I always liked things behind things – what hides behind the obvious, the otherworld, etheric doubles, and cosmic currents.

Nato Thompson: You appear to have a close relationship with your pets in Animal Attraction as well as *Embracing Animal*. What role do you see your pets playing in your life and work?

Kathy High: My pets are endlessly fascinating: they pull pranks all the time and are really tricksters. And at times they offer comfort, unadulterated comfort – uncomplicated, unconditional "love". Animals can exhibit a kind of personal magnetism that is quite compelling. And they can also be weird, bratty and exhibit behaviors that are unfamiliar to us (as non-humans, the "other"). Perhaps they represent part of the parallel world to ours – one I can witness daily.

Also there are times when we have all had the funny feeling that our pet is all too familiar and is perhaps the reincarnation of someone else – perhaps it's a revisitation, a second round ("Oh no, our dog is really Uncle Fred!"). Some gesture or habit of theirs is just too coincidental, too similar to someone who was here before. If that should occur, then the pets must have a memory of their previous life – or at least we do. (Or are we just projecting our own desires for "the habitual" onto our pets??) This "familiarity" builds bounds and feelings because we have seen or experienced this event previously, breeding responsiveness and a close connection with our pets.

I now live with a lot of animals (and only one other person). We constitute a kind of family (dysfunctional sometimes as we growl at each other). We form a pack, a herd, a gaggle, and as such we act out together, play together and share a lair, food, sleep. We try not to fight too much, occasionally we defend each other, we all have favorites and allies. We are all animals in concert.

Nato Thompson: I would like to get your opinion of a quotation by Steve Baker from his book *The Postmodern Animal*. Can you comment on the following:

"What does it mean, exactly, to say that postmodern artists and philosophers fear pets? It is not that they fear the creatures themselves (though they may feel contempt for them). It is closer to what has been called 'anthropomorphobia'— a fear that they 'may be accused of uncritical sentimentality' in their depiction or discussion of animals. They seem almost unanimous in regarding sentimentality as a bad thing."

Kathy High: People are crazy about animals. And there is a lot of fear (by artists/intellectuals) of being sentimental around animals. People project all kinds of desires onto their animals – to make pets into "little humans". I, too, suffer from this fear and am sometimes suspicious of my own work with my pets. I try not to think of my pets as "human" but rather as non-human. They represent extensions of ourselves, symbolic and archetypal.

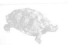

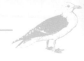

There is a constant struggle for me between earnestness and irony when talking about pets. It is easy to describe them sincerely, but one doesn't want to appear too "sappy" (picture wide-eyed kitties painted on velvet). Pets are, at the same time, paradoxical and difficult to unravel (picture twitching paws and gnarled teeth, tongues lashing). I think there is pressure on contemporary artists to be ironic and critical. Somehow, today, sincerity – to me – takes a certain amount of bravery.

Pets exemplify the way we as a culture work with "nature" – we domesticate nature. Understanding this relationship is critical to understanding ourselves and our place in the world: we trim our lawns, landscape our parks, eliminate prey for local deer so they become like big dogs grazing in our yards, squirrels climb in our offices for their lunch, etc.

Nato Thompson: In *Embracing Animal*, you take care of the transgenic rats, Echo and Flowers, through homeopathic medicines that you take yourself. Does this reflect your thoughts on the pharmaceutical industry and science world in general?

Kathy High: I have worked outside the aleopathic medical system for a number of years. I have studied and been treated with alternative medicines for about the past 17 years. My primary doctors are an acupuncturist and a homeopath.

I have also studied the history of medicine in relationship to women's health. Previous video projects of mine look at physicians' practices towards women, historically, pointing out the inherent biases in the medical industry, the pharmaceutical industry, in the legislation of woman's bodies, and how that history influences decisions still made. In these works, I dealt with the implications of new medical and science technologies in relation to the body, from the rest cure practiced in the late 19th century to present-day assisted reproductive technologies and genetic engineering.

In *Embracing Animal* I "read" my rats as subjects of the medical profession. My rats are retired breeders (like me), and exist in a long line of subjects for the pharmaceutical industry. I understand the need to conduct medical experiments on animals. I am not an "animal rights" advocate. But I value the input of the rats in this research process. And I would like to see them counted and acknowledged in the research they participate in. *The Guide for the Care and Use of Laboratory Animals* states that laboratory rats (genus Rattus) and mice (genus Mus) are not covered by the national regulatory governances and the Animal Welfare Act amended in 1985, and are not reviewed under the Regulatory Enforcement and Animal Care Inspection. In other words, lab rats and mice are not protected in the same ways that other animals such as cats, dogs, and monkeys are. There are probably over 20 million rats and mice in use for research in this country, making up more than 90 percent of the animals used in research, but they are undocumented – no one knows their exact numbers. This defies a kind of contract we have with animals who participate in our lives. Temple Grandin, the autistic woman who designs cattle chutes for slaughterhouses, speaks of this "ancient contract" we have with animals to give them decent living conditions when they "serve" us. I believe we must ritualize transgenic rats' participation in our experiments to honor their contributions. They are hybrid, part human and rat, living experiments towards our better health. They have been created in our own image. Pay homage to Transgenic Rats, the Animal Bioreactors!

Nato Thompson: What does "becoming animal" mean to you?

Kathy High: "What good does it do to perceive as fast as a quick-flying bird if speed and movement continue to escape somewhere else?"
- A Thousand Plateaus

"Becoming animal" to me is about a deep, intuitive understanding of human and non-human, and is also about transitions and transformations. "Becoming animal" is about acting out, acting dominant, acting basic, marking territory, acting pack-like. "Becoming animal" is also about becoming changlings, monsters, or engaging in bestiality - "trans-play". It is behavior that falls outside our (conventional) boundaries, and is an exchange of energies, untamed and monstrous.

As part of my installation, there is a cage housing the two transgenic lab rats. The lab rats are manufactured to emulate human diseases. They are another metaphor of "animal-to-human"/ becoming animal --- they literally reflect the autoimmune diseases that I have. As Donna Haraway describes the Onco-MouseTM as her sibling, these rats are my sisters, my twins.

NATALIE JEREMIJENKO

Born in Mackay, Australia, in 1966, Natalie Jeremijenko moved to the United States to receive her Ph.D. in mechanical engineering from Stanford University. She has since held teaching positions in mechanical engineering at Yale University and New York University's Center of Advanced Technology and is currently a professor of art at the University of California at San Diego. Jeremijenko produces numerous technological projects with varying groups and identities, including her fictional collective The Bureau of Inverse Technology (BIT).

Jeremijenko works prolifically on subjects ranging from botany to genetic engineering, using vehicles as diverse as street protests and the internet. She has focused considerable attention on animals. In her Feral Robotic Dogs project of 2003, Jeremijenko, together with students at Yale, Pratt, and Bronx River Art Center, re-engineered a child's dog toy for radical purposes. Using the toy dog for its robust engineering possibilities, Jeremijenko created an amusing tool for finding environmental contaminants. Released in a pack, the Feral Robotic Dogs use sophisticated programming to sniff out contaminants and then gravitate toward the dog sniffing the most. According to Jeremijenko, the dogs are released into public sites in order to "arouse public interest in the local environment," and to "demonstrate the viability of 'feral' data collection and empirical strategies for activist and cultural work." Feral dog release sites include the Snake River in Idaho, Baldwin Park in Orlando, Florida, and the Bronx River in New York. She also offers a "hobbyist kit" on her website that provides the public with the appropriate gear to retool their own toy dogs.[1]

In 2000, Jeremijenko initiated a series of projects under the umbrella term Ooz ("zoo" spelled backwards). The Ooz projects find novel methods for animal/human interaction through simple engineering. Animals enter the Ooz environment by choice and participate in a give-and-take relationship with the viewer. With her team of assistants, Jeremijenko has produced a robotic goose that humans can pilot to interact with living geese. The robot goose swims on a pond, approaches a flock and then uses a series of rudimentary forms of goose language (ruffling feathers or stretching its neck) to communicate. Other Ooz projects include a robotic water strider, an interactive horse-feeder, a bat-feeding bar and, as part of the *Becoming Animal* exhibition, an interactive bird project titled *For the Birds* (2005).

Commissioned by ZKM, the Center for Art and Media in Karlsruhe, Germany, *For the Birds* consists of a series of "smart" bird perches. The perches, designed with Phil Taylor of Advanced Architecture, are equipped with sensors which, when landed on, trigger lights, emit sound, dispense food, or squirt water. The emitted sounds were developed in collaboration with SOHO Rep artistic director Daniel Auchin. These bird technologies address the visitors near the perches and translate bird desires into human actions.

As an untested experiment, *For the Birds* poses the following questions: How long will the birds take to learn that they can control human behavior with these perches? How often will humans respond to a request for food? Which musical phrases will they preferably trigger?

Visitors will notice that the birds' actions trigger verbal requests such as "Sprinkling some of those seeds just around here would be appreciated. You might consider that the way you live changes the options on my menu. But I work in concert with plants to cross-pollinate, replant, fertilize, replenish — what do you do?" The birds provide multiple arguments in favor of feeding animals, despite the popular request to the contrary. The work is a valuable demonstration of peaceful interdependence. The bird may preempt a visitor's incorrect reasoning and educate her by triggering another audio response: "If you presume that providing feed for birds attracts mice, you are wrong. The competitive pressure between birds and mice is the most effective mouse control option known. Not supplementing my food actually encourages mice and, hey, given that you are changing the climate ..." Although visitors might marvel at the novelty of birds communicating with humans in their environment, current corollaries already exist: birds nesting in bridges and windowsills, navigating freeways to find their way home, and using light poles to attract tourists' attention.

Like all of Jeremijenko's projects, *For the Birds* is open-ended in terms of its results: It is a public experiment. It remains to be seen whether the birds will playfully communicate with the audience or simply find one or two perches to continuously land on for food. What is certain, however, is that Jeremijenko produces new forms of human/animal interaction that lend themselves to a greater and more pragmatic sense of becoming animal.

(Footnotes)

1 Natalie Jeremijenko's projects can be viewed at http://xdesign.ucsd.edu/

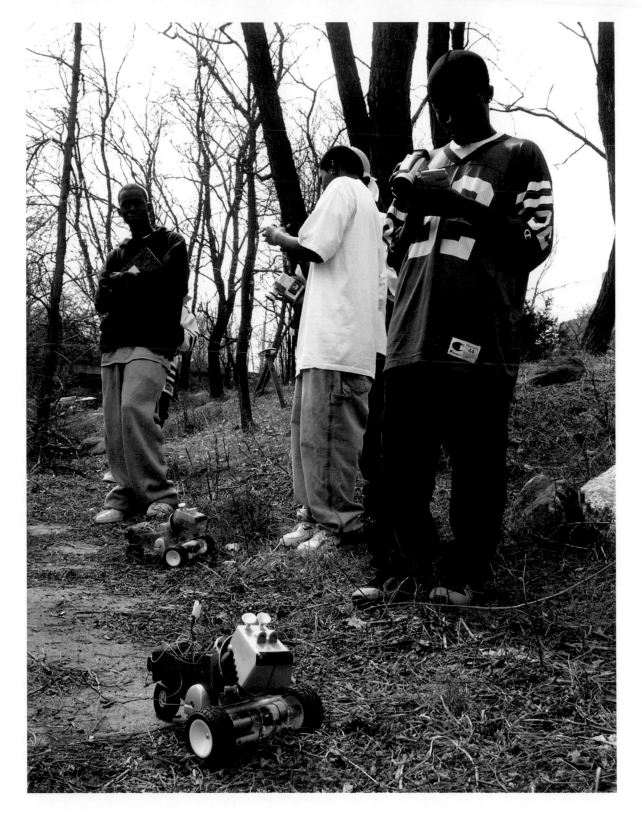

Natalie Jeremijenko, Bureau of Inverse Technology, *Feral Robotic Dogs*,

Bronx River Center release, 2002.

Becoming Animal

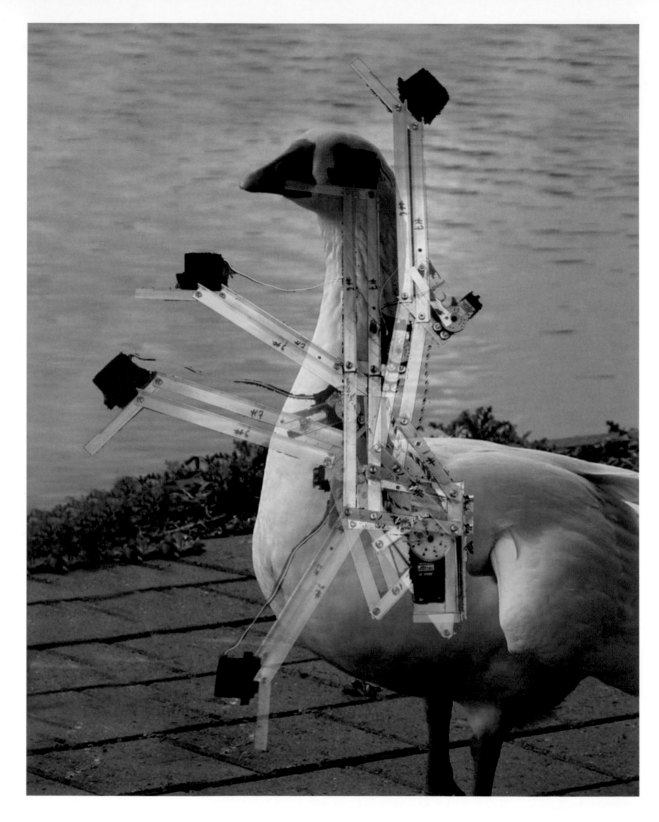

Natalie Jeremijenko, *Zeewolde Ooz*, 2003.

Becoming Animal

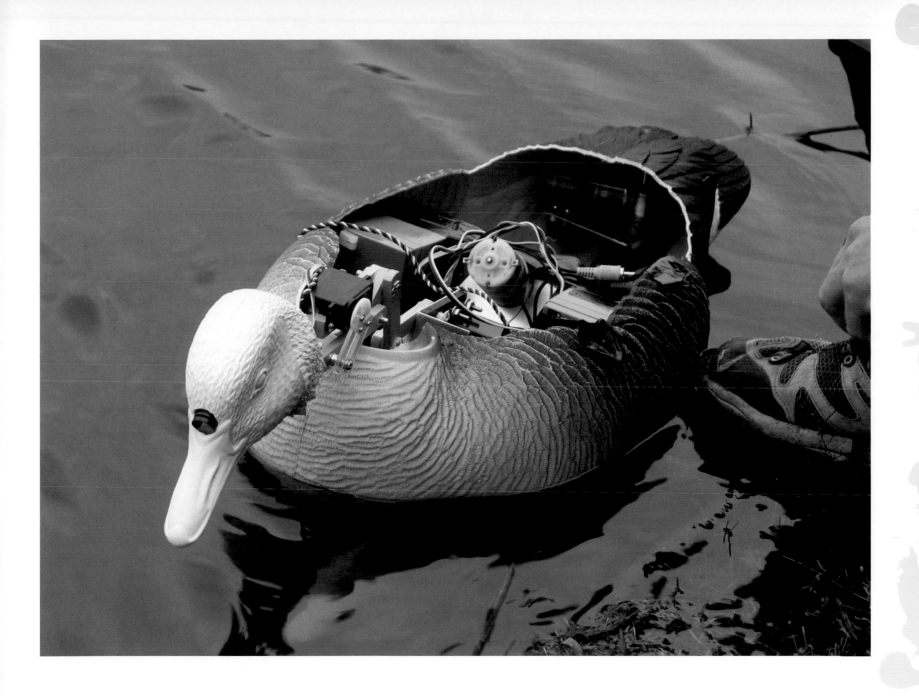

Natalie Jeremijenko, *Zeewolde Ooz*, 2003.

Becoming Animal

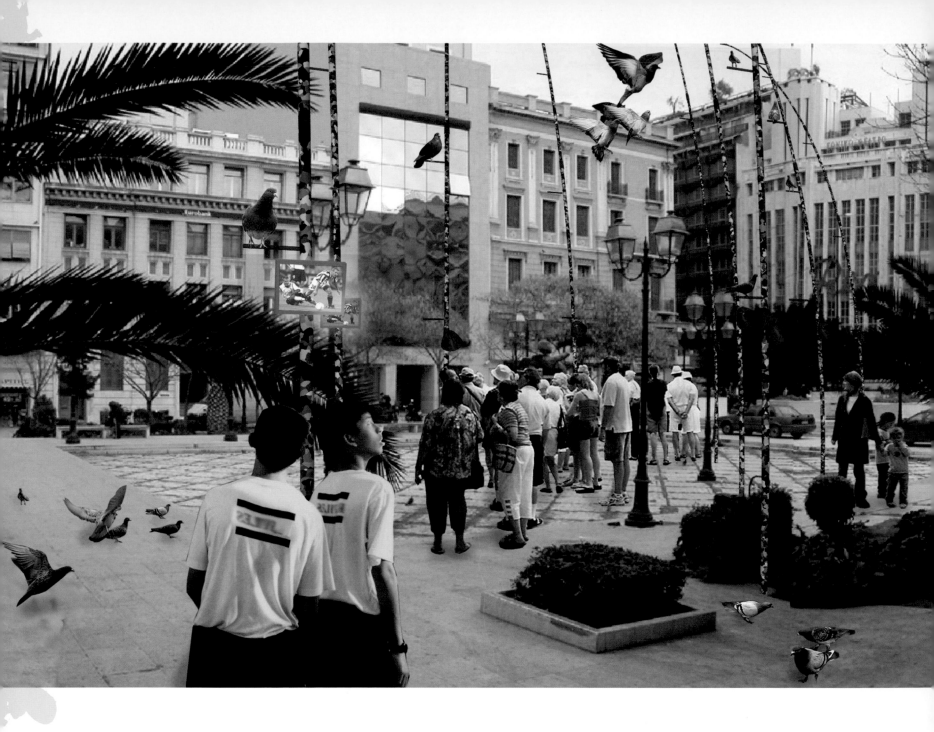

Becoming Animal

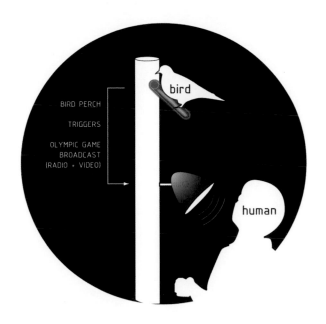

Natalie Jeremijenko, diagram, *For the Birds*, 2004.

Natalie Jeremijenko, *For the Birds*, proposal for the 2004 Olympics, 2004.

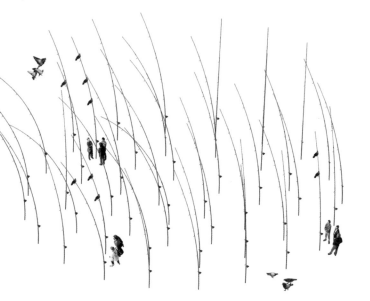

Natalie Jeremijenko, diagram, *For the Birds*, 2004.

NICOLAS LAMPERT

Nicolas Lampert is an artist, writer, musician, and activist. As a graduate student at the California College of Arts and Crafts (now CCA) in Oakland, Lampert produced a small magazine titled *Animal Trap* filled with drawings inspired by Jean Dubuffet and stories that ranged from train-hopping across America to forest-defense actions to anti-globalization protests in Seattle and Quebec City. His post-punk anarchist leanings inform his evocative drawings and collages, which he often affixes to lampposts, walls, and newspaper boxes.

Lampert began his Machine Animal collages, which merge machines and animals in disturbing ways, in 1995 as a reaction to incursions of machines into nature. In *Locust Tank* (1995), a World War I tank fuses with a locust, the bearer of plagues; the result is a black and white image of an entity with an insatiable appetite and bellicose attitude. A less seamless juxtaposition appears in *Kangaroo* (1995), in which skeletal fragments of an anatomical drawing fuse disproportionately with the oversized head of a kangaroo, and speaks to an increasingly cyborg culture.

After moving to Milwaukee in 1999, Lampert initiated the Meatscapes series: glossy color images from cookbooks, encyclopedias, and old magazines layered into threatening towers of meat. Recalling Martha Rosler's collage series Bringing the War Home: *House Beautiful* (1967-72), these works juxtapose iconic images of everyday America with its underlying cruelties. One telling example is *Where's the Chickens* (2001), in which a lone cowboy smokes a cigarette in a field of grain while a mountain of chicken, mashed potatoes, and gravy looms ominously in the distance.

Although visual art is his primary medium, Lampert explores similar themes in sound recordings. *Beneath the Lake*, an ambient noise project, juxtaposes natural/animal sounds with grinding industrialism. Many of Lampert's compositions are influenced by his time spent in rural Wisconsin and traveling up Alaska's "Inside Passage" waterway. *Beneath the Lake*'s somber melodies lend themselves to visions of barren landscape in which the natural world dwarfs that of the human.

Lampert served as a co-editor and writer for *Peace Signs: the Anti-War Movement Illustrated*, a collection of international posters and graphics against the war in Iraq. He is currently working on a survey of American political art with John Couture titled "A People's Art History of the United States." His work can be viewed at www.machineanimalcollages.com

Nicolas Lampert, *Kangaroo*, 1995.

Becoming Animal

Nicolas Lampert, *Locust Tank*, 1995.

Becoming Animal

Nicolas Lampert, *Armored Warthog*, 2000.

Nicolas Lampert, *Meatscape*, 2000.

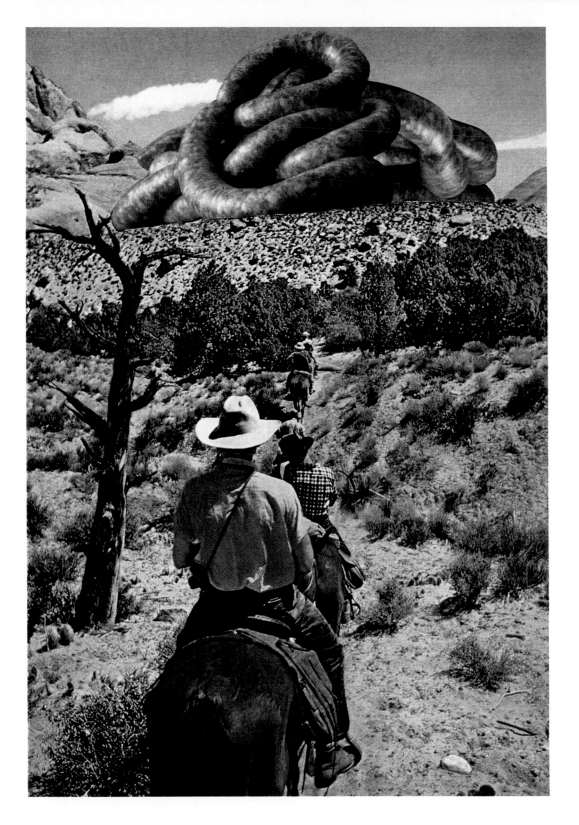

Nicolas Lampert, *The Ride to Sausage Mountain*, 2000

Becoming Animal

Nato Thompson: As an artist who participates politically in multiple agencies (author, street activist, propaganda producer), how do you see the question of animals fitting in?

Nicolas Lampert: Animals are part of every dialogue no matter what medium one works in. Everything is interconnected, a notion that is apparent in the natural world but is largely ignored in an industrialized mindset. It is startling how the subject of animals has largely been ignored, although their presence surrounds us whether wild, domesticated, utilized for labor, clothing or food. We cannot survive without animals. Addressing issues of animals and the natural world is paramount not just for artists, but for everyone.

In all too many cases, the concern for animals is left to scientists, environmentalists, and farmers, which further compartmentalizes the issue, leaving the responsibility up to the "specialists." Yet there are no true specialists on this issue, and no dialogue on animals can be complete without also looking at the larger systemic issues of hierarchical structures, consumerism and corporate control that reign over the issue. For an artist, the issue of animals is all-encompassing and, perhaps through visual work, an artist can encourage more discussion on the subject. 'Animals" is also a very broad term that applies to us. Humans are animals, albeit one that can be extraordinary selfish and shortsighted.

Plate VIIII — *Chicken*

Nato Thompson: As the name implies, in your Machine Animal collages you combine a piece of machinery with an animal or insect. This hybridization can lead to an unsteady feeling as these worlds that are supposedly distinct suddenly collide. How do you feel about this synthesis?

Nicolas Lampert: Uneasy. The collages are a warning sign and meant to provoke critical thought. The juxtaposition of the two supposed separate entities allows the viewers to come to their own conclusions on both animals and machines, alone and when they merge. Loosely, the collages speak of a world engulfed in its own technology. An uncertain future where genetic engineering, robotics and science have run amok. The collages speak of extinction, metamorphosis and the definition of progress. Should progress be measured by profits and asserting dominance over nature, or could progress be measured by living in relative balance with the environment and creating minimal disruption to the cycles of the natural world? In some cases, certain machine-animal collages are terrifying and appear as a blueprint for a future militaristic design. *Locust Tank* is a harrowing image that speaks not only of a technology devoid of a human element (a soldier) but of a mindset to conquer. At the same time, I have noticed children react to *Locust Tank* with wonder and astonishment, similar to viewing images of dinosaurs. What does one make of this? Is the interest in the tank, the insect, or both?

Nato Thompson: At times your work almost has a nihilistic feeling to it, as though there is simply no controlling the forces of technology and capital that are acting upon culture (particularly that of the U.S.). As you indicated, *Locust Tank* lends a sense of a swarming fatalism.

Nicolas Lampert: Looking at world politics and the state of the environment, it would be difficult not to be alarmed. To ignore these problems or to accept them as beyond our capacity to fix would be irresponsible. I think we can control the forces of technology and capital, but the time to act is now. *Locust Tank* is metaphoric of industrialism and capital rolling over the planet, but it does not mean that it can't be derailed. We are seeing a large-scale rebellion in the southern hemisphere against the ideas of the World Bank, the IMF, and the WTO. History has taught us that people's movements are both unexpected and very successful. The grass-roots idea of protecting and sustaining local economies is growing. In the U.S., eco-building and community-supported agriculture are slowly gaining momentum. In any case, a viable alternative needs to be presented to people before they will consider a change. Indigenous communities throughout the world provide a working alternative to mass consumption and industrialization. There are many positive signs one can find, but they exist by-and-large outside the radar of the mass media.

Nato Thompson: It could be a fun exercise to compare your *Meatscapes* to the history of landscape painting but, at the same time, somewhat silly. What would you say are the influences on your work?

Nicolas Lampert: The comparison to the history of landscape painting is

an interesting point, and it is definitely an influence. Collage, however, has been a larger influence, and it has significant differences from painting. The medium has a long history of being not only a subversive tool but a humorous one as well. The Dada movement, which emerged in response to World War I, viewed landscape painting with disdain. They felt that this type of approach was adopting a passive stance, merely copying the world and not trying to change it. Metaphorically, the arranging and re-ordering of images suggest discontent and a need to become active. The *Meatscapes* are meant to be absurd, but there is a serious side to them as well. The collages, which act more as staged photographs, are meant to ask questions about the larger implications of being disconnected from our food source. The people in the images are purposely nonchalant about the massive piles of meat, which echo the general lack of understanding of the environmental impact of the large-scale industrial production of meat. I also like to think of these images as "monuments to meat," which brings up a host of questions of the role of a monument.

Nato Thompson: It's interesting that monuments can act as sculptural reminders, a physical antidote for cultural amnesia whether this implies the meat industry, a war memorial or a city mayor. A monument works in civic space and is designed to produce social norms as a form of public memory. How do you see your work, and what methods do you use in producing a public/social memory?

Plate X – *Cow*

Nicolas Lampert: Monuments remind us of past events. A facet of the machine-animal collage series is that they are difficult to date to a specific time period. At times, an image may seem contemporary or it could equally appear as a relic from the early 1900's, a Dada-like collage or a lost manual for an invention. The confusion in time periods allows us to look at history as events and ideas that often repeat themselves. The names and dates change, but the impulses that drive human behavior often remain fairly constant. With this in mind, I try to focus my art on the larger, more systemic issues. I rarely address current events or a politician because those types of individuals are often interchangeable. Monuments, as you mentioned, work in the public sphere, and I feel it is important for artists to consider their audience and who it is they are trying to reach. I try to devote equal time placing images and objects in the street as I do in the gallery. The work can take on a different meaning in the streets, but in any case it registers as a social message, reaches a broad audience and acts as a counterbalance to the barrage of advertisements.

Nato Thompson: What does "becoming animal" mean to you?

Nicolas Lampert: Since much of my work is about animals becoming machines, perhaps equal thought should be placed on the ramifications of that scenario. In modern life, we have distanced ourselves from animals and the environment to the point where they are an afterthought. "Becoming animal" is bridging this gap and placing these concerns at the forefront of our priorities.

LIZ LERMAN
DANCE EXCHANGE

Founded in 1976 by choreographer Liz Lerman, the Dance Exchange is a national leader in modern dance performance and a pioneer in the theory and practice of public art. The Dance Exchange has partnered with myriad institutions, including Boston's Museum of Science, the Isabella Stewart Gardner Museum, the Chicago Historical Society, and the Smithsonian's Hirshhorn Museum and Sculpture Garden.

The company has revolutionized ideas about who gets to dance through its cross-generational professional troupe and participatory projects. With a unique approach to combining information, emotion, narrative and imagery into a choreographic whole, Liz Lerman and her company have created over 70 works for stages throughout the world. These works have addressed such diverse subjects as the defense budget, nuclear waste, the 1904 St. Louis World's Fair, immigration, the Underground Railroad, and the nature of praise. For these and many other accomplishments, Liz Lerman was recognized in 2002 with a Macarthur "Genius Grant" Fellowship.

Reflecting on the potential of genomics to alter the human condition, Liz Lerman Dance Exchange is creating a major new dance/theater work, Ferocious Beauty: Genome, which will be developed in residency at MASS MoCA as part of its *Becoming Animal* program. Combining movement, music, spoken word, and projected text and imagery, the project will culminate in an evening-length stage performance. Lerman says of the work-in-progress, "Mapping the human genome...each word in that phrase carries so much weight. The idea of a map that tells us about our essential nature, that gives us, like all good maps, destinations, special relationships, topography, and, like all good maps, needs a legend in order to read it. Human, the way we orient ourselves in the cosmos, can be read in new terms given the information the genomic revolution has unleashed, including what makes us different from each other, as well as from animals and plants — in fact all living things. And the word "genome"... in need of many metaphors, a word that leaves the public cold and left out since no one knows what it means."

Companion programming to *Ferocious Beauty: Genome* will include movement workshops, town meetings, and panels, all enlivened by encounters between artists, humanities scholars, and scientists. Describing these encounters, Liz Lerman says "The scientists who have let me into their labs across the country have had a profound effect on how I am thinking about this piece. More and more I've come to see art-making as an act of translation. This can mean translating my own notions into an expressive form for the stage, or listening to a scientist's attempt to create a metaphor that someone less studied can understand."

Scientists engaged in the project have noted the power of art to convey ideas about science. Dr. Eric Jakobsson of the National Institutes of Health has said: "...Mammals learn by playing...Obviously there is a major element of play in the Dance Exchange approach to science. At first it was startling to me to see how well the dancers presented scientific ideas. But in the context of the behavioral and adaptive significance of play, the perspective changes, and it should not be surprising that dance might be a good way to present substantive scientific concepts."

Lerman continues: "Ultimately, the body is the landscape for the research, for the arguments, for the tests, for the experiments, for the focus of our best minds and best ethicists and best marketers, and best theologians: In the work we allow the artist to be mediator, synthesizer, referee, judge, and seer as we contemplate the long-term effects of genetic manipulation on humans within the larger animal world."

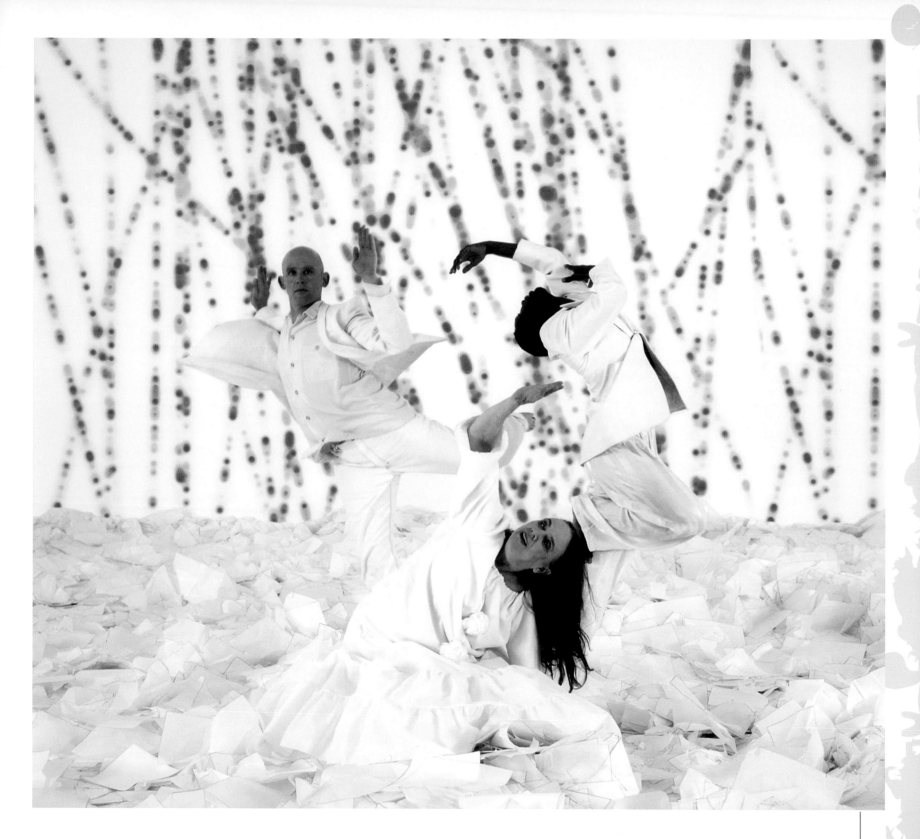

Liz Lerman Dance Exchange: *Ferocious Beauty: Genome*, 2006

Becoming Animal

MICHAEL OATMAN

Michael Oatman was born in Burlington, Vermont, in 1964. He began his work in collage while pursuing a BFA from Rhode Island School of Design in 1986 and later an MFA from the University at Albany in 1992. He teaches at the Rensselaer Polytechnic Institute in Troy, New York. Oatman's long history of experimentation with collage has resulted in a body of work he describes as "maximum collage," a term he uses to move his work from the two-dimensional format of magazine cut-outs to complex collage environments of antiques and readymades. With roots in the papier collés of Picasso and Braque, collage allows for jarring juxtapositions and nuanced historic meanings. Oatman attributes his affinity for collage to the pleasure of manipulating the material residue of history.

In his previous project at MASS MoCA, *Long Shadows: Henry Perkins and the Eugenics Survey of Vermont (Vermont Pure)* (1995) (2000), Oatman transformed a gallery into the fictitious home of the first director of the Fleming Museum. Using actual objects owned by Perkins, including his desk and lantern, Oatman created an elaborate "maximum collage" that allowed the viewer to enter the working space of one of Vermont's chief eugenicists. Oatman uses the terms "still-films" and "un-environments" to describe his meticulous practice of composing new environments from historic detritus.

Michael Oatman's studio is a treasure trove of *Popular Mechanics* magazines, old encyclopedias, mildewed children's books, piled-up newspapers, and bins of junk collected at tag sales. In works such as *Code of Arms* (2004), Oatman investigates the DNA strand of American culture through the medium of collage. In a double helix form that approximates the genetic code, *Code of Arms* is a bricolage of Boy Scout merit badges, Roman coins, flowers, compact discs, vegetables, clowns, and spiritual signifiers.

By juxtaposing together hundreds and, at times, thousands of cut pieces, Oatman produces entirely new worlds. In his collage *Study for the Birds* (2001), Oatman equips the winged with semi-automatic weapons, Gatling guns, machine guns, and bazookas. This work was followed by his more elaborate *The Birds* (2002), in which the range of birds and weapons increases and the main image has been joined by side panels with gun-toting bird vignettes. With a wink at Alfred Hitchcock's 1963 thriller of the same title, *The Birds* presents an alternative universe where the hunted become the hunters. Oatman has since produced numerous bird and gun collages, including *Study for the Birds III* (2003), *Familiar Songbirds II* (2003), and *Familiar Songbirds III* (2003). In each, Audubon-inspired environments become home to a bellicose atmosphere of gun-toting gulls, eagles and finches.

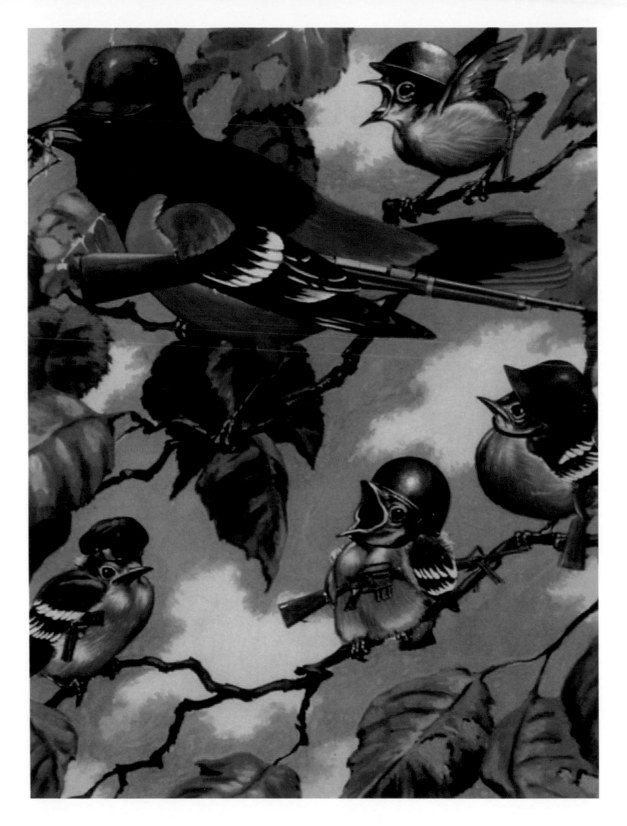

Michael Oatman, *Familiar Songbirds II*, 2003.

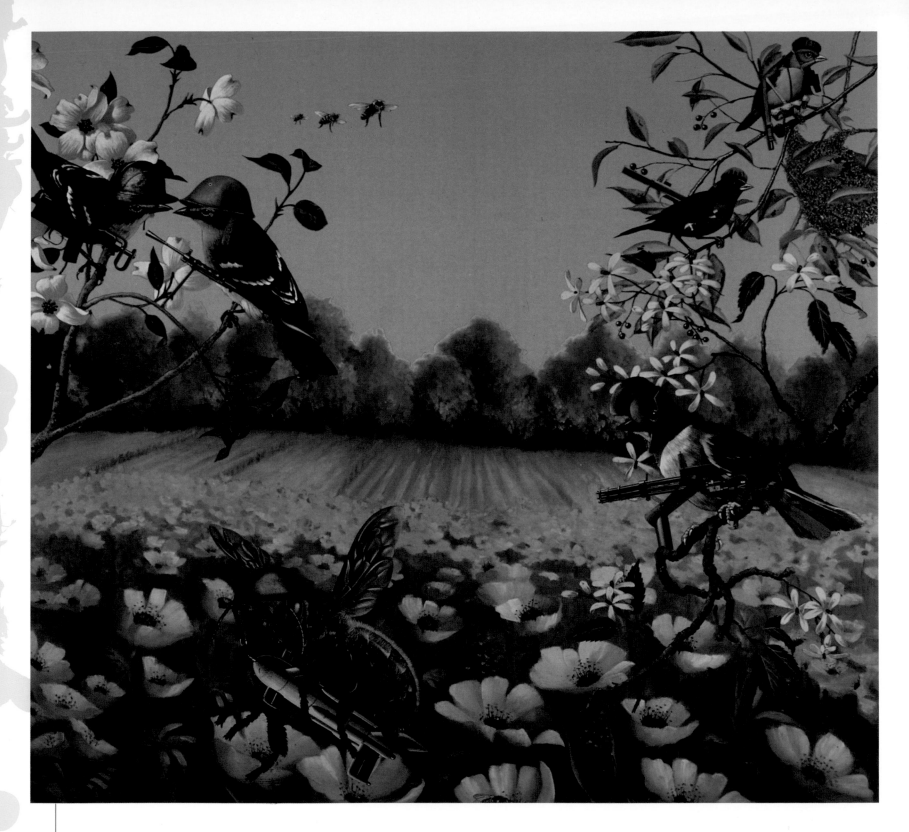

Michael Oatman, *Reënactment*, 2004.

Photo: Leif Zuhrmulen

Becoming Animal

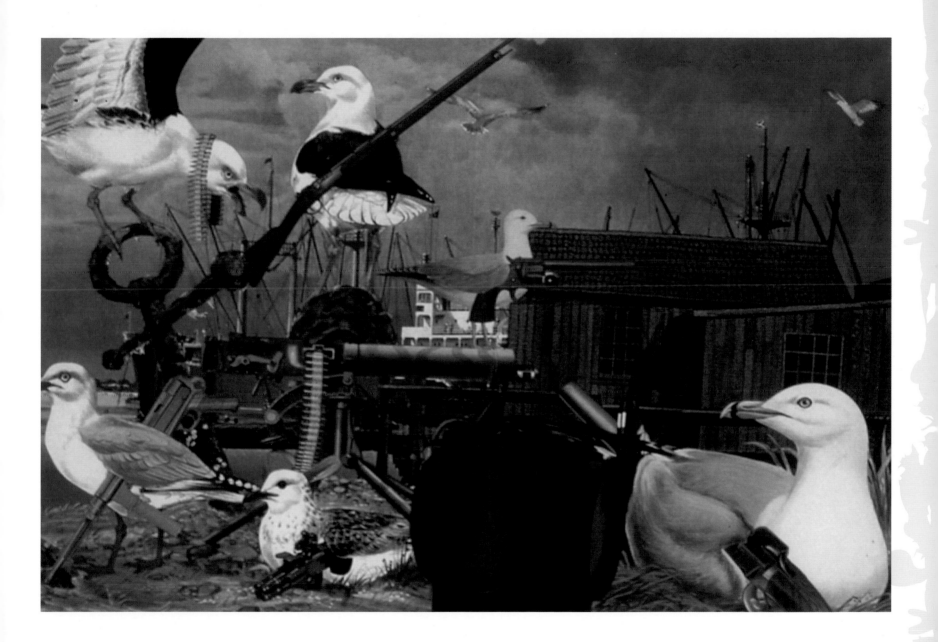

Michael Oatman, *Study for The Birds III*, 2003.

Becoming Animal

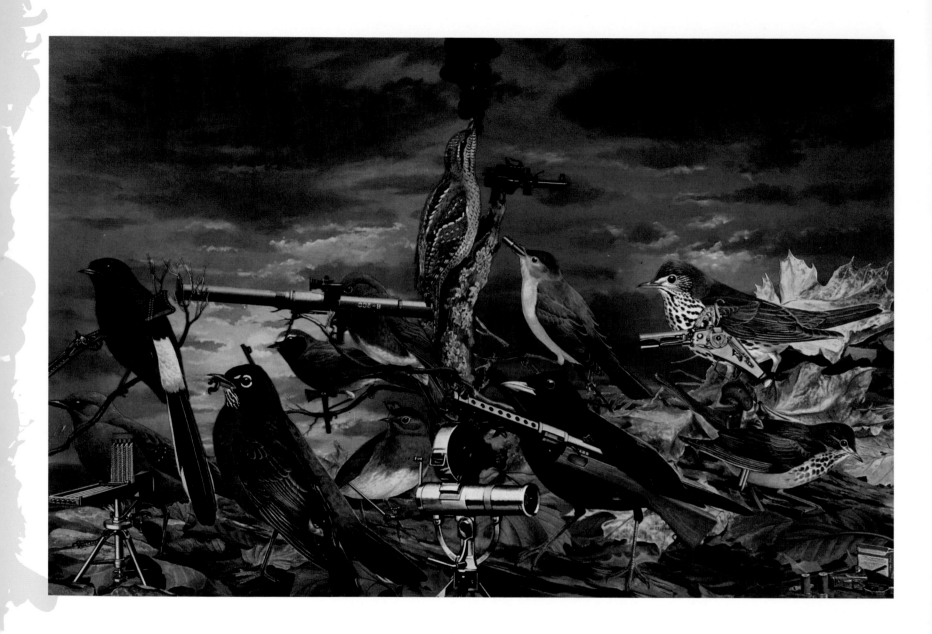

Michael Oatman, *Study for The Birds*, 2001.

Photo: Leif Zuhrmulen

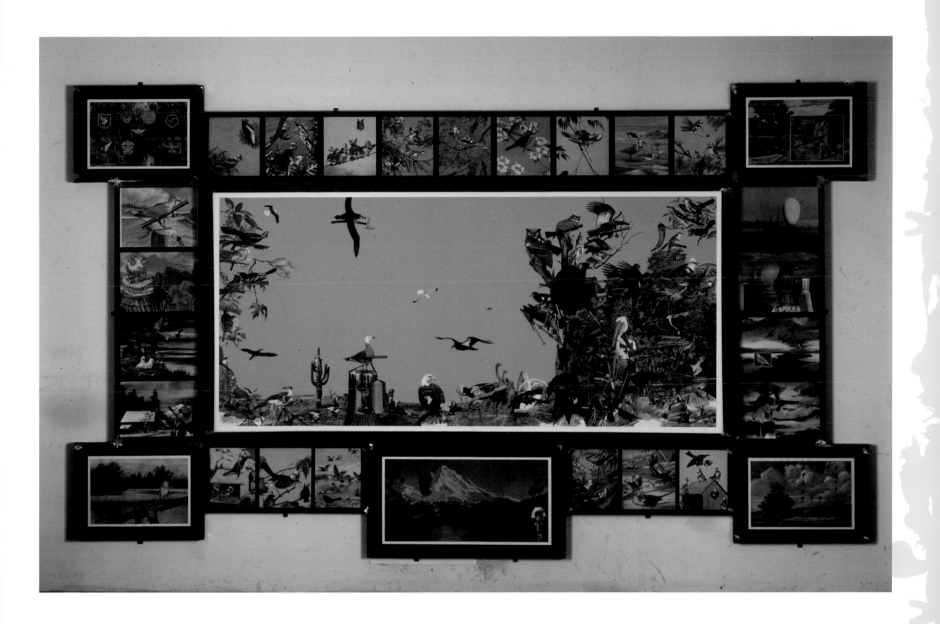

Michael Oatman, *The Birds*, 2002.

Collection of the Albany Institute of History and Art. Photo: Arthur Evans

Becoming Animal

Nato Thompson: You often describe your work as "maximum collage" which moves from straightforward collage to sculpture to installation. The term collage often brings to mind the idea of the collector, as collage generally means producing order out of scavenged historic ephemera. As a lover of history and definitely a collector, what do you think of your work in terms of Walter Benjamin's idea of the collector as someone who personally makes sense of history?

Michael Oatman: This is something that we all do; it's a function of memory. My favorite Bart Simpson koan is "the pile is the natural enemy of the hole." The image piles in my studio have a way of turning history into tidy messes, ordered for one particular project, then reabsorbed into other mounds as ideas change ("mess is lore", as painter and friend Frank Owen has said). When it gets to the bursting point, more storage room than studio, that's when I go to work. Histories emerge. The holes end up being the art.

A great service called The Clipping Room still existed when I was a student at the Rhode Island School of Design. You could go in and request any images you wanted. A guy would disappear into the back and emerge with a manila folder bulging with *National Geographic* magazine photos, old line engravings, product labels. You signed them out like borrowing books. For me, it was the ideal library - all pictures.

Plate XI – *Great Black Backed Gull*

I think people with libraries wake up one day and discover, "I have a library." That's how it happened for me. Building a library becomes a deliberate act, but only after the pleasure of form is discovered within one's own books. Themes emerge. With any kind of collecting there is a moment where you see yourself ordering a tiny universe, finally recognizing that your idea of history can only evolve through personal means. For Benjamin, the flea market was the ultimate work, unfolding in time, no center, no end, and yet everything as it should be. A networked cultural organism, a coral reef.

Nato Thompson: If I may make a shot in the dark, I am willing to bet that part of the inception for your *Birds* series came from the fact that so much great illustration surrounds both bird and gun enthusiast magazines. Why do you think this is?

Michael Oatman: I think of the running gag in Fargo where Sheriff Margie's husband is desperately trying to paint a prize-winning duck stamp design. He never leaves the house, and is always cooking eggs. As a subject, I think birds are one of the places artists start, trying to paint the mysterious and the everyday. What could be a more appealing contrast than the creature that is right outside the windowsill, suddenly made terrifying once inside the house? In recent years there has been a revolution in taxidermy, where the most naturalistic mounts have yielded to more "artistic" interpretations, like pairs figure skating. Suddenly the animals have become only interesting if they are pushed that much closer to the human, toward a kitsch version of themselves. We'd invite them into our homes, only if they behave like adults.

Birds are funny and scary to begin with. Now, add a glock under wing. Fingerless animals trying to get off a round is pure mayhem. *The Birds* was inspired by many sources, including Hitchcock's eponymous picture, but a more important source is the 19th-century German storybook Struwwelpeter, or "Shock-headed Peter." In one tale a hunter falls asleep in the woods and is discovered by a passing rabbit. Donning his glasses and picking up his blunderbuss, the visually impaired rabbit walks upright into town, randomly shooting humans. The drawings are terrifying, and there's something doubly disturbing about nature taking revenge in an urban setting.

Gun forms embody the human in terms of negative space. Images of guns imply how the user holds them. Think of gun terms: cradle, cock, shoulder, discharge, sling, sight.

Nato Thompson: Your piece *Code of Arms* takes a DNA strand as its subject matter and intertwines many fragments of eclectic information of branding and personal identification. How do you see these forms operating on the genetic code?

Michael Oatman: Animals were among the first symbol forms devised by humans. As a way of possessing their qualities (lions = bravery, falcons = speed, bears = strength), animals dominated heraldic shields, armor, epic poems and hieroglyphics. As an exercise, I ask my design students to go around the room and identify the number of animal references on their bodies. There is rarely a person who does not have a tattoo, sports logo, piece of jewelry, shoe form or clothing pattern that is not animal-inspired (or a direct depiction).

The first American registered trademark was the Ralston Purina "Checkerboard Square", fittingly a manufacturer of animal feeds. This 19th-century mark is at the front end of literally billions of symbols that comprise the DNA of media, of culture, of technology. Now that it is possible to patent life forms, to "trademark" them, I wanted to acknowledge my acquired genetic code, memory in the guise of a symbol map. My favorite region of *Code of Arms* shows a stream of Boy Scout merit badges (I achieved the rank of "Life Scout") emerging from the parietal eye of a Buddha. Merit as the western version of enlightenment.

Nato Thompson: What does "becoming animal" mean to you?

Michael Oatman: I think back to my own encounters with wild animals and Plate XII – *Rooster*
the desire I had for communication, not just as a way of guaranteeing my own safety but in looking for recognition as another being. I see becoming animal as a kind of partnership. We're forced together in limited space driven by dwindling resources and greater access to technology. Humans are essentially 99% similar to the order Diptera, the common housefly. Looking into those eyes we see a mirror of who we used to be, and who we may be again.

MOTOHIKO ODANI

Motohiko Odani, who grew up in the historic Japanese city of Kyoto, conflates Japan's past and present in his work. Odani studied at the Tokyo National University of Art and Music from 1995-97, where his traditional craft skills, such as woodcarving, began to show the influences of popular culture. The prolific Odani takes on a wide variety of subjects, ranging from waterfalls, to satellites, to bloodbaths. Odani (along with Yukate Sone) represented Japan at the 2003 Venice Biennial.

Odani's 1997 work *Fair Completion* anchored his debut solo show, *Phantom-Limb*, at P-House in Tokyo. Described as a "blood bubble machine," the white plastic and steel sculpture stands three meters high and spews soap bubbles out of a grate on its top. Contained within each bubble is a single drop of the artist's blood, which, when the bubble bursts, splattered onto the white plastic walls. The heat generated from the lights in the gallery then baked the blood into a thin, brown film that coated the walls.

In *Phantom-Limb* (1997), the viewer is confronted with a familiar Odani aesthetic: the sexualization of innocence. A series of six C-prints depicts a young girl in a white dress, lying on the ground, her hair fanned out under her, with her palms facing upward. The girl's palms are covered in what appears to be blood — the result of her crushing a fistful of raspberries.

Odani's haunting work *Erectro* (2003), featured in Becoming Animal, presents a taxidermy baby deer with its spindly legs in traction. The deer stands helplessly as its legs are "healed." The assistance of these elaborate medical devices appears more torturous than therapeutic on what may be the cutest and most endearing of all non-human animals.

Odani's cute aesthetic becomes a transformed Garden of Eden in the short video loop *Rompers* (2003), also featured in *Becoming Animal*. A young girl with ponytails sits on a tree branch as she sings and swings her legs. Her forehead is mutated, her dress is dangerously short, her toes are elongated, and honey oozes from a gaping hole in the tree. Below her swinging feet, transgenic frogs leap rhythmically to the tinkling pop music in a trance-like circle, and occasionally the girl looks up and snatches a fly with her miraculously lizard-like tongue. This transgenic Garden of Eden feels like a lush, hypnotic MTV video with a nod to Takashi Murakami. Odani's work uninhibitedly embraces the mutant side of nature by overlaying it with the sweetness of honey and the candy-colored palette of Teletubbies.

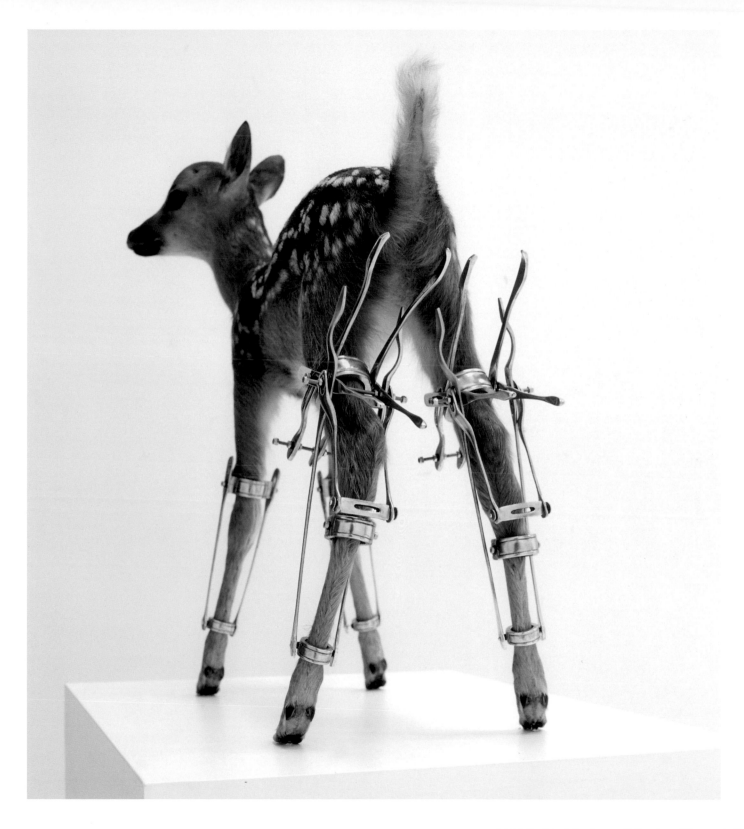

Motohiko Odani, *Erectro*, 2003. Courtesy of Yamamoto Gendai.

Erecctro courtesy of Toahiko Ferrier Collection

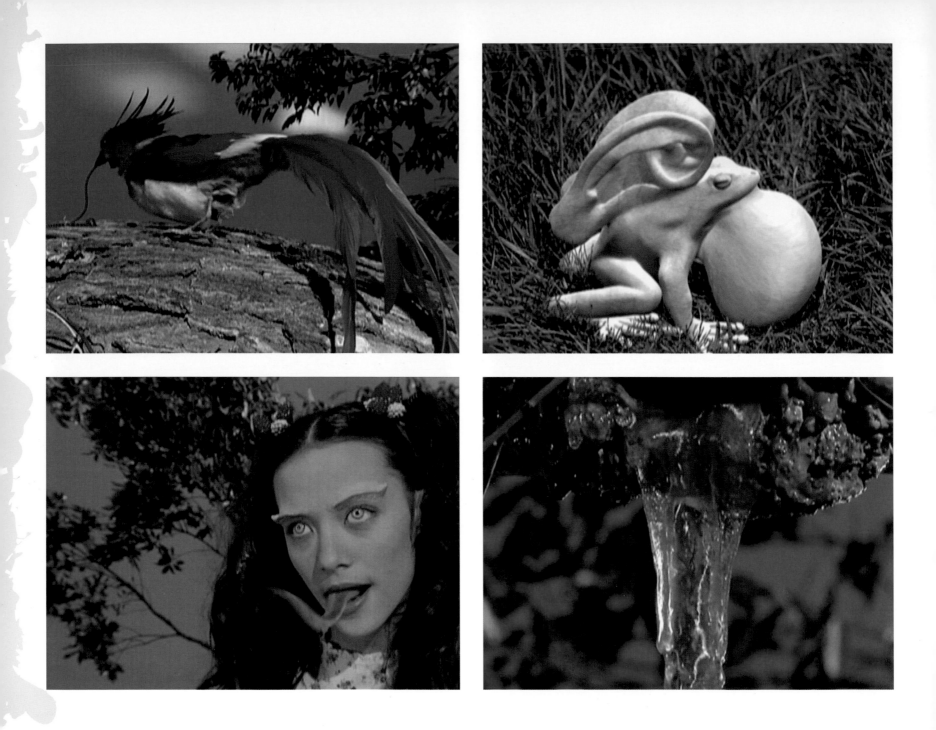

Motohiko Odani, video stills, *Rompers*, 2003. Courtesy of Yamamoto Gendai.

Motohiko Odani, *Rompers*, 2003. Courtesy of Yamamoto Gendai.

Becoming Animal

Nato Thompson: Your sculpture *Erectro* (2003) uses the epitome of cute, the baby deer, as its subject matter. What do you think the relationship is between cute and animals, and how do you use this as a source of inspiration?

Motohiko Odani: I don't think baby animals are pure and innocent. In the case of baby animals born with disabilities by inheritance, mixed feelings run through me.

Nato Thompson: Both *Rompers* (2003) and *Erectro* have an underlying, if not explicit, quality of sexuality. What is the relationship between sexuality and animals in these pieces?

Motohiko Odani: Animals are naked, and their genitalia are exposed all the time. Their sexuality is more available and stronger than ours.

Nato Thompson: Your video *Rompers* has a psychedelic drug-induced feeling to it, reminiscent of MTV videos and Japanime videos. Are these sources of inspiration for you?

Motohiko Odani: *Rompers* brings out my sunny side. Many children's TV programs have obscure or clear metaphors (and implied comparisons) hidden behind characters. They are revealed much later, as we age, in the process of becoming old. I wanted *Rompers* to be a germinating apparatus for children's Eros by including elements of Eros in its parts, making Freud's interpretation of Eros possible for children. The video is structured so that the poison of *Rompers* signifies the elements of adult programs for children. But for adults, it would be interpreted as an obscure children's program.

The sources of inspirations for this video were the 1980's Japanese children's TV programs such as Bornfree and Izenborg. They combine everything, including real-time actions, characters in bodysuit costumes, scenes with miniature sets and animation. Lacking unity in their production, there was a special "awkwardness" that can only appeal to children. Visually, there was a psychedelic, drug-induced feeling to these programs as well. The child's brain mechanisms that smoothly connect all these independent elements, the world of chaos, are the very core of *Rompers*.

Concerning MTV, I think it has great mechanisms for getting people's attention efficiently, in a short period of time. Although I am Japanese, I am not interested in Japanimation.

Nato Thompson: What does "becoming animal" mean to you?

Motohiko Odani: I believe that humans are already, forever and ever, animals. Humans wake up in the morning, move around, eat, excrete, occasionally have sex, eat, excrete, and when night comes... they fall asleep. In the end, humans have the minimal activity patterns of an animal.

Plate IX – Axis *Deer*

Plate X – *Frog*

PATRICIA PICCININI

Patricia Piccinini was born in Freetown, Sierra Leone, in 1965 and moved to Australia with her family in 1972. After receiving a degree in economics in 1988, she shifted her interest to studio art, completing a BA in painting in 1991. Since then, her work has been exhibited internationally at such distinguished venues as the Berlin Biennale in 2001 and the Australian Pavilion in the 2003 Venice Biennale.

Piccinini gives form and body to a future that seems just this side of science fiction. Using digitally manipulated photographs, silicon-based sculptures, and video, Piccinini has developed a bizarre hybrid world populated by her invented transgenic animals. In 2000, Piccinini began developing a series of works based on the laboratory-developed "SO1" or "Synthetic Organism 1." SO1 is a DNA strand developed at the University of Texas from purely inorganic materials. The enthusiastic public relations statement exclaimed that "SO1 will have no specific function, but once it is alive we can customize it." [1] The implications of a potentially malleable, scientifically developed form of life were enough to nudge Piccinini to produce the imaginary SO2, an evolutionary extension of SO1 resembling an amorphous fleshy mole. In *Social Studies* (2000), SO2 debuts in public life surrounded by gleefully amused children. When viewing the haunting *Still Life with Stem Cells* (2002), what strikes the viewer is the tenderness with which children accept this shocking being.

Piccinini confesses familial emotions toward her hybrid sculptures. After SO2, she explored the development of SO3 in the sculptural work, *The Young Family* (2002-2003). As yet another evolutionary step, SO3 introduces human DNA to the cocktail. In this life-sized sculptural work, the exhausted SO3 mother lays with her playing and suckling young. She is a fleshy hybrid animal-human, or more appropriately platypus-human. Lying on a sculpted leather base, the mother curls up and stares off in space, absorbed in her thoughts. While her babies feverishly suckle, her tired and weathered eyes provide an all-too-human window to her soul.

Piccinini's *Nature's Little Helpers – Bodyguard* (2004) is the first in a series of works titled *Nature's Little Helpers*. Unlike *The Young Family*, the *Bodyguard* evokes fear rather than sympathy. According to Piccinini, she designed the hypothetical *Bodyguard* to protect a near-extinct bird, the Golden Helmeted Honeyeater, or the "He-ho" as it is more commonly known. *The Bodyguard*, a vicious simian creature, is equipped with sharp incisors and a powerful jaw to dig into the bark of trees and release sap for the He-ho to suck. The He-ho's diet consists of increasingly rare nectar and gum tree sap. The combination of deforestation and the hunting of possums, whose biting typically releases the sap, leave the survival of the He-ho in doubt. A genetically designed answer to an environmental problem, *the Bodyguard* is yet another human creation to compensate for the meddling of humans. This paradox is emblematic of the future that Piccinini's uncanny sculptures and photographs portray, that of a complicated and evolving symbiosis.

(Footnotes)

1 Jonathan Leake and Roger Dobson, "First artificial DNA can create new forms of life," London Times, January 25, 2000.

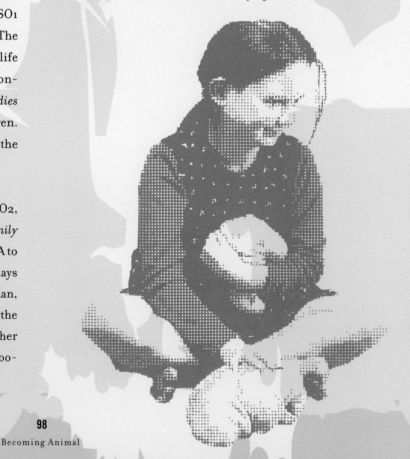

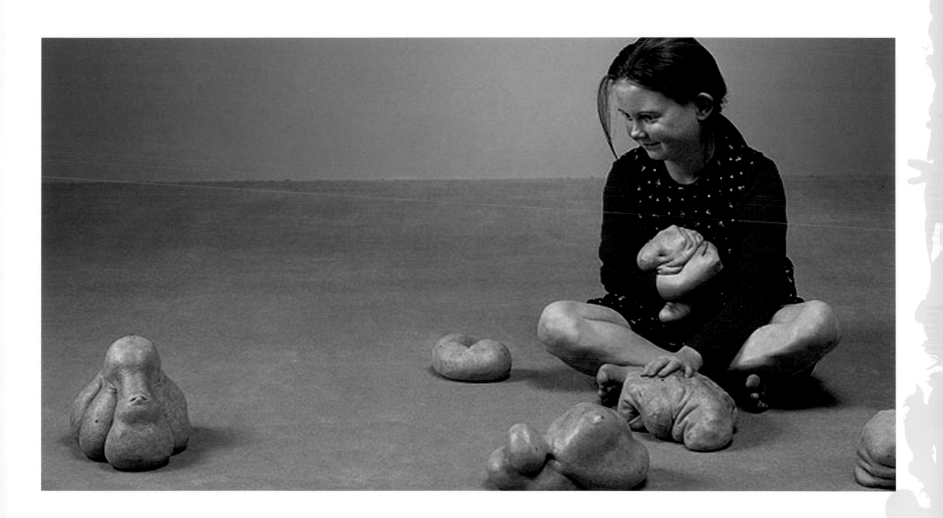

Patricia Piccinini, *Still Life with Stem Cells*, 2002

Becoming Animal

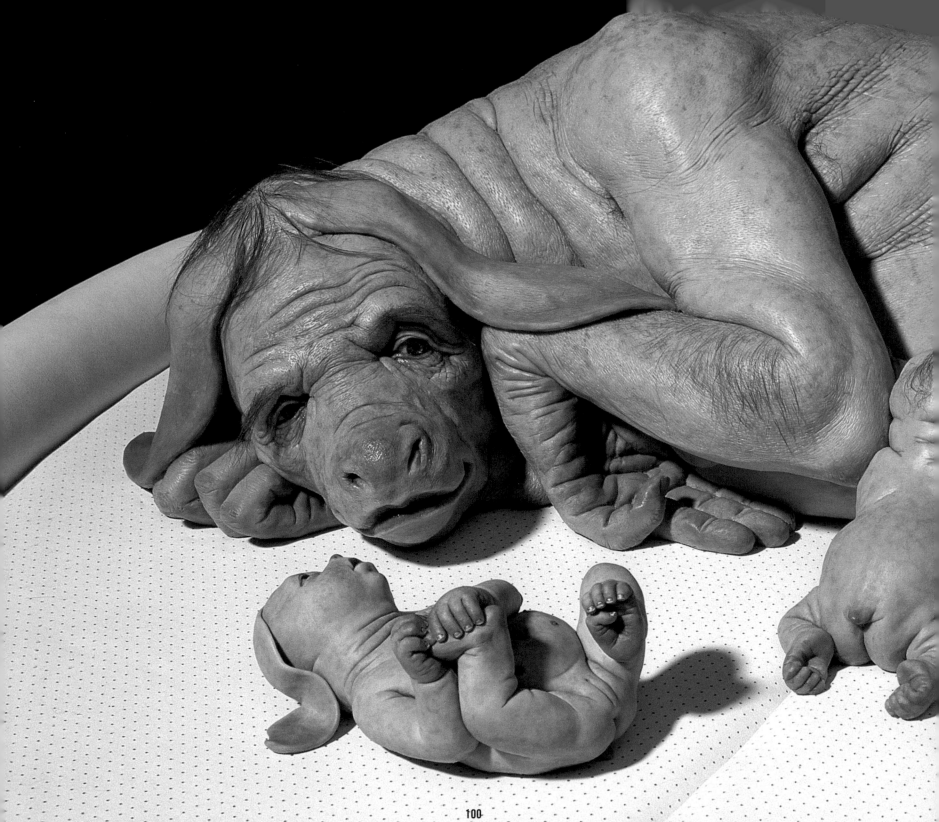

Becoming Animal

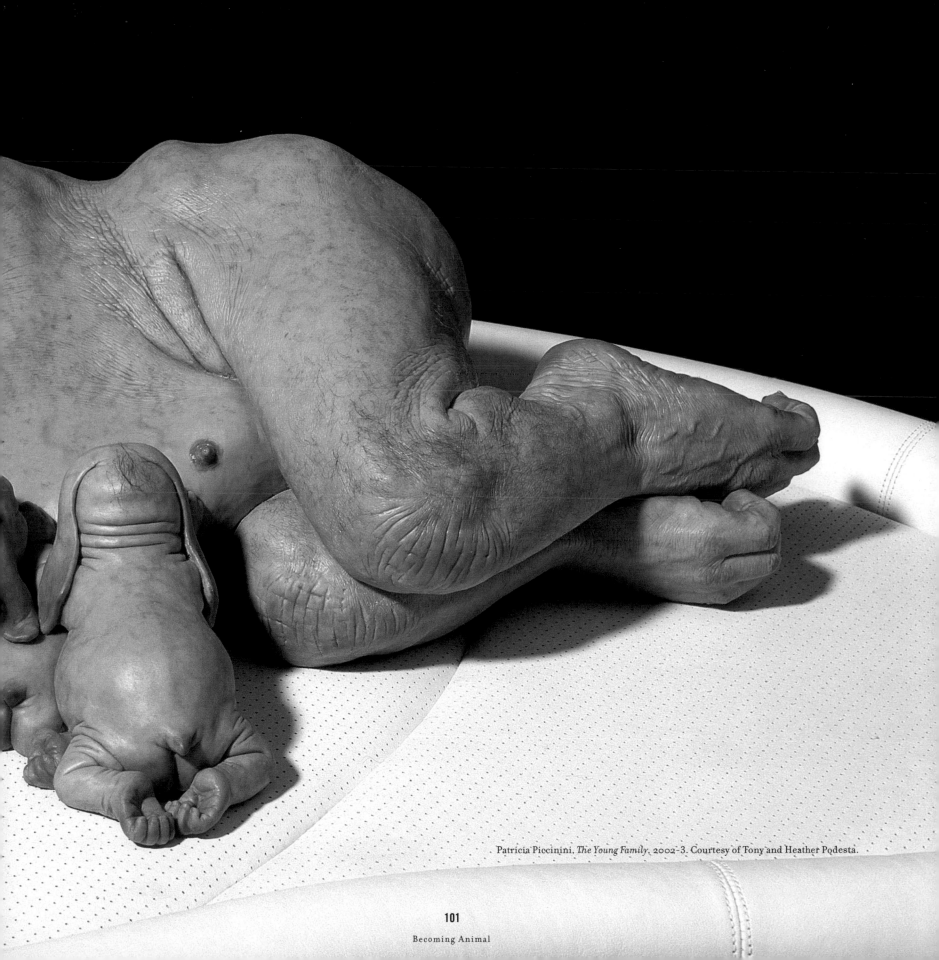

Patricia Piccinini, *The Young Family*, 2002-3. Courtesy of Tony and Heather Podesta.

Becoming Animal

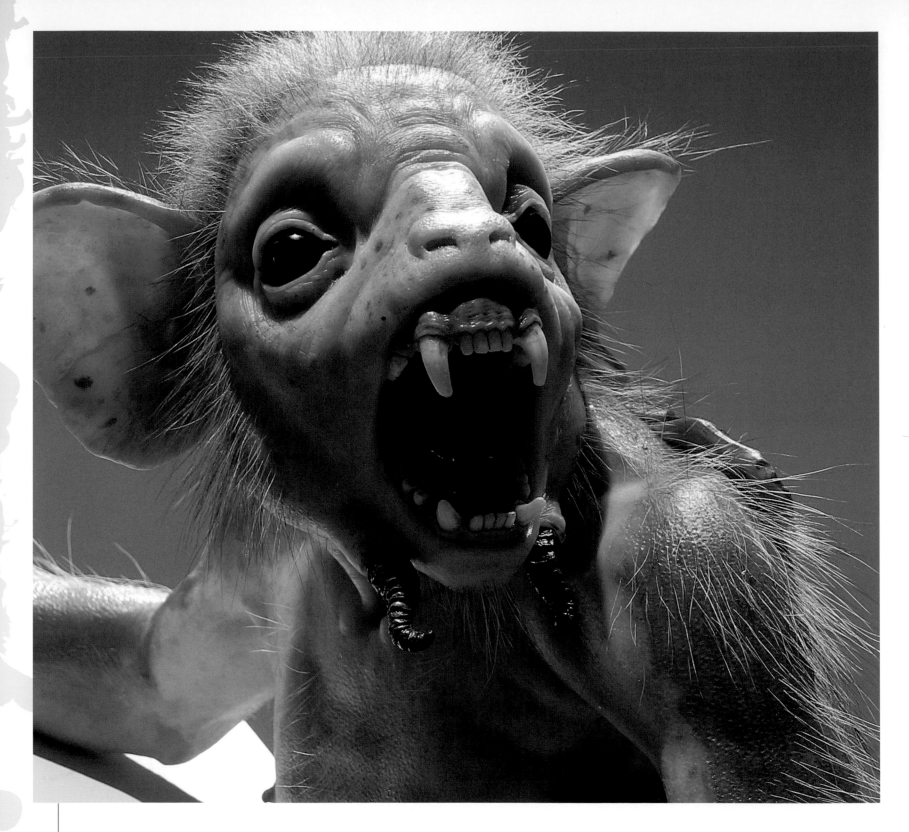

Patricia Piccinini, detail, *Nature's Little Helpers — Bodyguard*, 2004.

Private Collection, New York. Courtesy of Robert Miller Gallery.

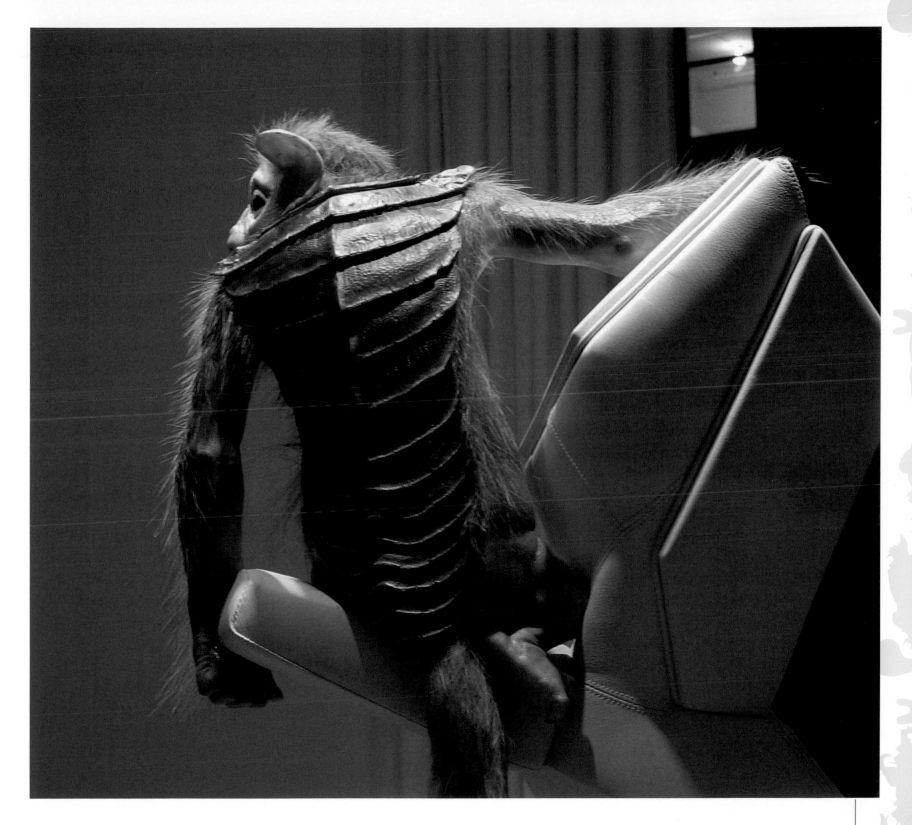

Patricia Piccinini, *Nature's Little Helpers — Bodyguard*, 2004.

Private Collection, New York. Courtesy of Robert Miller Gallery.

Nato Thompson: In both *Still Life with Stem Cells* (2002) and *The Young Family* (2002-2003) the gaze of the main figures in your sculptures play an important role. By providing an interior space, you seem to be saying something about their subjectivity.

Patricia Piccinini: The gaze of both of these works is quite introspective. This is partially because I wanted to avoid the obvious theatricality of directing their gazes straight to the viewer, but mostly because I wanted the works to have a sense of independence and self-possession. The reflective gazes of these works separate them from us; they are not looking straight at us, imploring us to do something or think something. They have their own worlds and their own concerns. They are, in the end, less interested in us than we are in them. This empowers them to a certain degree, as they are complete within themselves.

Nato Thompson: Your work is fleshy, both in techniques and subject matter. How do you see the flesh as important to your work?

Patricia Piccinini: What interests me is the way that flesh is changing as a result of medical and scientific research. All of my works take place at a time when flesh is becoming plastic. Ultimately the aim of genetic engineering, stem cell research and the like is to control flesh, to make it malleable and plastic. In the past we could meddle with the flesh, usually destructively, but we could never control it; it would follow its own path, and there was little more we could do than watch.

For many years, my works have revolved around the question of what we will do with flesh when we can control it. As such, it is important that in the physical manifestation of the works they really conjure up the fleshiness of the beings they represent. I think there is a nice conceptual irony in my use of silicone – basically a kind of plastic – to create flesh in works that talk about the plasticity of flesh.

Nato Thompson: You have produced two synthetic organism series, SO2 and SO3; do you feel as though you are producing your own mythological genetic lines?

Patricia Piccinini: The idea that these are mythological creatures is an interesting one. I do see them as mythological, although not because they are fantastic or unreal but rather because I am using them to tell stories about the world we live in or to try to explain or explore ethical issues that are important to our times. Myths and the creatures that inhabit them are there to try and explain things about a world that is often inexplicable. As I said, I do not think that the essence of myth is its fantastical or otherworldly quality. In fact, usually myths reflect the reality of their times, except distilled to a point where it is too concentrated to seem like part of everyday life. I certainly don't see my work as 'science fiction' or 'futurism' or some sort of glimpse of a world to come. On the contrary, my works are absolutely rooted in what is happening now, just taken to their apparently illogical extremes.

Plate XI – *Pig*

Nato Thompson: In *Nature's Little Helpers – Bodyguard* (2004) the protector functions as a genetically created intervention to protect a creature who is already suffering from human intervention (the disappearance of the possums, for example). What do you make of this paradox?

Patricia Piccinini: *The Bodyguard*, and the other works in the *Nature's Little Helpers* series, is about how much, or how little, we are willing to do to undo the damage we have done to the world. There is a clear paradox in the work in that it suggests that we intervene to fix a situation caused by our intervention in the first place. At its simplest, the work is about doing the wrong thing for the right reason, and about the fact that we never seem to learn that we are not as smart or in control as we think we are. The work simultaneously extols the idea that we need to do something while critiquing our desire for a simple, technological solution to a complex ecological problem. The real answer to the endangered bird's problems is both much easier and more difficult: changing how we use land. It is no accident that this creature is so much more fearsome and dangerous looking than many that I have made. We find him threatening because, in the end, the real threat to these birds is us.

Nato Thompson: What does "becoming animal" mean to you?

Patricia Piccinini: To me it means that we are finally recognizing our own animal-ness. We tend to anthropomorphize animals, and see in them characteristics that we readily identify as 'human'. However, I think it is more interesting to recognize that many of these so-called 'human traits' that we see in animals are just animal characteristics that we share in common. As modern ideas of evolutionary biology have developed, we have had to try to find ways to describe what makes us 'human/special/unique'. Communication, social hierarchy, tool-making, empathy, hunting for sport; all have been suggested as 'uniquely human' traits, yet all can be found as behaviors in other animals. Even DNA has not come to our aid. If we have learned anything from the genetic mapping of ourselves and other organisms, it is that much of our DNA is shared. The same genes that control the development of our eyes are there in other primates, and even in insects. We have more DNA in common with rats than we have different. In fact, we share DNA with vegetables. "Becoming animal" is about acknowledging that our place in the world of life is less supreme than we would like to think.

Plate XII – *Baboon*

ANN-SOFI SIDÉN

Ann-Sofi Sidén was born in Stockholm, Sweden, in 1962. In her large-scale, elaborately researched projects, Sidén brings installation, archiving, architecture, and multi-channel video into her expanded documentary oeuvre. Although she takes on a broad range of topics, Sidén consistently touches on the subjects of surveillance, gender, psychoanalysis, and site specificity.

Her project for *Becoming Animal*, the *Queen of Mud Museum* (2004), continues her longstanding interest in experimental documentary film and sculpture. Related works include *Codex* (1993), a dramatization of punishments drawn from court cases of women convicted of crimes in Sweden between the 15th and 19th centuries; *Warte Mal!* (1999), a 13-channel video installation portraying the lives of prostitutes in the Czech Republic; *Who told the Chambermaid?* (1998), a 17-channel surveillance work showing the multilayered goings-on in a hotel in Luxembourg; and her most recent video installation, *3 MPH, Horse to Rocket* (2003), depicting her own 25-day horseback ride through Texas, ending at NASA Ground Control in Houston.

The Queen of Mud Museum (QMM) is a museum within a museum whose collection is dedicated to the research and display of material concerning two characters who have been the subject of much of Sidén's work. From the *Queen of Mud*'s incarnation in 1988, until 1997 when she met a New York psychiatrist in Sidén's film *QM, I think I call her QM*, co-directed by Tony Gerber, Sidén has documented the transformation of these characters through video and film. The archive of film footage is vast, including 16 mm film material of the Queen of Mud recorded in 1992. There are also film recordings of QM's travels in time in *The Astronomer* (1992), where QM meets herself in a past life as a female astronomer in the 19th century, and in space, when QM visits a group of stargazing nomads who are harassed by gun-wielding military police in *Nomad Camp* (1992).

With the November 2004 opening of the *QMM* at the Moderna Museet in Stockholm, Sidén revisits, for the first time since 1997, the QM character that occupied ten years of her art-making career. In so doing, it appears that the new subject of Sidén's unconventional form of documentary could, quite possibly, be herself and her own art practice seen through her alter ego, the *Queen of Mud*.

Sidén's first public performance as QM was recorded in the short video *NK, QM Visits the Perfume Counter* (1989), in which QM visits an exclusive department store and smells Chanel No 5. Reminiscent of the 1970s performance art of Adrian Piper and Valie Export, the video documents the reactions of the salesclerks and customers at the site of this naked muddy ur-creature. This material was first shown in the ad hoc TV talk show performance *Who Is Queen of Mud?* (1989), in which QM is interviewed by a journalist about her preparations, including the perfume counter visit, for her upcoming journey to another planet. The talk show inaugurated a series of videos from 1989 – 1995 in which the mythologies of QM grow increasingly surreal and complex.

In 1994, while at an artist residency program at P.S.1 in New York, Sidén participated in an artist-initiated site-specific project that became a crucial point of departure for her work. *Who has enlarged this hole?* (1994) was based on research at the home of deceased psychiatrist Alice E. Fabian. As Sidén investigated Fabian's life, she came to realize that the psychiatrist had suffered from paranoid schizophrenia. Living a double life cooped up in her apartment, Fabian monitored the world with a meticulously detailed (and microfilmed) diary, a tape recorder and a Polaroid camera. She communicated with what she called poltergeists, spooks, and agents. This richly detailed life of a lonely, isolated woman became a platform for Sidén to investigate questions of psychiatry, surveillance, and gender in many of her subsequent projects: *It's by confining one's neighbor that one is convinced of one's sanity I* (1994), *It's by confining one's neighbor that one is convinced of one's sanity II* (1995), and *Would a course of Deprol have saved van Gogh's ear? (See what it feels like, Rooseum)* (1996).

As a method, Sidén continues to recycle QM projects. Excerpts from her 16 mm film *The Clocktower* (1995) are used for a dream sequence in the film *QM, I think I call her QM*. The 35 mm film brings together the two separate strains – Fabian and QM. Fabian is portrayed as a Dr. Ruth Fielding who discovers QM living under her bed. She decides to study QM and locks her up in a chaotic adjacent bedroom. As the film progresses, we discover the constant paranoia and meticulous note-taking of Dr. Felding and the enigmatic extra-lingual qualities of QM. Scripted as a complicated blend of documentary, science fiction and allegory, *QM, I think I call her QM* embodies the evolving investigations of Ann-Sofi Sidén.

With the *Queen of Mud Museum*, which holds a digital archive of over 3,500 articles, Sidén walks the visitor through an evolving investigation into "the other." Whatever the *Queen of Mud* ultimately means, we see her as a foil for the "other" within. Rather than placing this ambiguous ur-creature in position diametrically antithetical to herself, Sidén makes room for transformation, for growth, for becoming.

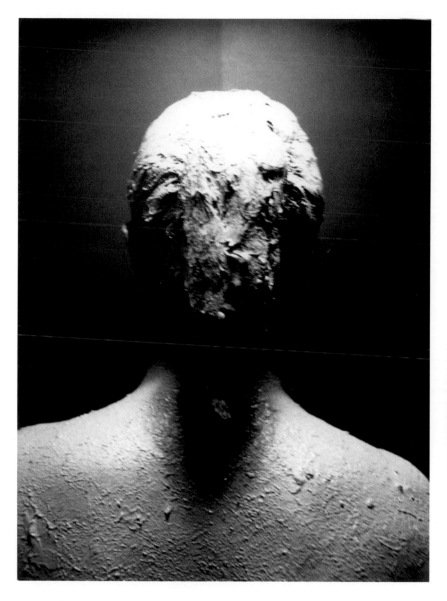 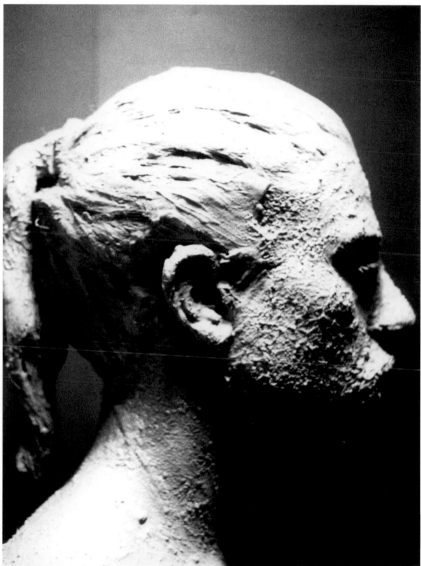

Ann-Sofi Sidén, *QM's head and shoulders*, from the back, 1988.

Ann-Sofi Sidén, profile shot of QM, facing right, 1988.

Photo: Lotta Antonsson

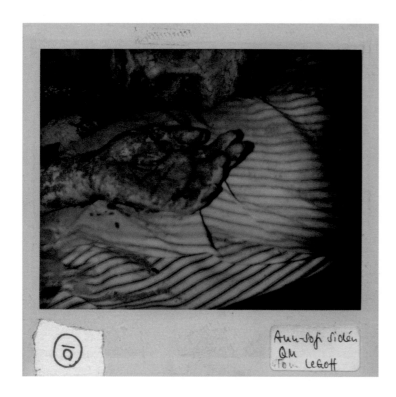

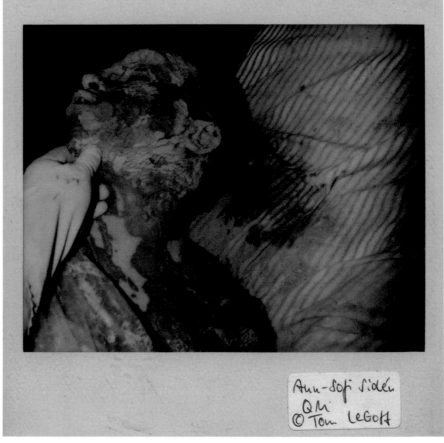

Ann-Sofi Sidén, production stills, *QM, I Think I Call Her QM*, 1997.

Photo: Tom LeGoff

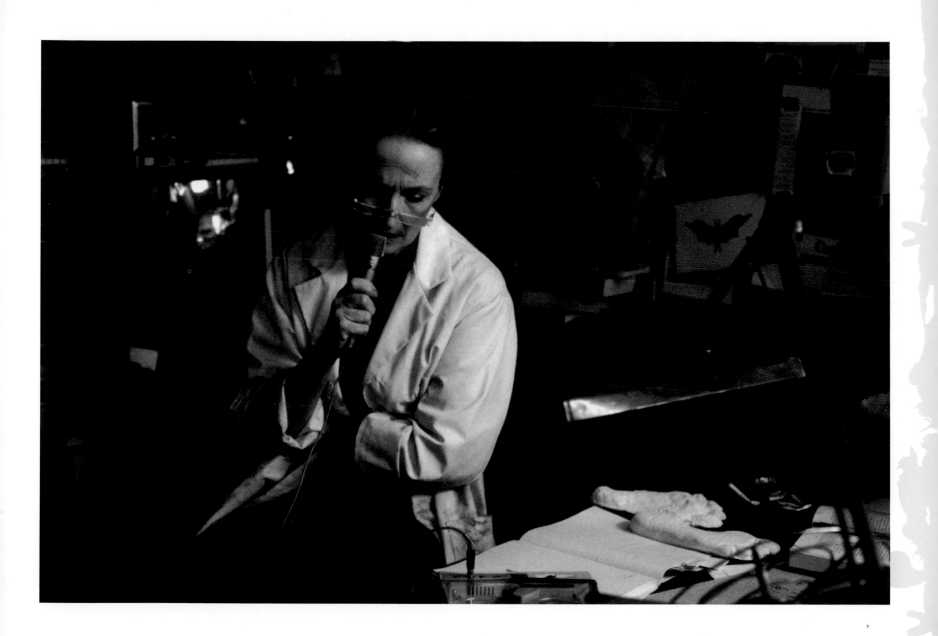

Ann-Sofi Sidén, *QM, I Think I Call Her QM*, 1997.

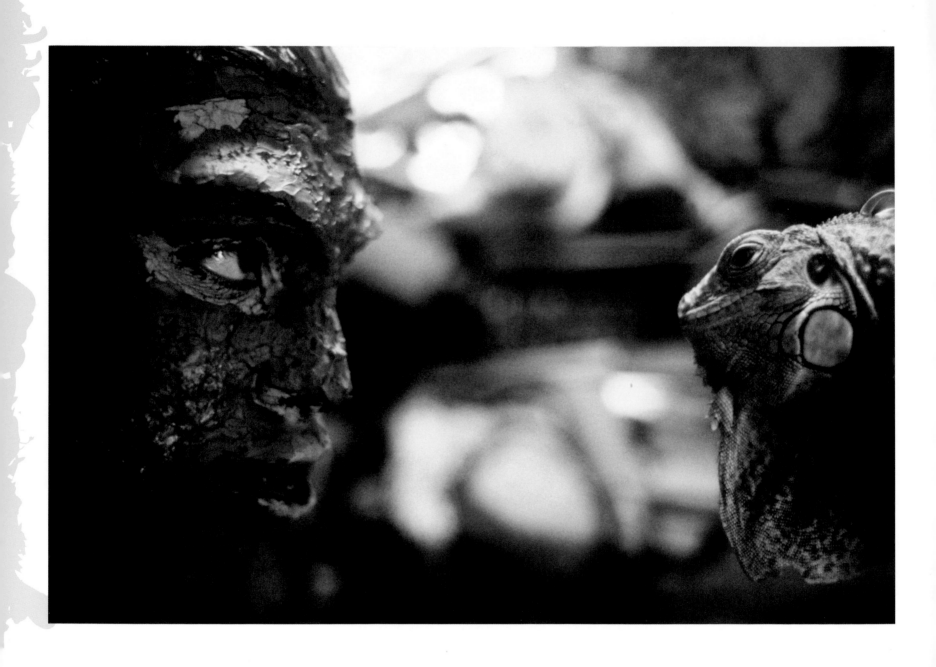

Ann-Sofi Sidén, *QM, I Think I Call Her QM*, 1997.

Becoming Animal

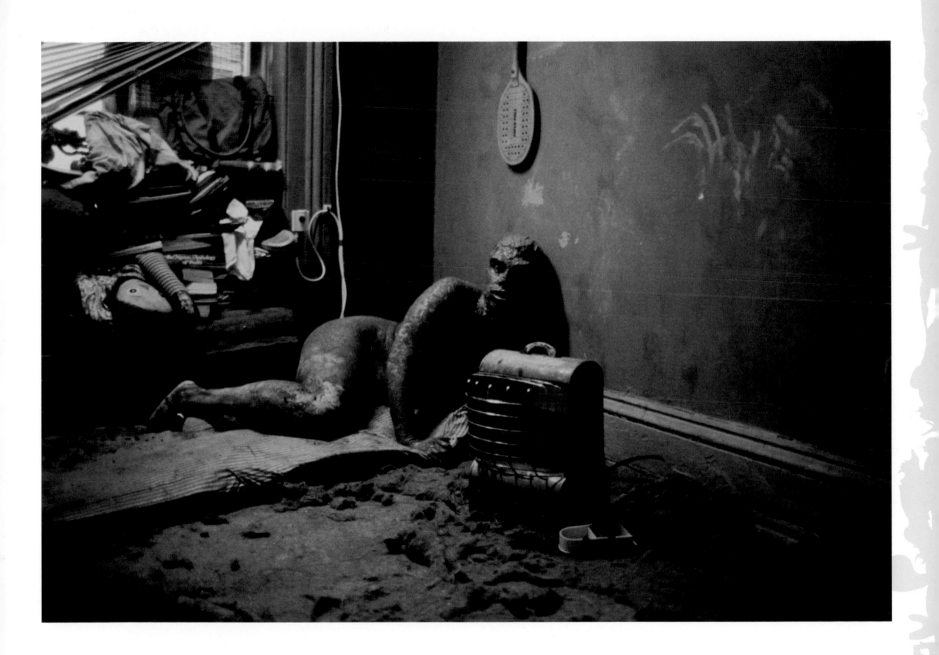

Ann-Sofi Sidén, *QM, I Think I Call Her QM*, 1997.

Becoming Animal

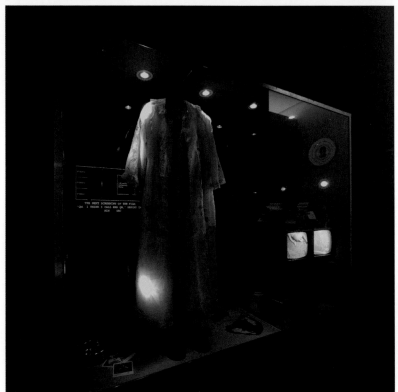

Ann-Sofi Sidén, *The Queen of Mud Museum (QMM),*

installation at the Moderna Museet, Stockholm, 2004

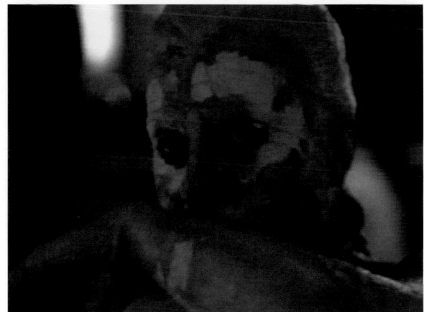

Ann-Sofi Sidén, video stills, *Chanel No. 5*, 1989.

Becoming Animal

Nato Thompson: The Queen of Mud Museum is a retrospective in a museum in a museum. That is to say, inside the exhibition *Becoming Animal* is the *Queen of Mud Museum* which is a look at the evolving persona of the *Queen of Mud* while, at the same time, a look at ten years of your career. How do you see these two forces complementing each other?

Ann-Sofi Sidén: The early video recordings reveal a character in the genesis of her evolution. *Queen of Mud* walks and talks, reflecting the environment around her: simple setups at a perfume counter, an art fair, or a fake TV talk show. It's just me, Ann-Sofi, in a thin layer of mud testing my idea, the world and myself; "thought" versus "action without thought." Her evolution becomes my evolution as an artist; the setups become more complex, testing both of us as QM is taught to walk a tightrope, or put into a real-life copulation situation. The objectification is made more complete--she no longer speaks. I keep her as a main character among others. Even now with the QM Museum I'm still both the puppet-maker and the puppet, but with the added role of collector of "things QM." QMM reveals how my various collaborators and I molded QM — her development as a character is charted in time. It also manifests the changing and diverse methods used to record her presence, thereby giving a glimpse into a ten-year span of my career through the prism of QM.

Plate XIII — Monkfish

Nato Thompson: In your film *QM, I Think I Call her QM*, a psychiatrist, Ruth Fielding, finds the Queen of Mud under her bed. Obviously, the subject of psychoanalysis plays a role here. How do dreams and the subconscious play in your work?

Ann-Sofi Sidén: The scene you refer to is taken directly from a dream I had once about my mom and myself. Here it is from the script for the film:

RUTH (to the recorder)
The time is now 3:05 AM. I woke up.
I dreamt that I was a newly born calf, my brown and white patched skin still wet and warm. It's a sunny day.

I'm standing on a winding dirt road in a landscape of fresh green hills. My mother who is a perfectly normal human is talking to me. I'm looking at myself and at another calf standing next to me on shivering legs. I ask her why she never told me that I have a twin sister and that I was born a calf. My mother looks at me reproachful, and says,
"But don't you understand...."
Her voice filled with an underlying motive that I absolutely don't get. End of recording. The time is now 2 AM.

RUTH hits "stop" and puts her tape recorder on the bedside table. She picks up a pill box and brings a few PINK PILLS to her mouth and swallows them with some stale coffee from a half-full mug. She rises and goes to bathroom. Camera stays on bed. We hear the sound of peeing and flushing. RUTH returns to bed. Ruth turns off the light and continues to mutter to herself.

RUTH (to herself) ..
If I only understood what she meant by that. Did she want to spare me the pain and hardship it would mean to try to live a normal life among normal people? Knowing full well that I was a calf? Did she feel it was better for me not to know? Or is it because it's not appropriate to be a... a... or is it because she was ashamed to have given birth to a calf, actually two calves.

Nato Thompson: Where/how do gender and animality converge, particularly in your performances as Queen of Mud?

Ann-Sofi Sidén: The perception of QM may be animal, Neanderthal or feminist (some have even labeled her as a feminist protest), but these are just labels put onto a female body in mud that doesn't fit in. In *The Art Fair* (1990), a male gallerist even goes so far as to stick his business card on her muddy chest while asking if any snakes are hidden in the mud. In *NK, QM Visits the Perfume Counter* (1989), one might see her presence at an exclusive perfume counter as something a civilized woman would do. But, like one of the sales-clerks says just before she sprays QM, there is also something repulsive about putting perfume over a layer of mud. In *QM, I Think I Call Her QM* (1997), the

psychiatrist puts QM in a test chamber. With a pearl necklace around her neck, QM hides under her dirty mattress like a hunted animal in the presence of a blindfolded gigolo, also placed there by the psychiatrist. This is where the theme hits the metaphor, and an example of the convergence you refer to.

Nato Thompson: You have often cited a strong interest in documentary, and your work suggests this as well. How does the Queen of Mud suggest a fictional apparatus in your documentary search through questions of psychoanalysis, surveillance and gender?

Ann-Sofi Sidén: My work with QM has never been a documentary as far as I'm concerned. It is, though, a search, and a spinning of a web around QM and her possibilities. She oscillates between predator and prey for procreation; she is a time-traveler; she is a guinea pig; and at one turn in her history, she is captured and held under surveillance by a psychiatrist who records and controls everything her subject/alter ego does or thinks. But QM looks back, and also observes, listens and learns; she acquires knowledge, and has some questions of her own.

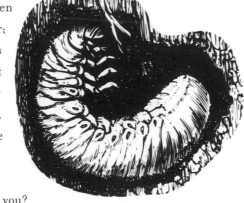

Plate XI – Common Cockchafer

Nato Thompson: What does "becoming animal" mean to you?

Ann-Sofi Sidén: To be seen, or not seen. I think that is what society is all about, to be recognized by the flock, or to hide from it.

Jane Alexander

1959 Born in Johannesburg, South Africa

1988 University of Witwatersrand, Johannesburg, South Africa, M.A.

1982 University of Witwatersrand, Johannesburg, South Africa, B.A.

 Jane Alexander lives and works in Cape Town, South Africa.

Selected Solo Exhibitions

2003 Art Museum Bloemfontein, South Africa

 South African National Gallery, Cape Town, South Africa

2002 DaimlerChrysler Konzernzentrale, Fourm Stuttgart-Möhringen, Germany

 DaimlerChrysler Contemporary, Potsdamer Platz, Berlin

 Pretoria Art Museum, Pretoria, South Africa

2000 *Jane Alexander*, Gasworks, London

1999 *"Bom Boys" and "Lucky Girls"*, Irma Stern Museum, University of Cape Town, South Africa

1986 *Sculpture and Photomontage*, Market Gallery, Newtown, Johannesburg, South Africa

Selected Group Exhibitions

2004 *Africa Remix*, Museum Kunst Palast, Düsseldorf, Germany

2002 *New Identities - Zeitgenössische Kunst aus Südafrika*, Kunst:Raum Sylt-Quelle, Rantum, Kunstverein Zehntscheuer, Rottenburg/Neckar (cat.)

2001 *Head North, Visual Cultures Dialogue*, BildMuseet, Umea, Sweden

 The Short Century: Independence and Liberation Movements in Africa 1945-1994, Museum Villa Stuck, Munich; Haus der Welt, Berlin; Museum of Contemporary Art, Chicago; P.S.1 Contemporary Art Center, New York (cat.)

 Africa Today, The Artists and the City, Barcelona Center for Contemporary Culture, Barcelona, Spain (cat.)

 World Wide Video Festival, Amsterdam, Netherlands (cat.)

 Dis/Location, Photo Espana 2001, Circulo de Bellas Artes, Madrid; Sala Rekalde, Bilbao, Spain; Centro Cultural de Maia, O'Porto, Spain

2000 7th Havana Biennial, Wilfredo Lam Centre, Havana City, Cuba (cat.)

 Voices of Southern Africa, British Museum, London

 partage d' exoticisms, 5th Lyon Biennial, Lyon, France (cat.)

 South Meets West, Kunsthalle Bern and Historisches Museum, Bern, Switzerland (cat.)

1999 *Global Art*, Galerie Seippel, Cologne, Germany

 Staking Claims, The Granary, Cape Town, South Africa (cat.)

 Lines of Sight, South African National Gallery, Cape Town, South Africa (cat.)

1998 Triennale der Kleinplastik, Europa-Afrika, SüdwestLB Forum, Stuggart, Germany (cat.)

 Africa, Africa, Tobu Museum of Art, Tokyo (cat.)

 DAK'Art Biennale de l'art africain contemporain, Dakar, Senegal (cat.)

1997 *Lifetimes*, Out of Africa Cultural Festival, Munich (cat.)

 South African Aborescence, Art Festival Nantes, Nantes, France

1996 *Fault Lines*, Castle of Good Hope, Cape Town, South Africa

 Colours-Kunst aus Südafrika, Haus der Kulteren der Welt, Berlin (cat.)

1995 *Identita e Alterita*, Venice Biennial, Palazzo Grassi, Venice

1994 5. Biennale con Havanna, Ludwig Form für zeitgenössische Kunst, Aachen, Germany (cat.)

 5th Havana Biennial, National Museum of Fine Arts, Havana City, Cuba (cat.)

 Xit, election exhibition, South African Association of Arts, Metropolitan Life Gallery, Cape Town, South Africa

Selected Bibliography

Arnold, Marion.
> *Women and Art in South Africa. Clarement, South Africa:*
> David Philip Publishers, 1996.

Deegan, Heather.
> *The Politics of the New South Africa: Apartheid and After.* Essex:
> Pearson Education Ltd., 2001.

Edmunds, Paul.
> "Jane Alexander at the Irma Stern."
> *Artthrob,* http://www.artthrob.co.za/99July/botframe.htm, 1999.

Geers, Kendell, ed.
> *Contemporary South African Art: The Gencor Collection.* Johannesburg:
> Jonathan Ball Publishers, 1997.

Nicol, Mike.
> *The Waiting Country – a South African Witness.* London: Gollancz, 1995.

Nolte, Jacqui.
> "Jane Alexander: Sculpture and Photomontage." *Third Text* no.36, 1996.

Oguibe, Olu.
> *Fresh Cream.* London: Phaidon Press Ltd., 2000.

Powell, Ivor.
> "Ask No Questions in the Presence of Jane's Ghouls." *Weekly Mail*
> (October 1986): 17-23.

Wilhelm, Peter.
> "Magical Disquiet." *Financial Mail,* July 21, 1995.

Rachel Berwick

1962 Born in Somers Point, New Jersey

1991 Yale University School of Art, New Haven, Connecticut, M.F.A.

1984 Rhode Island School of Design, Providence, Rhode Island, B.F.A.

Rachel Berwick lives and works in Providence, Rhode Island.

Selected Solo Exhibitions

2004 Brent Sikkema Gallery, New York

2000 *Hovering Close to Zero*, Brent Sikkema Gallery, New York

1998 *may-por-e'*, Brent Sikkema Gallery/Wooster Gardens, New York

1997 *may-por-e'*, Real Art Ways, Hartford, Connecticut (cat.)

1995 *Two Fold Silence*, Thomas Nordanstad Gallery, New York

1993 *Sounding Measures*, Thomas Nordanstad Gallery, New York

Selected Group Exhibitions

2004 26th Bienal de São Paolo, São Paolo, Brazil

2003 *Transversal - 4th Bienal do Mercosul*, Porto Alegre, Brazil

A River Half Empty, The Aldrich Contemporary Art Museum, Ridgefield, Connecticut (cat.)

2002 *How Extraordinary That the World Exists!*, CCAC Wattis Institute for Contemporary Arts, San Francisco, California (cat.)

2001 *Egofugal*, 7th International Istanbul Biennial, Istanbul (cat.)

2000 *The Greenhouse Effect*, Serpentine Gallery, London (cat.)

1996 *A Scattering Matrix*, Richard Heller Gallery, Los Angeles

1995 *La Belle et la Bete: Art Contemporain Americain*, Musee d'Art Moderne de la Ville de Paris, France (cat.)

1994 *Promising Suspects*, The Aldrich Contemporary Art Museum, Ridgefield, Connecticut (cat.)

1993 *Rachel Berwick and Michael Joo*, Thomas Nordanstad Gallery, New York

1992 In Through the Out Door, Thomas Nordanstad Gallery-Skarstedt, New York

Selected Bibliography

Brackman, Yvette.
Review, "may-por-e'." *Time Out New York*, no.120: 51.

Gookin, Kirby.
Review, "Sounding Measures." *Artforum* (February 1994): 88-89.

Israel, Nico.
"Rachel Berwick, Brent Sikkema." *Artforum* (December 2000): 147.

Johnson, Ken.
Review, "may-por-e'." *The New York Times*, December 19, 1997.

Jury, Louise.
"Parrots Speak Lost Rainforest Tongue." *The Independent on Sunday*, April 2, 2000.

Lloyd, Ann.
Review, "Sounding Measures." *Art In America* (June 1994): 97.

Richard, Frances.
Review, "may-por-e'." *Artforum* (April 1998): 118.

Rush, Michael.
Review, "may-por-e'." *New Art Examiner* (December-January 1997-98): 56.

Springer, Claudia.
"Rachel Berwick Economies of Desire." *Woman's Art Journal* (Fall 2002-Winter 2003): 16-20.

Zimmer, William.
Review, "A Glimpse of Contemporary Taste." *The New York Times*, February 25, 1996.

Brian Conley

Born in Chicago, Illinois

1985 University of Minnesota, Minneapolis, Minnesota,
Ph.D. in philosophy

1981 University of Minnesota, Minneapolis, Minnesota, M.F.A.

1978 Independent Study Program, Whitney Museum, New York

1974 State University of New York, Binghamton, New York, B.A.

Brian Conley lives and works in New York.

Selected Solo Exhibitions

2004 Decipherment of Linear X, Pierogi Gallery, New York

2001 ArtPace Foundation for Contemporary Art, San Antonio, Texas

2000 Xenotransplantation, Anthony Wilkinson Gallery, London; Zinc Gallery,
Stockholm

1995 Superior / (Cranial), Pierogi 2000 Gallery, New York

Selected Group Exhibitions

2004 Red Archive, Metropolitan Complex, Dublin

Trunk Show, King House, Roscommon; Sirius Art Centre, Cobh,
Cork, Ireland

2003 Affinity Archives, Metropolitan Complex, Dublin

2002 ArtBasel, Basel, Switzerland

Artissima, Turin, Italy

2001 BitStreams, Whitney Museum of American Art, New York

Marks of Omission, Arthouse Multimedia Center, Dublin

evol, Gallery L, Moscow

2000 War/Art/New Technologies, Pierogi 2000 Gallery traveling exhibition,
Yerba Buena Center for the Arts, San Francisco; Post Gallery,
Los Angeles; Block Artspace, Kansas City, Missouri

1999 Rage for Art, Pierogi 2000 Gallery, New York

1997 2001; Just What Do You Think You're Doing, Dave?, Williamsburg Art
Center, New York

Current/Undercurrent, Brooklyn Museum, Brooklyn, New York

1996 New York Artists, Galerie Guth & Maas, Reutlingen (Stuttgart), Germany

Fictional Archives - Four Walls, Leung Institute, Oslo, Norway

Dissociationism, Four Walls, New York

1995 Multiples, Pierogi 2000 Gallery, New York

1993 New York in Sarajevo - Art Umjetnost, Obala Theatre, Sarajevo,
Yugoslavia

Propaganda, M.A.P., Baltimore, Maryland

Body Modification, Hallwalls Contemporary Art Center,
Buffalo, New York

1992 240 Minuten, Esther Schipper Gallery, Berlin; Art Cologne,
Germany

Proposals for an AIDS Memorial, Municipal Art Society and
Public Art Fund, Clocktower, P.S. 1, New York

Selected Bibliography

Pace, Linda, ed.
Dreaming Red: History of the Artpace Foundation.
San Antonio: Artpace a Foundation for Contemporary Art, 2003.

Heller, Steven and Karrie Jacobs.
Angry Graphics: Protest Posters of the Reagan Bush Era. Utah:
Gibbs Smith Publishing, 1992.

Humphries, Jane.
"C98 Review: Dublin II." CIRCA (Winter 2001): 52-54.

Weiss, Allen S.
Unnatural Horizons. New Jersey: Princeton Architectural Press, 2000.

Mark Dion

1961 Born in New Bedford, Massachusetts

2003 University of Hartford School of Art, Hartford, Connecticut

1986 University of Hartford School of Art, Hartford, Connecticut

1985 Whitney Museum of American Art, Independent Study Program, New York

1984 School of Visual Arts, New York

Mark Dion lives and works in Beach Lake, Pennsylvania.

Selected Solo Exhibitions

2004 *Rescue Archaeology*, Museum of Modern Art, New York
Office for the Center for the Study of Surrealism and its Legacies, Manchester Museum, Manchester, United Kingdom
Universal Collection, Historisches Museum, Frankfurt am Main, Germany

Tropical Travels, Thomas Ender (1817-1818) and Mark Dion, Academy of Fine Arts, Vienna

2003 *RN: The Past, Present and Future of the Nurse Uniform*, The Fabric Workshop and Museum (in collaboration with J. Morgan Puett), Philadelphia, Pennsylvania

Mark Dion: Collaborations 1987-2003, Joseloff Gallery, Hartford, Connecticut; American Fine Arts, Co., New York

2002 *Mark Dion: Encyclomania*, Villa Merkel, Esslingen to Kunstverein Hannover, and Bonner Kunstverien, Bonn, Germany

Microcosmographia, University of Tokyo Museum, Tokyo

Ursus Maritimus, Goodwater, Toronto, Ontario, Canada

2001 *Cabinet of Curiosity for the Weisman Art Museum*, Weisman Art Museum, Minneapolis, Minnesota

2000 *Museum of Poison*, Bonakdar Jancou Gallery, New York

1999 *Two Banks: The Tate Thames Dig*, Tate Gallery, London

Where the Land Meets the Sea, Yerba Buena Center for the Arts, San Francisco

1998 *Adventures in Comparative Neuroanatomy*, Deutches Museum, Bonn, Germany

The Natural World, Vancouver Art Gallery, Vancouver, British Columbia, Canada

1997 *Trophies & Souvenirs*, London Projects, London

Mark Dion: Natural History and Other Fictions, Ikon Gallery, Birmingham, United Kingdom; Kunstverein, Hamburg, Germany; De Appel, Amsterdam, Netherlands

Homage- Jean-Henri Faber, Galerie des Archives, Paris

Curiosity Cabinet for the Wexner Center for the Arts, Columbus, Ohio

1996 *Two Trees*, American Fine Arts, Co., New York

A Tale of Two Seas: An Account of Stephan Dillemuth's and Mark Dion's Journey Along the Shores of the North Sea and the Baltic Sea and What They Found There, Galerie Christian Nagel, Cologne, Germany

1995 *Unseen Fribourg*, Fri-Art Centre d'Art Contemporarian, Fribourg, Switzerland (cat.)

Flotsam and Jetsam (The End of the Game), De Vleeshal, Middleburg, Netherlands

1994 *Arisoteles, Rachel Carson, Alfred Russel Wallace*, Galerie Metropol, Vienna

When Dinosaurs Ruled the Earth (Toys 'R' U.S.), American Fine Arts, Co., New York

1993 *The Great Hunter, The Marine Biologist, The Paleontologist and the Missionary*, Galerie Marc Jancou, Zurich

The Great Munich Bug Hunt, K-Raum Daxer, Munich, Germany (cat.)

1992 Galerie Christian Nagel, Cologne, Germany

1991 *Frankenstein in the Age of Biotechnology*, Galerie Christian Nagel, Cologne, Germany

1990 *Extinction, Dinosaurs and Disney: The Desks of Mickey Cuvier*, Galerie Sylvana Lorenz, Paris

Selected Group Exhibitions

2004 São Paolo Bienal, São Paolo, Brazil

For the Birds, Artspace, New Haven, CT

2003 *The Magic of Trees*, De Zonnehof, Amersfoort, Netherlands

Artist's Lecture as Performance, Whitechapel Art Gallery, London

2002 *The House of Fiction*, Sammlung Hauser und Wirth, St. Gallen, Switzerland

Museutopia, Karl Ernst Osthaus Museum der Stadt Hagen, German Hellgreen, Hofgarden, Dusseldorf, Germany

2001 *Lateral Thinking: Art of the 1990s*, Museum of Contemporary Art, San Diego, California

2000 *Ecologies*, The David and Alfred Smart Museum of Art, University of Chicago, Chicago, Illinois

Small World-Dioramas in Contemporary Art, Museum of Contemporary Art, San Diego, California

1999 *The Museum as Muse: Artists Reflect*, Museum of Modern Art, New York

1998 *The Natural World*, Vancouver Art Gallery, Vancouver, British Columbia, Canada

1997 XLVII Venice Biennale, Nordic Pavillon, Venice

Skulptur Projekte in Münster, Münster, Germany

1996 *Berechenbarkeit der Welt*, Bonner Kunstverein, Bonn, Germany

1995 *Mapping: A Response to MoMA*, American Fine Arts, Co., New York

1994 *Cocido y Crudo*, Museo Nacional Centro de Arte Renia Sofia, Madrid

1993 *Project for the Birds of Antwerp Zoo, On Taking a Normal Situation and Retranslating it into Overlapping and Multiple Readings of Conditions Past and Present*, Museum van Hedendaagse Kunst, Antwerpen, Belgium

1990 *Biodiversity: An Installation for the Wexner Center*, Wexner Center for the Visual Arts, Columbus, Ohio

The (Un)Making of Nature, Whitney Museum of American Art, Downtown at Federal Reserve Plaza, New York

1989 *Here and There: Travels*, Clocktower Gallery, Institute for Contemporary Art, New York

The Desire of the Museum, Whitney Museum of American Art, Downtown at Federal Reserve Plaza, New York

1988 *The Pop Project Part IV, Nostalgia as Resistance*, Clocktower Gallery, Institute for Contemporary Art, New York

1987 *Fake*, New Museum of Contemporary Art, New York

1986 *Rooted Rhetoric*, Castel Dell'Ovo, Naples, Italy

Selected Bibliography

Birnbaum, Daniel.
"Stream of Conscience." *Artforum International* (November 1999): 116-121.

Herbert, Martin.
"Mark Dion: Classified Information." *Dazed and Confused* (October 1999): 104-108.

Kwon, Miwon.
"Unnatural Tendencies: Scientific Guises of Mark Dion." West Bromwich, England: Hill Shorter, 1997.

Riemschneider, Burkhard and Uta Grosenick.
Art at the Turn of the Millenium. Cologne: Taschen, 1999.

Simon, Jason.
"Jean Painleve and Mark Dion." *Parkett* 44 (1995): 154-171.

Rattemeyer, C., et. al.,
"A Thousand Words: Mark Dion talks about Rescue Archaeology." *Artforum International* (November 2004): 180-181.

McClister, N.
"Mark Dion." *Bomb*, no. 85 (Fall 2003): 8-11.

Schwendener, M. Revier,
"Mark Dion: American Fine Arts / Aldrich Museum." *Artforum International* (Summer 2003): 192-93.

Sam Easterson

1972 Born in Hartford, Connecticut

1999 University of Minnesota, Minneapolis, Minnesota

1994 Cooper Union for the Advancement of Science and Art, New York

Sam Easterson lives and works in North Hollywood, California.

Selected Solo Exhibitions

2003 *Grand Arts*, Kansas City, Missouri

Center for Land Use Interpretation, Los Angeles, California

Carleton College, Northfield, Minnesota

2002 RARE Gallery, New York

2001 Atlanta College of Art, Woodruff Arts Center, Atlanta, Georgia

2000 RARE Gallery, New York

Selected Group Exhibitions

2004 *Entropy*, Galerie Museum, Bolzano, Italy

2003 *Through the Eye of the Wolf*, Beall Center for Art and Technology, University of California, Irvine, California

Animal Magnetism, Exploratorium, San Francisco, California

Occurances, School of the Art Institute of Chicago, Chicago, Illinois

2002 *Dogs: Wolf, Myth, Hero and Friend*, traveling exhibition, Natural History Museum of Los Angeles, Los Angeles

Media Field: Old New Technologies, Williams College Museum of Art, Williamstown, Massachusetts

2001 *Video Jam*, Palm Beach Institute of Contemporary Art, Palm Beach, Florida

Sciences et Cite, Centre pour l'image Contemporain, Geneva

Video Marathon, Art in General, New York

2000 Instituto Cubano del Arte e Industria Cinematograficos, Havana, Cuba Sydney Film Festival, Dendy Opera Quays, Sydney, Australia

Junge Hunde 2000, ArtCinema, Germany

1999 *Paradise 8*, Exit Art/The First World, New York

In Passing, Bard Center for Curatorial Studies, Annandale-on-the-Hudson, New York

Sam Easterson/Matt Monahan, Archipel, Apeldoorn, Netherlands

1998 *Video Selections*, Rockefeller Center, New York

Pandaemonium?, London Electronic Arts/The Lux Center, London

Dialogues: Sam Easterson/T.J. Wilcox, Walker Art Center, Minneapolis, Minnesota

Dissolving the Walls, Art in General, New York

1997 Biennial Exhibition, Whitney Museum of American Art, New York

Station to Station, Artists Space, New York

1996 *Video Collections*, Gallery 4C, New York

Fuzzy Logic, Institute of Contemporary Art, Boston, Massachusetts

1995 Massachusetts College of Art, Boston, Massachusetts

1994 Knitting Factory, New York

Selected Bibliography

Bart, Emily.
"Wild Kingdom." *RES 4* (July/August 2001).

Feaster, Felicia.
"Lights! Camera! Alligator!" *Creative Loafing* (June 20-26, 2001).

Gilman-Sevcik, Frantiska.
"Sam Easterson @ RARE." *Flash Art* (January/February 2001).

Taubin, Amy.
"Voice Choices: Station to Station." *The Village Voice*, April 15, 1997.

Samson, Oliver.
"Vision Quest." *Surface*, no. 28, 2001.

Kathy High

1954 Born in Bryn Mawr, Pennsylvania

1981 State University of New York, Buffalo, New York, M.A.

1977 Colgate University, Hamilton, New York, B.A.

 Kathy High lives and works in Troy, New York.

Selected Solo Exhibitions

2004 *Soft Science: Embracing Animal*, Judi Rothenberg Gallery,
 Boston, Massachusetts

2003 The School of the Art Institute of Chicago,
 Chicago, Illinois

2002 Red Vic, San Francisco, California
 Scribe Video Center, Philadelphia, Pennsylvania

2001 *Drama Queens: Women Behind the Camera*,
 Guggenheim Museum, New York

 Reel Women Festival, Austin, Texas

2000 13th Annual Virginia Film Festival 2000, Vinegar Hill Theatre,
 University of Virginia, Charlottesville, Virginia

Selected Group Exhibitions

2004 *Real to Reel: An Independent Survey of Contemporary Experimental Works
 in Independent Film, Video & New Media*, Nelson-Atkins Museum of
 Art, Kansas City, Missouri

 Evolutionary Girls Club, Carnegie Art Center, Tonowanda, New York

2003 *Standby: No Technical Difficulties*, Pacific Film Archive, Berkeley,
 California; Museum of Modern Art, New York

 Emergency Filmmaking Project: Contingencies, The Substation: A
 Home for the Arts, Singapore

2002 *Zoo*, Catalyst Arts, Belfast, Ireland; CCA Kitakyushu, Japan; The Soap
 Gallery, Tokyo; Rootx/Time Based Arts, Hull, United Kingdom;
 Videotage Arts Space, Hong Kong

Dis.Art.Tec4 Festival, Museo de Arte y Diseño Contemporáneo, Costa Rica

Gene(sis): Contemporary Art Explores Human Genomics, Herny Art
Gallery, Seattle, Washington

2001 Queer Articulations Film Festival, Princeton University,
 Princeton, New Jersey

 Body as Byte, Kunst Museum, Luzern, Switzerland

 Women in the Director's Chair, Chicago, Illinois

 Hong Kong Lesbian and Gay Film Festival, Hong Kong, China

2000 *American Century Part II*, Whitney Museum of American Art, New York

 Indiegirls II, Filmhuis Cavia, Amsterdam, Netherlands

 Melbourne Queer Film and Video Festival, Prahran, Victoria, Australia

Selected Bibliography

Camper, Fred. Review,
 "Animal Attraction."
 Chicago Reader, December 5, 2003.

Huntington, Richard.
 Review, "Installation with a Point."
 Buffalo News, March 5, 2004.

Macor, Alison.
 "Filmmaker's Pet Project is Part of 'Digital Divas.'" *Austin-American
 Statesman*, September 6, 2001.

Sevilla, María Eugenia.
 "Documentan obras el riesgo en el arte." *Reforma*, July 15, 2003.

Shrage, Laurie.
 "From Reproductive Rights to Reproductive Barbie: Post-Porn Modernism
 and Abortion." *Feminist Studies Journal* (Spring 2002).

Zimmerman, Patricia R.
 States of Emergency: Documentaries, Wars and Democracies.
 Minneapolis, Minnesota: Minnesota Press, 2000, p. 10, 146.

Natalie Jeremijenko

1966 Born in Mackay, Queensland, Australia

1997 Stanford University, Palo Alto, California, Master of Engineering

1994 University of Melbourne and Royal Melbourne Institute of Technology, M.S.

1991 Royal Melbourne Institute of Technology, Melbourne, Australia, B.F.A.

1988 Griffith University, Queensland, Australia, B.S.

1987 Monash University, Victoria, Australia, B.S.

Natalie Jeremijenko lives and works in New York and San Diego, California.

Selected Solo Exhibitions

2004 *OneTrees TwoWheeling,* San Francisco OneTrees, San Francisco, California

A Game Goose, Telic, Los Angeles

D4PA (Designed for Political Action), Republican National Convention, New York

Feral Robotics, Gigantic Art Space, New York

2003 *Introducing the OOZ: The Goosing Phase,* De Verbeelding Kunst Landschap Natuur, Zeewolde, Netherlands

Feral Robotic Dog Pack Release, Bronx River Arts Center, Bronx, New York

2002 *Feral Robotic Dog Pack Release Baldwin Park,* Florida Film Festival, Maitland, Florida

2001 *BitPlane, Suicide Box,* Control_Space ZKM, Karlsruhe, Germany

2000 *Neologisms,* Storefront for Art and Architecture, New York

1999 *The Bureau of Inverse Technology,* Postmasters Gallery, New York

Tree Logic, MASS MoCA, North Adams, Massachusetts

1994 *Tree Logic,* The Architecture Gallery, University of California, Berkeley, California

Selected Group Exhibitions

2003 , Art Space, New Haven, Connecticut

Reconfiguring Space, Art in General, New York

2002 *Infotechture,* Artist Space, New York

2000 *AEN,* Walker Art Center, Minneapolis, Minnesota

Unnatural Science, MASS MoCA, North Adams, Massachusetts

Prankster, White Columns, New York

Greater New York, P.S.1 Contemporary Art Center, New York

Vital Signs, Leonard and Bina Ellen Gallery, Concordia, University, Montreal

1999 *Frames of Reference: Reflections on Media by Rockefeller and MacArthur Film/Video/Multimedia Fellows,* Solomon R. Guggenheim Museum, New York

1998 *Ecotopias,* Yerba Buena Center for the Arts, San Francisco

Dutch Electronic Art Festival, Rotterdam, Netherlands

Dromology: Ecstasies of Speed, New Langton Arts, San Francisco

1997 Whitney Biennial, Whitney Museum of American Art, New York (cat.)

Documenta X, Kassel, Germany (cat.)

Technology in the 1990, Museum of Modern Art, New York (cat.)

Film+arc.graz, 3rd International Biennial, Graz, Germany

Computer Life, Blasthaus Gallery, San Francisco

1996 *Prix Ars Electronica,* Linz Gallery, Linz, Austria

New York Video Festival, Lincoln Center for the Performing Arts, New York

Secrets: Works by Merry Alperen, Andrea Modica, Sage Sohier, and the BIT, Ansel Adams Center for Photography, San Francisco

Selected Bibliography

"The Technology Review 100: World Wide Web." *Technology Review: MIT's Magazine of Innovation* 102, no. 6 (November-December 1999): 102-111.

Allen, Jan.
"Letting Go." *C Magazine,* no. 58 (May-August 1998).

Dyson, Fran.
"Planting Paradox." *CIRCA* (Winter 1999): 14-15.

Eakin, Hugh.
"Up and Running." *Art News* (June 1999): 41.

Eldridge, Courtney.
"Better Art Through Circuitry." *The New York Times,* June 11, 2000, p. SM 25.

Johnson, Ken.
"The Bureau of Inverse Technology." *The New York Times,* July 9, 1999, sec. E, p.35.

Mikhail, Kate.
"They Fly Through the Air with the Greatest of Ease." *Independent* (London), April 13, 1999.

Madoff, Steven Henry.
"Out of the Ether, a New Continent of Art." *The New York Times,* February 14, 1999, p. AR 37.

O'Grady, Jim.
"To an Artist's Eyes, Beauty is Trash, and Trash Beauty." *The New York Times,* January 20, 2002, The City, p. 4.

Travis, John.
"Genes on Display." *Science News,* December 16, 2000, p. 392.

Nicolas Lampert

1969	Nicolas Lampert was born in Washington, D.C.
1995	California College of the Arts (formerly C.C.A.C.), Oakland, California
1992	University of Michigan, School of Art, Ann Arbor, Michigan
	Nicolas Lampert lives and works in Milwaukee, Wisconsin.

Selected Solo Exhibitions

2002 *In the Kitchen and other Collage Work*, Contemporary Artists Center, North Adams, Massachusetts

2001 *The Collage Art of Nicolas Lampert*, Basil Hallward Gallery, Powell's City of Books, Portland, Oregon

Selected Group Exhibitions

2004 *For the People*, installation by the God Bless Graffiti Coalition, Cell Space, San Francisco, California

Paper Politics: Socially Engaged Printmaking, In These Times, Chicago, Illinois

The Interventionists: Art in the Social Sphere, installation by the God Bless Graffiti Coalition, MASS MoCA, North Adams, Massachusetts

Art of Zines, San Jose Museum of Art, San Jose, California

2003 *Machine-Animal Collages*, Discovery World, Milwaukee Public Museum, Milwaukee, Wisconsin

Drawing Resistance, Maltwood Art Museum and Gallery, University of Victoria, British Columbia, Canada

War and Peace: Artists' Voices, Gallery 281, Milwaukee, Wisconsin

2002 *Drawing Resistance*, The Institute for Social Ecology, Plainfield, Vermont

2001 Telluride International Experimental Film Festival, Telluride, Colorado

Department of Space and Land Reclamation, Chicago, Illinois

2000 *Pork: The Other White Meat*, The Q-Hut, Portland, Oregon

Selected Bibliography

Bigelow, Bill and Bob Peterson, ed.
Rethinking Globalization: Teaching Justice in an Unjust World. Milwaukee: Rethinking Schools Press, 2002.

Eisenstein, William.
Review, "Rebel Art: Drawing Resistance: A Traveling Political Art Show." *Urban Ecology* (Spring 2002).

Macphee, Josh.
Stencil Pirates: A Global Study of the Street Stencil. Brooklyn: Soft Skull Press, 2004.

Mann, James, ed.
Peace Signs: the Anti-War Movement Illustrated. Zurich: Edition Olms, 2004.

Rodgers, Christy.
"Art and Protest: Drawing Resistance: A Traveling Political Art Show." *What If? A Journal of Radical Possibilities* (August 2002).

Thompson, Nato.
"Chimerical Miracle Whip: Into the Border Lands with the Wild Kingdom." *New Art Examiner* (March 2001).

Walsh, Michael.
Graffito. Berkeley: North Atlantic Books, 1996.

Yanke, Pete.
"Drawing Resistance: A Traveling Political Art Show: Interview with Nicolas Lampert and Sue Simensky Bietila." *Black Thorn* (Spring 2002).

Liz Lerman

1947 Born in Los Angeles, California

1970 The University of Maryland, B.A. Dance

1982 George Washington University, M.A. Dance

2002 MacArthur Fellowship recipient

Liz Lerman works in Tacoma Park, Maryland.

Past Projects

2004 *Body after Body, Place after Place*, a site-specific dance for corpus, an installation by Ann Hamilton. MASS MoCA, North Adams, Massachusetts

2003 *Oh, Brad! They're Dancing in the Galleries*, Hirshhorn Museum and Sculpture Garden (Smithsonian Institution, Washington, DC)

2002 *Uneasy Dances*, Tampa Bay Performing Arts Center, Tampa, Florida

2001 *Hallelujah: In Praise of Paradise Lost & Found*, Power Center, University Musical Society, Ann Arbor, Michigan

2000 *Hallelujah: In Praise of Fertile Fields*, Doris Duke Studio Theater, Jacob's Pillow Dance, Becket, Massachusetts

1999 *Moving to Hallelujah Skirball Cultural Center*, Los Angeles, California

1999 *Hallelujah: In Praise of Animals and Their People*, Lisner Auditorium, Washington, DC

1998 *A Moving Lecture: 50 Modest Reflections on Turning Fifty*, Gammage Auditorium, Arizona State University, Tempe, Arizona

1998 *White Gloves/Hard Hats*, Garde Arts Center, New London, Connecticut

1994-1996 *The Music Hall's Shipyard Project*, a two-year residency that culminated in a weeklong festival that included major public events, exhibits, on-stage and site-specific performances, storytelling, and dance-mediated forums all exploring Portsmouth, New Hampshire's 200 year-old shipyard history, politics, environment, and culture

1995-1997 *Shehechianu*, a full evening work that explored the mingling of personal histories in three 20th-century epochs

1994 *Safe House: Still Looking*, a collaboration with singer/composer Ysaye Barnwell that reflected the Underground Railroad in contemporary searches for safety and shelter

1991 *The Good Jew?*, a complex work that integrated dance with a wide range of theatrical techniques to take an unflinching look at issues of faith, ethnicity, and identity

1986 *Still Crossing*, one of six international dance companies selected to perform at the centennial of the Statue of Liberty

Michael Oatman

1964 Born in Burlington, Vermont

1992 State University of New York at Albany, Albany, New York, M.F.A.

1986 Rhode Island School of Design, Providence, Rhode Island, B.F.A.

Michael Oatman lives and works in Troy, New York.

Selected Solo Exhibitions

2003 *Jackknife: Collages by Michael Oatman*, The University of Wyoming Museum of Art, Laramie, Wyoming

2002 *Dowsing With a Knife*, Francis Colburn Gallery, University of Vermont, Burlington, Vermont

2001 *Idol*, Williams College Museum of Art, Williamstown, Massachusetts (cat.)

1999 *The Last Library (Kosovo Requiem)*, Phoenix Gallery, New York

1996 *Murder and other Wonders: Film Studies*, Julian Scott Gallery, Johnson State College, Johnson, Vermont

1995 *Long Shadows: Henry Perkins and the Eugenics Survey of Vermont*, The Fleming Museum, University of Vermont, Burlington, Vermont

1994 *Michael Oatman's Menagerie*, Schaght Fine Arts Center, Russell Sage College, Troy, New York

1993 *Michael Oatman Presents Robert MacKintosh: The Responsibilities of Disappearance*, L/L Gallery, University of Vermont, Burlington, Vermont

1992 *Testimony of the Harding Photograph*, commissioned by Margery and Homer Harding, Schodack, New York

1991 *Michael Oatman*, The Knitting Factory, New York

1990 *Frames of Reference*, Webb and Parsons North, Burlington, Vermont

Group Exhibitions

2004 *Some American Art*, Firlefanz Gallery, Albany, New York

Some Assembly Required, Mary Ryan Gallery, New York

War and Peace, Metaphor Contemporary Art, Brooklyn, New York

2003 *Economical Food Circus*, Contemporary Arts Center, North Adams, Massachusetts

For the Birds, Artspace, New Haven, Connecticut (cat.)

Living With Duchamp, Tang Teaching Museum and Art Gallery, Skidmore College, Saratoga Springs, New York

Unplugged: Painting in the Age of Technology, Albany International Airport Art and Culture Program, Albany, New York

2002 *40 Artists, 40 Miles*, The Arts Center of the Capital Region, Troy, New York

2001 *The Art of Illumination; Medieval to Modern*, Manhattanville College Library, Purchase, New York

Art at the Edge of the Law, Aldrich Museum of Contemporary Art, Ridgefield, Connecticut (cat.)

2000 *Redlining the Turtle*, Contemporary Artists Center, North Adams, Massachusetts

Unnatural Science, Massachusetts Museum of Contemporary Art, North Adams, Massachusetts (cat.)

1999 Exhibition of Artists of the Mohawk/Hudson Region, Albany Institute of History and Art, Albany, New York (cat.)

1998 IV International Graphic Arts Biennial, Varosi Muveszetim Museum, Gyor, Hungary

1997 *Un$_6$natural$_{12}$thirst$_6$ (Tale of the Middleman)*, RCCA: The Arts Center, Troy, New York

1996 *Paper*, Firehouse Gallery, Burlington, Vermont

1995 *Hardware*, Art in General, New York

Hidden Histories, Les Urbach Gallery, Albany, New York

1994 *Myths and Mysteries*, Institute of Contemporary Art, Boston, Massachusetts

1993 Invitational, Provincetown Artist's Colony, Provincetown, Massachusetts

1992 *Politics and Art*, Levinson/Kane Gallery, Boston, Massachusetts

Goodbye to Apple Pie: Contemporary Artists View the Home in Crisis, DeCordova Museum and Sculpture Garden, Lincoln, Massachusetts

1991 *Volume I*, Boulevard Projects Space, Albany, New York

1990 *Tom Breitenbach, Gayle Johnson, Michael Oatman*, RCCA: The Arts
 Center, Troy, New York

Selected Bibliography

Bjornland, Karen.
"Another Captivating Art Exhibit Lands at Airport's Gallery."
Schenectady Gazette, November 6, 2003.

Buckeye, Robert.
"Long Shadows: Henry Perkins and the Eugenics Survey of Vermont: An
installation by Michael Oatman." *Art New England*
(February-March 1996): 68.

Collins, Erica.
"Suspended Narratives: Provocative works on display in Kingston." *The
Coventry Courier*, October 23-24, 2003.

Gardner, Karen.
"Artist Re-creates Controversial Vermont Moment." *North Adams
Transcript*, July 15, 2000.

Jaeger, William.
"Factory Direct 1 + 2." *Art New England*
(October/November 2002): 37.

McQuaid, Cate.
"DeCordova Annual is Full of Surprises." *The Boston Globe*,
June 19, 2002.

New American Paintings, Volume #50. Boston, Mass.:
The Open Studios Press, 2004.

Smith, Roberta.
"In Their Own Worlds: Giant Hybrids of Fact and Fantasy."
The New York Times, August 11, 2000.

Sutherland, Scott.
"Michael Oatman Presents: Robert MacKintosh & The Responsibilities of
Disappearance." *Art New England*, July 7, 1993.

Temin, Christine.
"Unnatural Selection at MASS MoCA." *The Boston Globe*, July 28, 2000.

Valdez, Sarah.
"Outlaws in Art Land." *Art in America* (November 2001).

Wright, Peg.
"'Menagerie' Explores Eurocentric Guilt with Animal Imagery."
The Daily Gazette, January 27, 1994.

Motohiko Odani

1972 Born in Kyoto, Japan

1997 Tokyo National University of Art and Music, Tokyo, M.A.

1995 Tokyo National University of Art and Music, Tokyo, B.A.

Motohiko Odani lives and works in Tokyo, Japan.

Selected Solo Shows

2004 *Modification*, KPO Kirin Plaza Osaka, Osaka, Japan (cat.)

Erectro, Yamamoto Gendai, Tokyo

Tokyo Style: Motohiko Odani, Moderna Museet, Stockholm, Sweden

2002 *9th Room*, Gallery Raku, Kyoto University of Art and Design, Kyoto, Japan (cat.)

2001 *En Melody*, Fine Art Rafael Vostell, Berlin; Marella Arte Contemporanea, Milan

1998 *Transfiguration*, Rötgen Kunstraum, Tokyo

1997 *Phantom-Limb*, P-House, Tokyo (cat.)

Selected Group Shows

2004 *Roppongi Crossing — New Visions of Japanese Art 2004*, Mori Art Museum, Tokyo (cat.)

Mediarena: Contemporary Art from Japan, Govett-Brewster Art Gallery, New Plymouth, New Zealand (cat.)

Happy-Go-Lucky, VHDG Stichting V / H de Gemeente, Netherlands

Strategies of Desire, Kunsthaus Baselland, Muttenz, Switzerland (cat.)

2003 50th Venice Biennale, Venice (cat.)

2002 Kwangju Biennale, Kwanju, Korea (cat.)

Cast Cycle, Scai the Bathhouse, Tokyo

Private Luxury, Mannu Art Museum, Osaka, Japan (cat.)

2001 *Translated Acts*, Haus der Kulturen der Welt, Berlin; Queens Museum of Art, Queens, New York (cat.)

Sonsbeek 9: Locus/Focus, Eusebius Church, Arnhem, Netherlands

7th International Istanbul Biennale, Istanbul / Tokyo Opera City Gallery, Tokyo (cat.)

2000 *ICON*, Gallery Celler, Nagoya, Japan

5th Biennale de Lyon, Art Contemporain, Halle Tony Garnier, Lyon, France (cat.)

1999 *VOCA*, The Ueno Royal Museum, Tokyo (cat.)

Fancy Dance, Art Sonje Museum/Soje Art Center, Seoul, Korea (cat.)

Guarene Arte 99, Fondazione Sandretto Re Rebaudengo PerL'arte, Torino, Italy (cat.)

Net_Condition, NTT InterCommunication Center (ICC), Tokyo

1998 *Presumed Innocence*, Maria Arte Contemporanea, Italy (cat.)

1997 *Tanagokoro 2 — Works on the plam —* Rötgen Kunstraum, Tokyo

Potential of Sculpture, Tokyo National University of Art and Music, Tokyo (cat.)

1996 *Morphe '96*, Spriral, Tokyo

1995 *Pool 2*, Rötgen Kunst Institut, Tokyo

Selected Bibliography

Anderson, John.
"Video Eye for Basel." *Miami Newtimes North*, December 4, 2003.

Byrt, Anthony.
"The Creepy Contemporary Sublime." *Contemporary Visual Arts and Culture* (February-May 2004): 53-55.

DiPietro, Monty.
"Soap Bubbles Bursting with Blood." *Asahi Evening News*, November 6, 1997, p.11.

Nagoya, Satoru.
"Motohiko Odani at Yamamoto Gallery." *Flash Art* (July-September 2004): 52.

Stephens, Christopher.
"Inside the Tent." *Kansai Time Out*, March 3, 2004.

Patricia Piccinini

1965 Born in Freetown, Sierra Leone

1991 Victorian College of the Arts, Melbourne, Victoria, Australia

1988 Australian National University, Canberra, ACT, Australia

1984 Universita di Firenze, Florence

 Patricia Piccinini lives and works in Melbourne, Australia.

Selected Solo Exhibitions

2004 *Patricia Piccinini: Sculpture*, Robert Miller Gallery, New York

 We Are Family, Bendigo Art Gallery, Bendigo, Victoria, Australia

 Repercussions, with Peter Hennessey, Greenaway Art Gallery, Adelaide, Australia

2003 *We Are Family*, Hara Museum, Shinagawa, Tokyo

 Love Me Love My Lump, Dryphoto Arte Contemporanea, Monash Centre in Prato, Tuscany, Italy

 We are Family, Venice Biennale 2003, Australian Pavilion, Venice, Italy (cat.)

2002 *Retrospectology: The World According to Patricia Piccinini*, Australian Centre for Contemporary Art, Southbank, Victoria, Australia (cat.)

 Call of the Wild: Patricia Piccinini, Museum of Contemporary Art, Sydney (cat.)

2001 *The Breathing Room*, Tokyo Metropolitan Museum of Photography, Tokyo

 Superevolution, Centro de Artes Visuales, Lima, Peru

2000 *Desert Riders*, Roslyn Oxley9 Gallery, Sydney

 Swell, Artspace, Sydney

1999 *Truck Babies*, Tolarno Galleries, Melbourne

1998 *Car Nuggets*, Arts Victoria, Melbourne

1997 *Psycho*, Tolarno Galleries, Melbourne

1996 *Your Time Starts Now*, Contemporary Art Centre of South Australia, Adelaide, Australia; Institute of Modern Art, Brisbane, Australia

1995 *Love Me Love My Lump*, The Basement Project, Melbourne

1994 *T.G.M.P.*, The Basement Project, Melbourne

 TerrUrbanism, Australia Centre, Manila, The Philippines

 Indivisibles, The Basement Project, Melbourne

1993 *Love Story*, Platform, Melbourne

1992 *All That Glistens*, Temple, Melbourne

1991 *The Body DIS-corporate*, Linden, Melbourne

Selected Group Exhibitions

2004 *Brides of Frankenstein*, San Jose Museum of Art, San Jose, New Mexico

 Supernatural Artificial, Tokyo Metropolitan Museum of Photography, Tokyo

 We are the world, Chelsea Art Museum, New York

2003 *Bloom mutation, toxicity and the sublime*, Govett-Brewster Gallery, New Plymouth, New Zealand

2002 *Tech/No/Zone*, Museum of Contemporary Art, Taipei, Taiwan

 (the world may be) fantastic, Biennale of Sydney, Sydney, Australia (cat.)

 Modified Terrain, Institute of Modern Art, Brisbane, Australia

2001 2nd Berlin Biennale for Contemporary Art, Kunst-Werke+Postfuhrant, Berlin

2000 Kwangju Biennial, Kwangju, Korea

 Sporting Life, Museum of Contemporary Art, Sydney

 Flow, National Gallery, Kuala Lumpur, Malaysia

 Make/Believe, The Fabric Workshop and Museum, Philadelphia, Pennsylvania

1999 *Signs of Life*, Melbourne International Biennial, Melbourne (cat.)

1998 *New Acquisitions*, National Gallery of Victoria, Melbourne

1997 *Wild Kingdom*, Institute of Modern Art, Brisbane, Australia

Fotofeis, Gallery of Modern Art, Glasgow, Scotland

Australian Perspecta, Museum of Contemporary Art, Sydney

1996 *Photography is Dead! Long Live Photography!*, Museum of Contemporary Art, Sydney

Perception & Perspective, National Gallery of Victoria, Melbourne

1995 *Fleshly Worn*, ASA Gallery, New Zealand

1994 *Critical Mass*, Arts Victoria Gallery, Melbourne

1993 *Deliquescence*, 200 Gertrude Street Gallery, Melbourne, Canberra Contemporary Art Space, Canberra, Australia

1992 *Deliquescence*, First Draft West, Sydney

1991 *Heretical Gestures at the Birth of Enlightenment*, Swanston Street Gallery, Melbourne

Selected Bibliography

Byrt, Anthony.
"The Creepy Contemporary Sublime," *Broadsheet* (February-May 2004): 53-55.

Clement, Tracey.
"Warped Reflections." *Artlink*, v.23 no.3, 2003: 52-57.

Fitzgerald, Michael.
"Not Dying, Changing." *Time Magazine*, March 22, 2004, p.62-63.

Gopnik, Blake.
"Australia's Beast-Case Scenario." *The Washington Post*, June 22, 2003, p.N 5.

Green, Charles.
"Patricia Piccinini." *Artforum* no. 9 (May 2002): 194.

"Inspiration Can Be Found in Everything: Patricia Piccinini." *Dazed and Confused* (January 2004): 108.

Larkin, Annette, ed. "Artists of the 21st Millenium: Patricia Piccinini." *Art Market Report* (Autumn 2004): 19.

Mania, Astrid. "Digital Fornication, Mutual Procuration, Patricia Piccinini!" *Broadsheet* (September-November 2003): 16-17.

Matsuura, Aya. "Patricia Piccinini We are Family." *Bijutsu Gahou*, November 30, 2003, p.190-191.

Mills, Kathryn.
"Consumed by Passion." *Australian Art Collector* (July-September 2004): 82-85.

Moir, Annabel.
"Fresh: We are family." *Object Magazine* no. 42 (June-July 2003): 16.

Saisho, Hazuki.
"We are Family." *Sankei Shimbun*, January 18, 2004, p.14.

Turner, Jonathon.
"Alien Nation." *ARTnews* (September 2003).

Ann-Sofi Sidén

1962 Born in Stockholm, Sweden

Ann-Sofi Sidén lives and works in Stockholm and New York.

Selected Solo Exhibitions

2004 *Ann-Sofi Sidén: In Between the Best of Worlds*, Moderna Museet, Stockholm (cat.)

Warte Mal!, BAK, Utrecht, Netherlands; Kölnischer Kunstverein, Cologne, Germany (cat.)

Who is the Queen of Mud? – The Clocktower and QM, I Think I'll Call Her QM, CAAM Centro Atlantico de Arte Moderno, Las Plamas, Gran Canaria, Spain

2003 *3 MPH (Horse to Rocket)*, Galería Pepe Cobo, Sevilla, Spain

QM, I Think I Call Her QM, Galerie Jirm Svetska, Prague

2002 *3 MPH (Horse to Rocket)*, Artpace, San Antonio, Texas

Warte Mal!: Prostitution After the Velvet Revolution, Hayward Gallery, London (cat.)

Warte Mal!, Moderna Museet c/o BAC, Baltic Art Center, Visby, Sweden

2001 *Fidei Commissum*, Christine König Galerie, Vienna

Station 10 and Back Again, Norrköpings Konstmuseum, Norrköping, Sweden

Ann-Sofi Sidén - The Panning Eye Revisited, Musée d'art Moderne de la Ville de Paris, Paris (cat.)

2000 *2 DVD Installations: Eija-Liisa Ahtila & Ann-Sofi Sidén*, Contemporary Arts Museum, Houston, Texas

Who is invading my privacy, not so quietly and not so friendly?, The South London Gallery, London

QM, I Think I Call Her QM, Hirshhorn Museum, Washington, D.C.

1999 *Warte Mal!*, Wiener Secession, Vienna

Days Inn & The Preparation, Galerie Barbara Thumm, Berlin

Who Told the Chambermaid? and The Preparation, Galerie Nordenhake, Stockholm

1998 *QM, I Think I Call Her QM*, Biografen Zita, Stockholm

1997 *Room Within the Room*, Swedish Radio, Stockholm

1995 *Excerpt III*, Gallery Lucas & Hoffman, Cologne, Germany

It's by Confining One's Neighbor that One is Convinced of One's Own Sanity, Galerie Nordenhake, Stockholm (cat.)

1993 *CODEX: from the city stones to the seat of shame: a reconstruction by Ann-Sofi Sidén*, Riksutställningar, Stockholm (cat.)

1991 *Sofi's Room*, Galleri Mehan, Stockholm

Performance Gretchens Monologue, Fylkingen, Stockholm

1990 *Performance Directaction*, Queen of Mud Inspects the Art Fair, Sollentuna, Sweden

Performance 179 kg, Come and Go, Act-90, Kulterhuset, Stockholm

1989 *Performance Queen of Mud Visits the Perfume Counter*, Varuhuset NK, Stockholm

1988 *Inget måleri*, Galleri Rotor, Gothenburg, Sweden

Performance TSSS, Greetings to the Swedish Farmers and their Asian Women, Geneva

Selected Group Exhibitions

2004 *Born to be a star – Sound Video, Installationen und Performances*, Künstlerhaus, Vienna

Biennale of Sydney, Sydney

Art 35 Basel: Art Unlimited, (Galerie Nordenhake, Berlin/Stockholm; Galería Pepe Cobo, Sevilla, Spain), Basel, Switzerland

Perspectives@25, Contemporary Arts Museum, Houston, Texas

Voluntary Memory, Barbican Center Art Galleries, London

2003 *Somewhere Better than this Place: Alternative Social Experience in Spaces of Contemporary Art*, Contemporary Art Center, Cincinnati, Ohio

Micropolitics, Part I, EACC Espai de'Art Contemporani de Castelló, Castellón, Spain

Women 2003, billboard project in Denmark & Sweden

Micropolitics, Part III, EACC Espai de'Art Contemporani de Castelló, Castellón, Spain

2002 *Acquisitions 2001, part 1 – Photographs, Videoinstallations, Video*, National Museum of Contemporary Art, Athens

Eight Nordic Tales, CGAC – Centro Galego de Arte Contemporanea, Santiago de Compostela, Spain

Elvis Has Just Left The Building, Künstlerhaus Bethanien, Berlin

2001 *Let's Talk about Sex*, Kunsthaus, Dresden, Germany

CTRL (Space), ZKM, Center for Art and Media, Karlsruhe, Germany

Berlin Biennale für zeitgenössische Kunst, Kunst-Werke, Berlin

Trauma, Dundee Contemporary Arts, Dundee, Scotland; Firstsite, Colchester, Essex, England; MoMA, Oxford, England

2000 *Scène de la vie conjugale*, Villa Arson, Nice, France

Through Melancholia and Charm - Four Installations, Galerie Nordenhake, Berlin

Kwangju Biennale 2000, Kwangju, Korea

Organizing Freedom, Moderna Museet, Stockholm (cat.)

1999 *Composite*, The National Museum of Contemporary Art, Oslo, Norway (cat.)

Dial M for..., Kunstverein München, Munich, Germany (cat.)

dAPERTutto, La Biennale di Venezia, (curated by Harald Szeemann), Venice (cat.)

Midnight Walkers & City Sleepers, Red Light District, Amsterdam, Netherlands

1998 XXIV Bienal de São Paulo, São Paulo, Brazil (cat.)

In Visible Light, Moderna Museet, Stockholm (cat.)

Manifesta 2, European Biennial of Contemporary Art, Luxemburg (cat.)

Arkipelag, Nordiska Museet, Stockholm

Nuits Blanches, Musée d'art moderne de la ville de Paris, Paris (cat.)

1997 *Conspiracy*, Uppsala Konstmuseum, Uppsala, Sweden (cat.)

Clean & Sane, Edsvik, Stockholm (curated by Maria Lind) (cat.)

Invasion, Saaremaa Biennial, Kingisepp, Estonia (cat.)

Around Us, Inside Us, Borås Konstmuseum, Borås, Sweden (cat.)

Letter & Event, Apex, New York (cat.)

1996 *See What it Feels Like*, Rooseum, Malmö, Sweden (cat.)

1995 *395'*, Sandvikens Konsthall, Sandviken, Sweden

A Tribute to Ingmar Bergman, Nordanstad Gallery, New York

Strange Phenomena, National Museum, Helsinki, Finland (cat.)

1994 *Who Has Enlarged This Hole?*, Alice Fabian, 53 W. 9th St., New York

Good Morning America, PS.1. Studio Artist Group Show at PS.1. Museum, New York (cat.)

1993 *Brown Tableaux for Five Monitors*, Sundsvalls Museum, Sundsvall, Sweden

Ad Hoc, Galerie Nordenhake, Stockholm

Prospect, Fotografiska Museet, Stockholm

1992 *Ecce Homo*, Liljevalchs Konsthall, Stockholm

1991 *AVE*, Audio Visual Art Festival, Arnhem, Holland

Selected Bibliography

Allen, Jennifer.
"On Through Melancholia and Charm." NU: *The Nordic Art Review*, no. 1, 2001.

Arrenius, Sarah.
"A Mud Queen as TV-star." *Index*, no. 1, 1996.

Birnbaum, Daniel.
"Shrink Rap: the Art of Ann-Sofi Sidén." *Artforum International* (Summer 1999): 138-41.

Estep, Jan.
"Feral Children and the Queen of Mud." *New Art Examiner*
(March 2001): 24-29.

Hoffman, Justin.
"Zonen der Ver-störung." *Kunstforum International,* no. 139
(December 1997-March 1998).

Lind, Maria.
"Ann-Sofi Sidén: Peeping on the Chambermaid." *Flash Art*
(International Edition), v.32 no. 207 (Summer 1999): 121.

Lind, Maria.
"Med besatthet som råmaterial." *Svenska Dagbladet,* September 9, 1995.

Rossholm-Lagerlöf,
Margareta. "Ann-Sofi Sidén." *Index,* no. 1, 1996.

Siegel, Katy.
"1999 Carnegie International." *Artforum International*
(January 2000): 148-9.

Volk, Gregory.
"On Ann-Sofi Sidén's 'Fideicommissum.'" *Camera Austria*
(November 2000).

MASS MoCA